the language of family

MARCH / 2018

To Sarah,
.Love, Dad xox

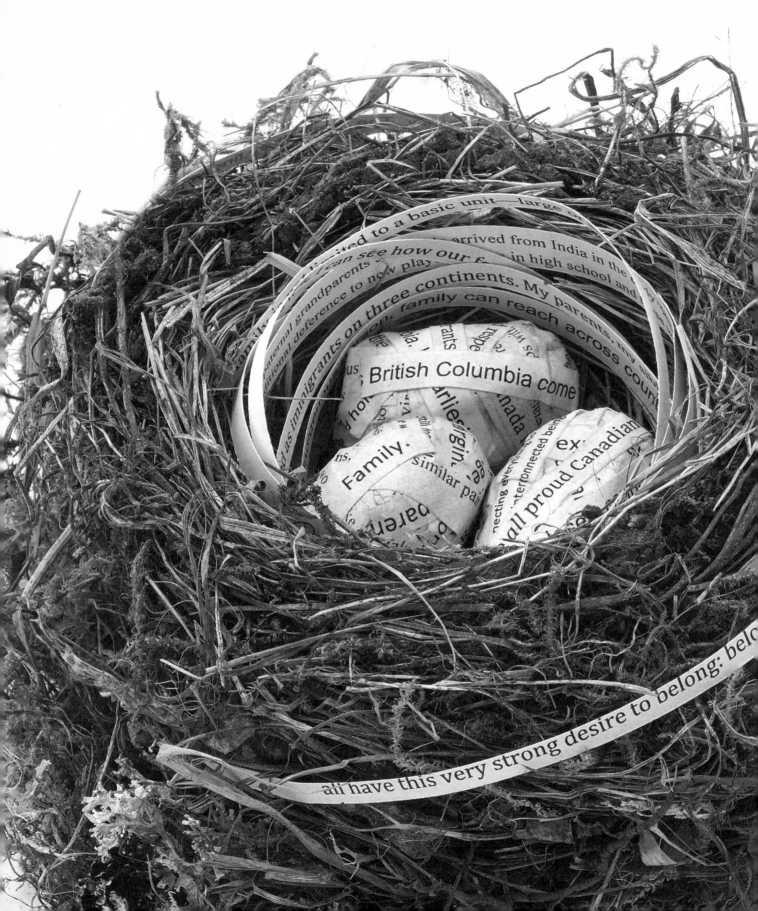

the language of family

Stories of Bonds and Belonging

Michelle van der Merwe / editor

ROYAL **BC** MUSEUM
VICTORIA, CANADA

CANADA 150

contents

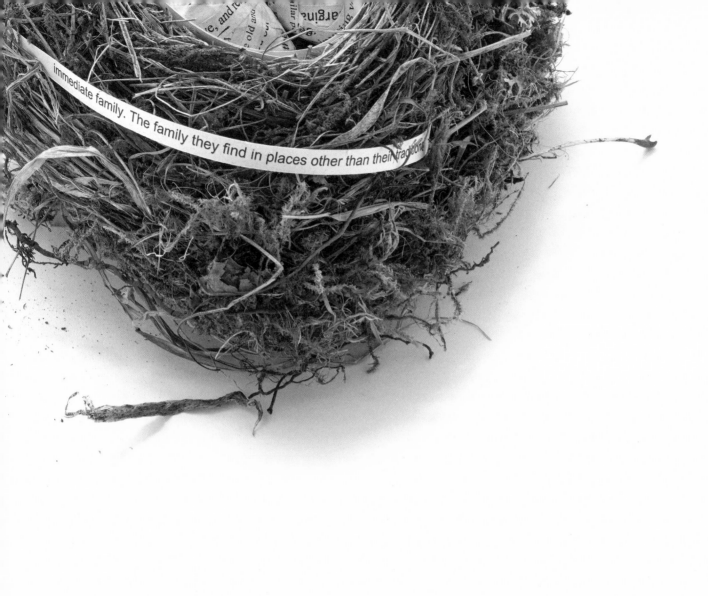

immediate family. The family they find in places other than their traditions

Michelle van der Merwe

preface

What does a book about family look like
when everyone's idea of family is different?

THIS WAS THE QUESTION WE HAD TO ANSWER when tasked with creating a book that explores this concept —the Royal BC Museum and Archives' contribution to the celebration of Canada's 150th anniversary.

One thing was clear—you can't just *tell* people what 'family' is. We needed to speak to people both inside and outside the museum and find out what family means to them. So we did just that. We invited museum curators, cultural luminaries, writers, poets and thinkers young and old, from First Nations, LGBTQ, Indo Canadian and Japanese Canadian communities, among others, to add their voices to the conversation in *The Language of Family*. The response was overwhelmingly positive and their informative and inspiring words, along with archival and modern imagery, have built this provocative collection of poems, essays and personal narratives.

What does family mean to us in a historical context as individuals, as a province and as a country, and what does it mean to us today? Is the word 'family' simply a metaphor and, if so, for what? How do you define family, and why?

Those were the questions posed in the invitation and the responses were as varied as the people who wrote them, but they are all connected through the thematic threads of growth and change, gatherings, generations and belonging—to both place and people. How would *you* answer those questions? What *is* family? I know that your answer would differ from mine. Each of us defines family in different ways based on our own life experiences and emotional attachments: who we are, where we are and where we come from—both physically and metaphorically.

If you look up the word family in the *Canadian Oxford Dictionary* it has multiple definitions, including "a group of people related by blood, legal or common-law marriage, or adoption", "all the descendants of a common ancestor", "a race or group of peoples from a common stock" and "a brotherhood of persons or nations united by political or religious ties". But family is so much more than these black-and-white definitions. I know this. We all know this.

Just as the contributors to *The Language of Family* are a reflection of the communities that make up our province and our country, their poems, stories and essays are a reflection of the broader definitions of family, those of blood and those of association to people or place. Their stories are powerful and heartfelt and insightful: They ask "What is Canada if not a giant family, of different branches...". They connect us to the land through tales of stewardship and poetry that speaks of the Salish Sea and what the earth remembers. They speak of families evolving through migration and belonging to the community you live in. They speak of the relationship between people and objects, images and museum collections. They speak of grandparents, fathers and sons, mothers, sisters, brothers, husbands, wives, children and friends. They speak of turkey dinners and connecting through food. They speak of separations and change. They speak of the quiet connections between people across the globe. They speak of the past, the present and the future. They speak of exclusion and marginalization and being odd. And they speak of interconnectedness and unconditional love.

No one story in this collection is the same as another, which is also true of families. So as you sink into its pages you may recognize elements of your own family experiences, or you may not. Either way, the words and images to follow will likely provoke, tease, enlighten and infuriate. Isn't that what family does best?

The crew of the *Saucy Lass*, 1900s. B-00617.

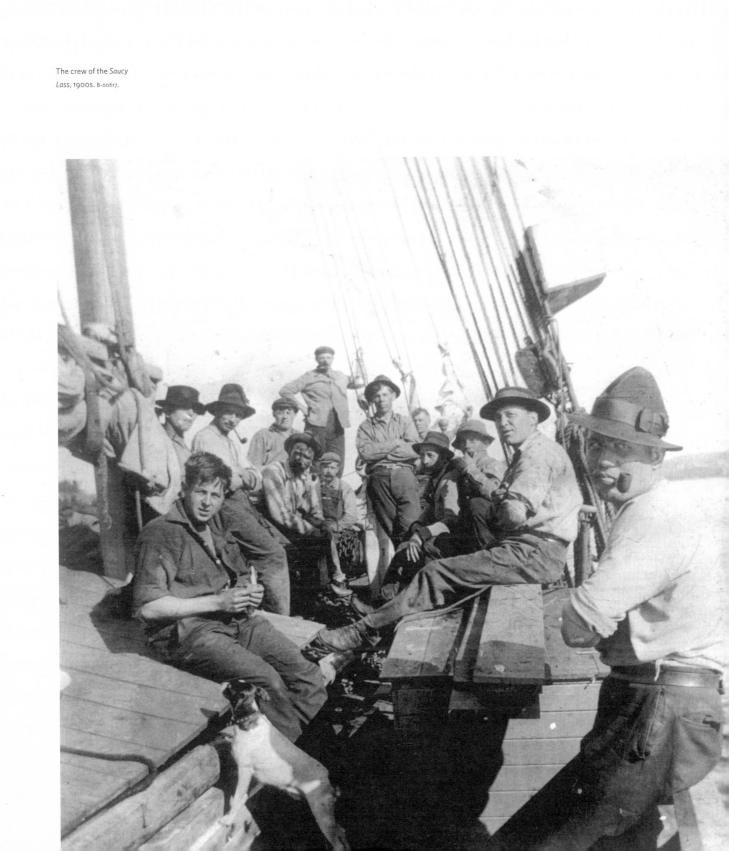

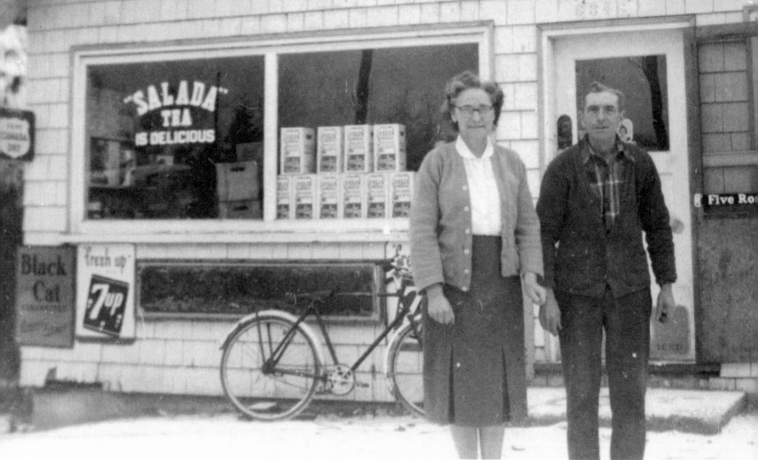

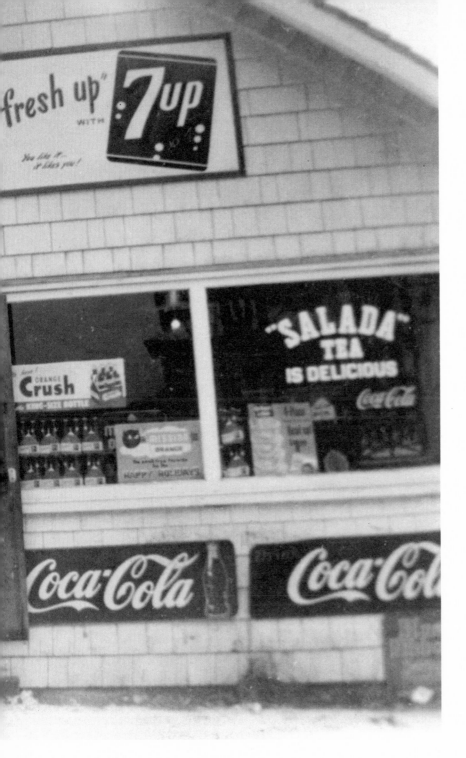

Mr. and Mrs. F.G. Bird
of County Line, 1950s.
C-05937.

Matsura (*left*) and
Fumi Uyenabe (*right*),
Victoria, *ca.* 1900.
C-07918.

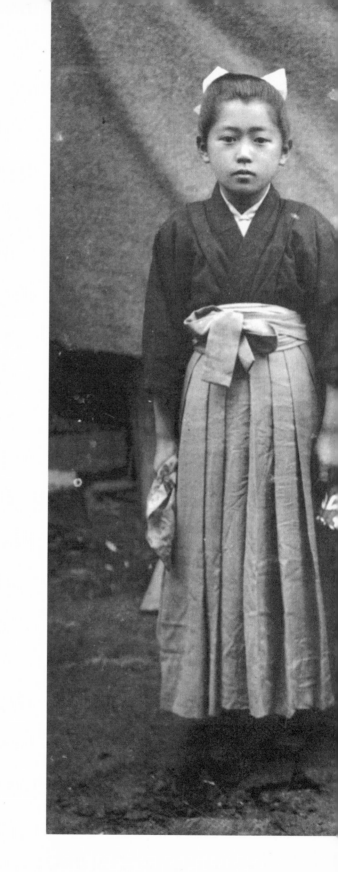

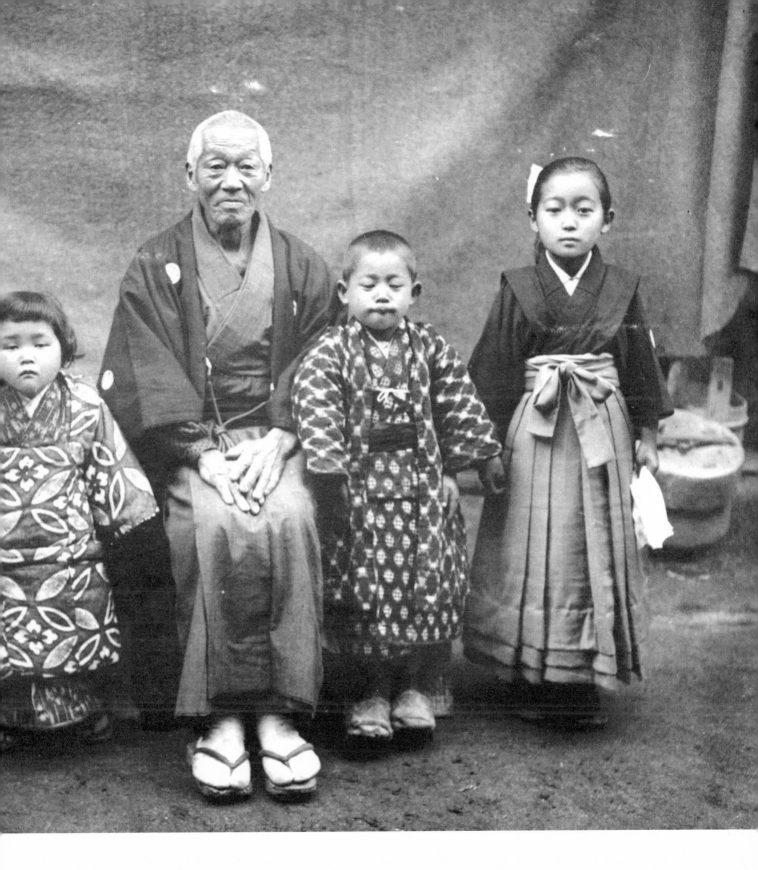

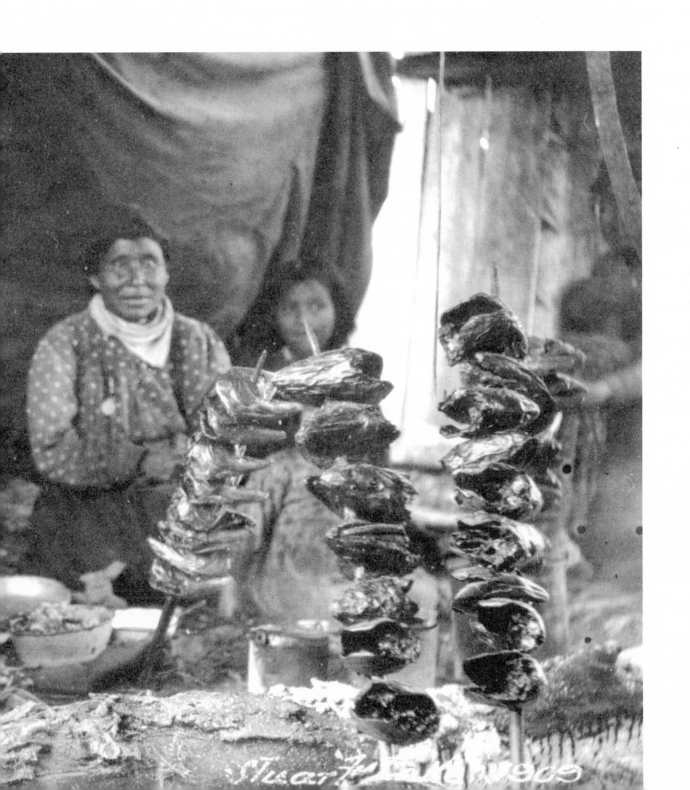

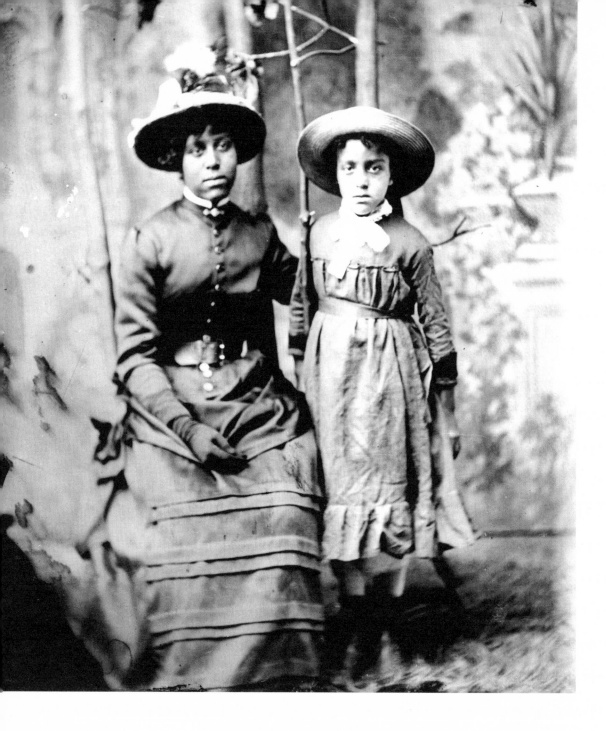

Sisters Marie A. and
Louise Stark of Salt
Spring Island, *ca.* 1886.
F-01893.

Jack Lohman

embracing the family

What is missing, when you walk into our museum,
is the people.

YOU DON'T NOTICE IT AT FIRST. Our museum, if anything, is a testament to the peopling of British Columbia. Its earliest nations. Its settlers and colonists. Its waves of migration. Here is the stuff of people's daily lives: their cooking pots, their shirts and skirts, the foods they ate and the chairs on which they sat.

You don't notice it because here you are, a person, surrounded by others, all wandering through the galleries, talking, looking, taking photographs, enjoying this spectacle of the past.

But there is an unremarked chasm between your presence and the personal objects you see. It's the people themselves: those who made things, who bought and used them, who gave them away or handed them down. They are here and not here. The material evidence shows us that they lived, and yet they are ghosts, hardly here at all.

Sometimes a museum can make it seem as if human history is a train journey—a busy gathering of people and places and the things we carry with us along the way. And once we've departed and the journey is over, what is left is a few pieces of abandoned luggage. Where the train stops, a man in a flat cap comes out—probably a curator—and collects what's left. When it comes to the record of past lives, the last stop is the museum.

I tell you this not to get you thinking of your imminent demise. But I want to remind everyone that a fundamental way into museum collections—and all they represent—is people. And not just 'people', since that word has an air of remoteness about it, but mothers and fathers, sons and daughters, grandchildren and cousins. To make sense of so many of the objects in our collections, you have to start with the stories of families.

...a meaning of family that changes because so much
 not of fixed historical notions but of

Objects derive their meanings from social relations. No object exists in isolation. Every object is an idea. A process. An exchange. When we speak of the life cycle of objects, as we often do in relation to (for instance) their environmental impact, we verge on saying their lifetimes. This is because our primary model is the human life, the very time span of creation and change we all experience.

The objects in museums are particularly interesting because they are often collected for their social meaning. It may not be the first thing visitors notice, but the reason many objects are saved and donated to museums is because of their importance to a family or group. Donor records are very revealing in this respect, and they are a good reminder of why we need to keep returning to the archives to reconnect with the stories there. The records often tell of gifts and bequests and tell us not that the object was so valuable in price that it became an heirloom, but that it was valued because humans cherished it and wanted to preserve the memories attached to it.

The human story of provenance is a story of great value, and it's something we in museums need to think more about. If we are to understand what is represented in an object, it's not enough to say abstractly "this represents the Haida nation" or "here is something the Chinese community used". It is hard for visitors to connect to such a remote language. Who among us conceives our own lives that way? I am, primarily, a man, a son, a brother-in-law. And objects, too, have these intimate connections. A wedding dress worn by a great-aunt represents not just the historical qualities of an earlier era, but the vivid potency of social ties. To preserve the dress and record its tales and anecdotes is to give us a very different and very rich history, not so much of hemlines, but of the things the legs beneath the hemlines got up to.

One of the pieces in the museum's extensive textile collection is a modern kimono that belonged to Akiko Kamitakahara.[1] Akiko was one of the thousands of Japanese Canadians sent to camps in the interior of British Columbia or east of the Rockies when Canada was at war with Japan in the 1940s. It was a time of racial hysteria. Japanese families were separated by the government, their communities destroyed. So intense was the cultural displacement that when Akiko visited her family in Japan many decades later, they discovered to their astonishment that this Japanese woman had never owned a kimono. They purchased her one and only kimono in Kyoto—a symbol of her Japanese heritage and a moving reminder of its complex shift

of what Canada is, is a product
ongoing change and absorption of new ideas.

to Canadian soil. Now part of the museum collection, the kimono is an object rich in historical outline and personal meaning.

Museum collections are full of objects such as Akiko's kimono, objects that tell stories of family. But what constitutes a family? How do those definitions evolve? What are the constants, and what terms might only make sense at a particular time and place? Asking these questions and considering ideas of belonging, gathering and breaking free allows us to see patterns over time—we can see the connections that unite all families at any time in history, the universals that unite kinship models among Ktunaxa to metropolitan Vancouver in 2016. It also points out the meaningful variety among Canada's many populations, a meaning of family that changes because so much of what Canada is, is a product not of fixed historical notions but of ongoing change and absorption of new ideas.

This is exciting history: of curious objects and their meanings; of our collections and how they came about; of people—how they live and how they care for one another. How does British Columbia come to be the place it is—on the edge of a continent, with its rich natural resources, with all that there is to draw people

like myself to its incomparable beauty? There are, of course, many histories that go into the making of place. But beneath them all is an often unspoken history: that of families working hard, sometimes separated, drawn together in ever closer unity. That is the history our exhibition celebrates.

changing nature of the family

FAMILY HAS PROVED A CURIOUS TERM TO EXPLORE. We start off thinking we know what it is: the family we grew up with, perhaps, or the conventional images on which we map our more or less perfect fit.

But families have never been that. The extended branches of First Nations kinship reveal a sense of inclusion that ideas of the nuclear family would struggle to cope with. Lineage proves an important source of pride to many, but how it is advertised (as it often is by objects), and just which line is drawn, remains highly contested. As Thomas King has argued in his wonderfully vigorous book *The Inconvenient Indian*, defining who belongs most to the First Nations has, like many a family squabble, harmed First Nations groups from within. He writes:

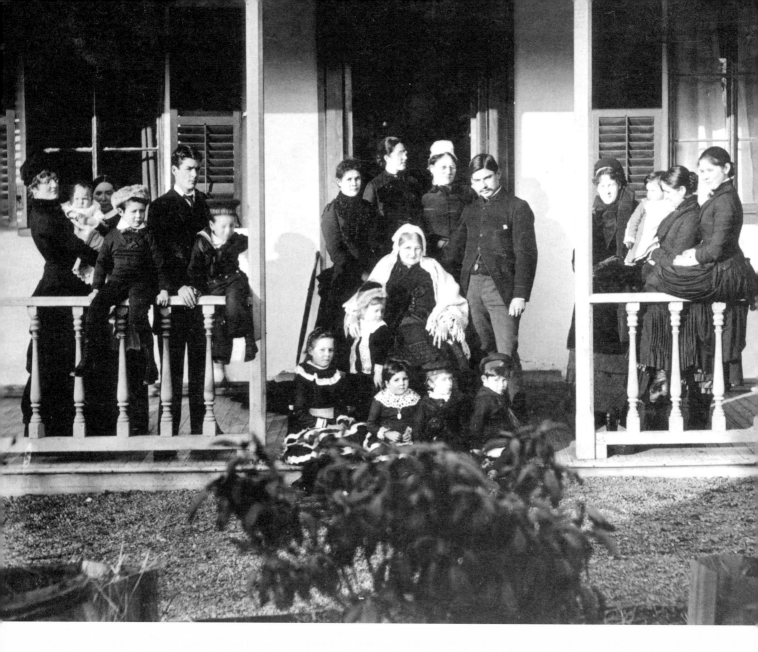

Four generations of
the Douglas family
surround Lady Amelia
Douglas, *ca.* 1885.
Maynard photograph. A-00840.

For decades we've beaten each other up over who is the better Indian. Full-bloods versus mixed-bloods. Indians on reservations and reserves versus Indians in cities. Status versus non-Status. Those who are enrolled in members of a tribe versus those who are not. Those of us who look Indian versus those of us who don't.[2]

As King's description shows, there is a politics to family identity that extends widely and has a profound social impact.

And the modern family has certainly thrown traditional notions to the wind. It may be that we have glossed over the complex family portraits of the past. Let's not forget that Anne of Green Gables—that poster girl for Canadian childhood—was an orphan. And not adopted by a married couple, but by a brother and sister who live together. This certainly wouldn't happen today.

What we do have today are single parents, divorced families extended over several marriages and multiple properties, gay parents who adopt, and a recent interest in the fluid boundaries of gender identity within families. Is all-American athlete Caitlyn Jenner still a dad, or some new term we have yet to coin within the family?

This sense of discovery moves in all directions. If what we mean by family is changing then that colours how we look at, and how we think about, the past. Novelist Wayson Choy wrote movingly of the startling revelation—three weeks before his 57th birthday—that he was adopted. His book *Paper Shadows* explores the rich and often hidden web of social and family relations that marked Vancouver's busy Chinatown in the first half of the 20th century.[3] For Choy, family is a place where change occurs not in the future, but in the past.

In museums we know all about this. It is perpetually surprising how new research and new discoveries make us go back and revisit our collections. The meanings shift as our own times do. There is a fascinating book of photographs from the 1850s and 1860s that the Royal BC Museum was lucky enough to acquire in 2013.[4] It is the Moody family's photograph album and it documents the life and interests of Richard Clement Moody, a soldier and public servant, and his wife and children. The album starts off as a 19th-century travelogue: there are images of Canada and Japan; Belgium, France and Italy; England and Scotland. But over time the album's interest has altered. In two of the photographs the colonial administrator draws our eye less than the two unidentified First Nations men

Families often represent

who appear. These may be the earliest photographs of First Nations people in British Columbia. They're quite a find. The photos start off as tourist snaps, if we can bend the term 'snap' to the endurance test that posing for an early photograph was. They later become an ethnographic document. Today they shine with pride. Who are these men? Can we know them? How do they fit into the history of British Columbia? What begins as a family album unearths a complicated social history of encounter and reliance. It includes much more information than any simple portrait of a family at home would imply. The family circle is wider than that. The Moody family album reminds us that where every family is concerned, it is always worth asking: who's coming to dinner?

There is too, among all this, a sense of generational change. If we are moving horizontally across time we are also moving vertically down the family line, from one generation to the next. Another cultural artifact of the Japanese exile in the Second World War is Joy Kogawa's novel *Obasan*. Kogawa is remarkably insightful about the generational pressure of that past. As her survivor Naomi puts it, "all of this belongs to yesterday and there are so many other things to attend to today".[5] Whose past is it? What are your obligations to the

memory of what your parents or grandparents endured? Naomi's silence is of a different quality to that of her elderly aunt (and adoptive mother) Obasan and Kogawa acknowledges this. But she also sees how important it is to know and to remember, and that such knowledge, however devastating, need not engulf the present. To bear the legacy of past generations is to carry forward better meanings and more fruitful prospects, to hold on to what is valuable but to do things differently too. Looking back enables you to move forward. And the place that generates that knowledge? The family.

bringing the outsider in

THE FAMILY IS THUS A WIDER CIRCLE THAN WE MIGHT AT FIRST ADMIT. If modern families seem to have lost a sense of traditional structure, if they seem broken somehow or too casual, they do in fact represent longstanding ways of coping with the world's complexity: of fixing what has broken, of finding what is lost, of incorporating what has been marginalized. I'll come to the socio-political lesson that this implies, for Canada and other countries. But first I want to examine the process by which this occurs.

the strength of nonconformity.

In 1973 the first North American meeting of People First was held in Vancouver. Established in Sweden in the 1960s, People First is an advocacy group for people with learning difficulties. What is so impressive about the organization—with branches in 43 countries—is that it is run by the members themselves, with all of the difficulties they face. People First treats cognitive disability not as an illness to be cured or a loss to be repaired or a stigma, but as a particular condition with special needs, a state to be supported and celebrated as one aspect of human diversity. It is part of a large set of post-war social movements that question whether we should aspire to a social norm and whether such a norm is achievable or desirable. As Andrew Solomon emphasizes in *Far from the Tree*, his prize-winning book on families who have children with exceptional needs, we don't want to lose difference—difference is what unites us.[6]

The point here is to celebrate the family's ability to incorporate difference. Solomon's 700-page book is a profoundly moving testament to this capacity of families to bear difference with all of its conflict and challenge, but also with love and meaningfulness. You expect your child at some level to mirror your own life: your genes, your values, your ambitions. So what happens when your child is deaf, or autistic, or becomes a criminal?

Families fall apart, more often than not. No one is being naive about this. But families survive—tougher, more resilient and more loving than ever.

This is an important idea. The term 'family' is often placed at the heart of social conservatism. But as museum collections show, that's not true. Families often represent the strength of nonconformity. The Doukhobor families of western Canada are the descendants of a tradition of religious rebellion, anti-materialism and radical pacifism. Socially normative behaviour this is not. In a case such as this, the family becomes a support system for internal values but also an engine for outward change, for saying: *we hold these different beliefs and there are other ways of thinking about the world.*

Both Andrew Solomon and Thomas King discuss the difficulty of these oppositional tactics. Solomon notes that "members of minorities who wish to preserve their self-definition need to define themselves in opposition to the majority"[7]—never an easy position. King points out with streetwise awareness that celebrating difference produces a lot of anger, "anger that Native people are still here and still a 'problem' for White North America, anger that … after all the years of having assimilation beaten into us, we still prefer to

remain Cree and Comanche, Seminole and Salish, Haida and Hopi, Blackfoot and Bellacoola."[8]

When we look at changing family structures it is this productive tension—between a sense of belonging and a need to assert one's independence—that emerges.

museum as family

MUSEUMS ARE GOOD SPACES TO THINK ABOUT SUCH THINGS. What we observe in the Moody family photograph album is enlarged by the letters the family donated, describing conditions beyond what we can see. Or take, for instance, the objects and archives associated with Joseph Pemberton, who first came to BC as a surveyor with the Hudson's Bay Company in 1851. That collection gives us a detailed portrait of BC life, not history from an academic perspective, but as it was lived: scripture readings, investments, household accounts, social pastimes. Pemberton's daughter Sophie became a prominent painter who exhibited not just in Victoria but in London and Paris. Focusing on the family provides more life, and a fuller historical perspective than, say, looking at one of Joseph Pemberton's maps.

A key word to use here is inclusion. The formal register of life omits so much. Museums are full of these public objects—someone's career on display, their moment of acclaim. If you're lucky the caption provides a passing reference to a wife or child. But if we shine a light on the subtle network of family connections, so much more emerges: histories that have been overlooked and the more nuanced movements, thoughts and feelings; less the public statement than the raised eyebrow or laughing smile.

And if the family is the space of inclusion, then perhaps museums need to think about two things: One is to raise the family as a point of discussion around

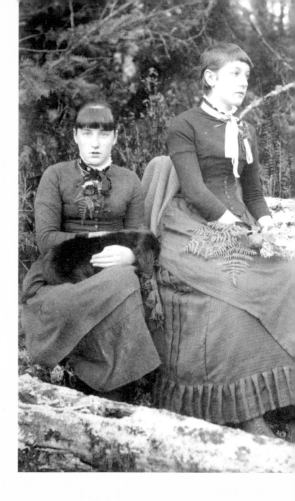

objects to enrich their meanings. But the second is to learn from the lessons we present and absorb those very methods of social responsibility.

Museums have done little to alter their basic model of operation. Perhaps it's time to shift the agenda. If a thematic look at families shows us we need not divide First Nations from, say, European pioneers, and that they share many beliefs and values and protocols in common, then why do we not within the museum proceed in a more integrated fashion ourselves?

In our museum the departments are separated: the natural history is over here, the social history over there, Indigenous matters distinct from those. But what happens if, as in a family, you include all the differences? The

Edith and Maude Muir
of Sooke with their dog,
ca. 1890. B-03333.

If museums help to shape our thoughts then
we should be willing to commit to ways
of thinking that could change the world.

prospects are exciting. You could have a First Nations approach to botany. You could compare a Victorian bodice to a Portuguese/First Nations shawl and, instead of seeing categorical differences, find similitude. You could take a spiritual understanding of how the land speaks and relate it to climate change. If museums help to shape our thoughts then we should be willing to commit to ways of thinking that could change the world. But we have to enact them, not pay lip service to ideas of inclusion. We have to be, genuinely, part of a family.

Increasingly we can see the impact this might have on the exhibitions we put on. The *Our Living Languages* exhibition celebrated the diversity of Indigenous languages but also encouraged a sense of their family connections. You couldn't help but hear, listening to the many voices, that there might be a link between different words and different peoples, and, for visitors, that was a good feeling. *Our Living Languages* won the Excellence in Exhibition award from the American Alliance of Museums for its ingenuity and the unique consultative process by which its stories were told. As Tracey Herbert, chief executive of the First Peoples Cultural Council, stated, no previous Royal BC Museum exhibition had gone so far to allow the community to "develop design, story layout, and

content" with such autonomy. In pursuit of families of languages we had become a museum family.

To carry the analogy further, I would like to suggest that the emphasis in these cases needs to align itself with the cherished outsiders, as Solomon and King might see them. The poor cousins. The tricky kids. If we've had a family model of stern paternalism, then we are well overdue for a family model of dissent and difference. Take the case of Indigenous knowledge. As something hitherto banished from the table and sent to its room, this seems to be a body of knowledge that even today is described with good intentions, but not adopted. It's curious. Most museums do not have a department of First Nations. Why is that? Why is such knowledge ethnographic and not on an equal footing with other expertise? Such connections are occurring and work in ethnobotany and ethnoecology is bringing to bear, for example, ancestral knowledge of medicine with current pharmacological ideas, or traditional land management with environmentalism. Such work is action, not description, and we are all the better for it.

It is perhaps—and I leave it to you to plumb the depths of your own family on this one—a case of relationships. Of respect for one another. Of listening. Of a willingness to change. For museums, that could

What is Canada if not a giant family, of different
of adoptions and intermarriages?

involve repatriating objects that have had their time
and place in the museum but might serve a better
purpose now elsewhere. Perhaps the model here is less
the restitution of a wrong than a much simpler one
of utility: that the world has changed and it's time for
certain artifacts to move on. It's less a question of right
and wrong and more the much better question of what
is the best thing for all of us.

our canadian family

I MENTIONED EARLIER THAT THIS WIDER SENSE
OF THE FAMILY, AS A PLACE OF INCLUSION, HAS A
SOCIO-POLITICAL DIMENSION. Museums have always
been safe havens for objects and could, with a little more
risk-taking, be havens of a wider practice and more
freely contested bodies of knowledge.

 Canada of course allies itself, perhaps better than
any country, to such a model. What is Canada if not a
giant family, of different branches, of the Indigenous and
the immigrant, of adoptions and intermarriages? What
the Truth and Reconciliation Commission so poignantly
revealed was just how devastating the loss of family
can be. The pain of broken families needs a counter-

Hélène Cyr photograph.

branches, of the Indigenous and the immigrant,

image. Perhaps the cultural mosaic has always been broken and what we need is a more organic image of the all-inclusive modern family. There'd be a few tough stories to tell round the dinner table but there would be laughter too, and forgiveness.

Perhaps now, as Canada reaches its 150th anniversary of Confederation, is the time to propose the family as a new symbol of national unity. Family as homeland, family as space and time, family as loss and absence, family as burden, family as memory or absence of memory, family as identity, family as history, family as narrative. The foundations are already laid with the deep sense of kinship among Indigenous peoples and the ongoing potency of families across the country—belonging to the whole but also celebrating their independence. As Walt Whitman once beautifully put it, "The diverse shall be no less diverse, but they shall flow and unite."[9]

The world stage is noisy at the moment. There is a lot of fear, and a strong sense that the best thing to do is build a wall, lots of walls, and shield ourselves from one another.

This is precisely what we mustn't do. It is time for Canada to really show its excellence to the world and cry: We are all part of this family and it is by joining together, from sea to sea, that we achieve greatness.

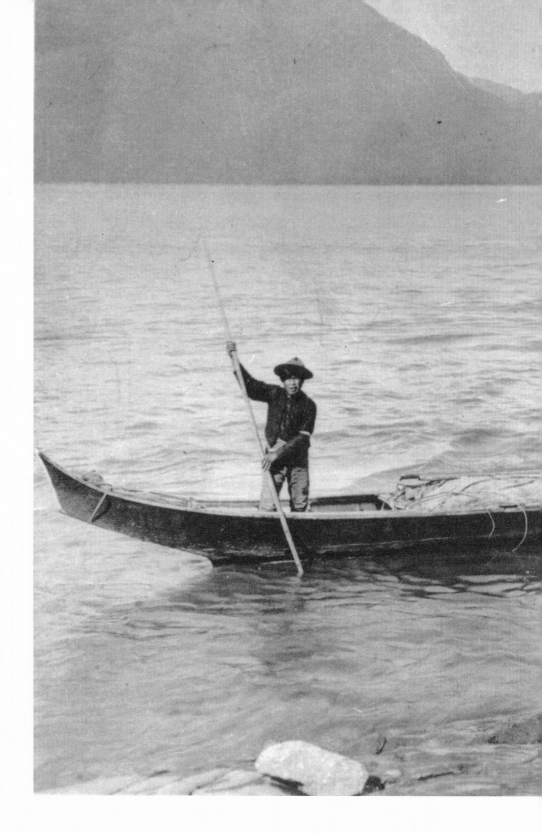

Taken at Prince Rupert
on the Skeena River, 1903.
Billy Wadhams photograph.
AA-00192 (PN16300).

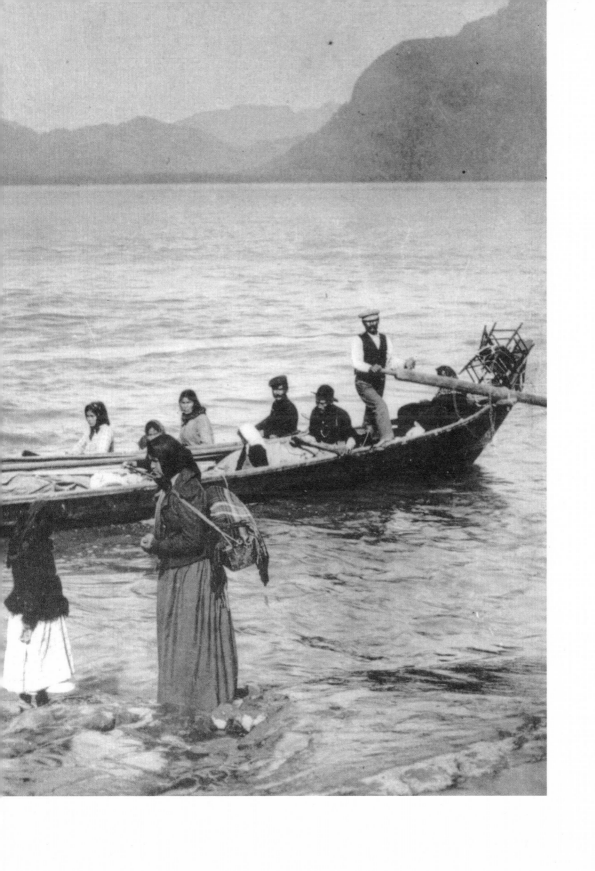

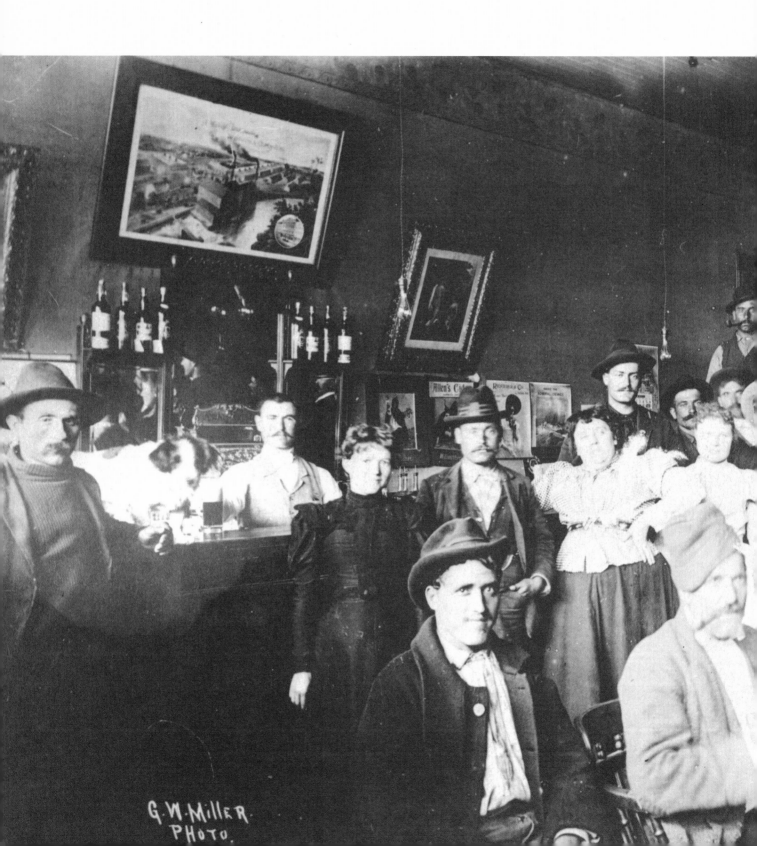

G. W. Miller
PHOTO.

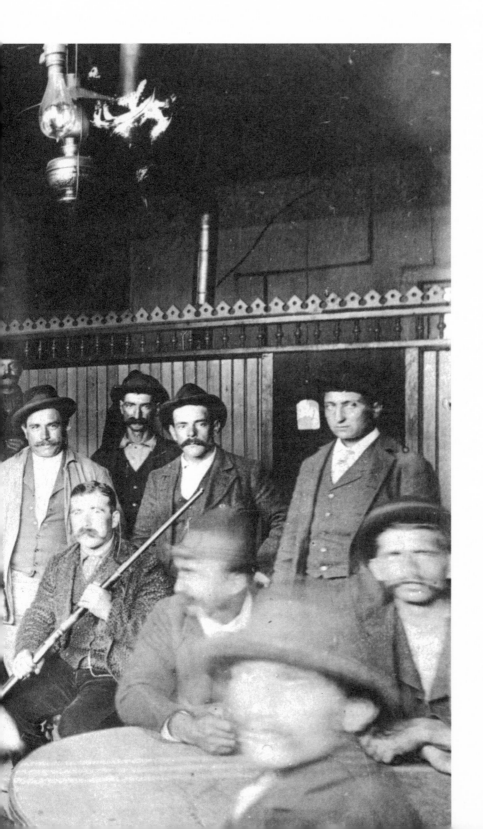

The Nap Mallette
Pool Hall, Nelson, 1899.
B-03152.

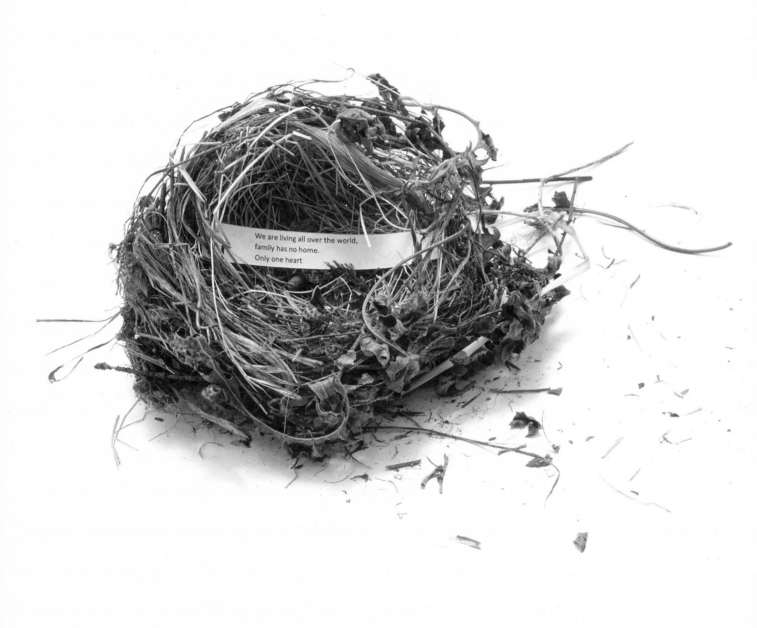

We are living all over the world,
family has no home.
Only one heart

Ann-Bernice Thomas

family tree

A spoken word piece, written to be read aloud.

I do not know where I will be buried.
In Canada; British Columbia, Ontario,
Jamaica, England,
or somewhere I haven't lived yet.

I don't know where my soul will return to the earth—
in flesh falling off bones
sinking into soil
until I am just dust in a box,
resting.

But,
my Nana died watching airplanes.
Inhaling and exhaling with each arriving and departing flight,
she counted the breaths as if they would give her lungs enough strength to float her away.
Up over the cinder block city,
over the grey, and the rain,

and the promise of the better 'someday',
she told her daughter she wanted to go home.
To the hot Jamaican sun that her husband couldn't run from.
To the fresh pear trees, and palm tree leaves,
fresh mountain breeze, and family down the street,
she wanted to go home.

But she died in England,
with the cancer cycling her system like it had heard her multiple wishes,
"I can take you there," it said.

So we did.

Flew her ashes back over the sea one last time
to be buried in her hometown,
homeland,
own land was hers
to be mine one day.
This is what legacy looks like.
What family sounds like,
bloodline pumping through veins,
and promises of that ever-elusive better 'someday',
pioneering is not new to us.
Survival in betterment is the only way to us,
so Nana moved from Jamaica to England to give her children a better life.

And I wonder what the earth remembers.
Will remember,
when her family is scattering further and further all over.
I am only just learning how to call Canada home,
and it still doesn't sit right with me
because we're the only ones out here.
The first to be buried out here,
home shouldn't feel so lonely.

I am only just learning how to call Canada home,

Shouldn't feel like resettling
in a land who's history is not quite your own.
Some days,
immigration feels like the recolonization,
of a land already claimed by too many hands,
and I want to be remembered.

Want us to be remembered,
the Thomas/Bailey family clan
who traversed so many great lands looking for something better,
somewhere safe,
to be black,
and free,
and together,
preserving our history as we know it to be—
In grade 12,
I was asked to make a family tree.

But I was hesitant, said;
"Teacher, my history did not have the privilege of being recorded."
"So do it," he said.
And I did the best I could.
I learned my family surnames.
Blake. Bailey. Thomas. Pratt. Keitel.

And I wear my grandmother's names,
Ann. Bernice; Merciful Bringer of Victory.

I have my Nana's smile, my grandma's hips.
And stories upon stories of childhood memories,
only childhood memories,
our children leave the nest so soon,
but,
I have that blood.
Made of restless star stuff,

we are interconnected beings,

nomadic therapeutic inheritance,
Jamaica, Sierra Leone, England, America, Canada, Japan, Korea, Holland,
We are living all over the world,
family has no home.
Only one heart
beating eons apart,
softly,
steadily,
so we can always hear it,
connecting us through our soul waves,
where Nana's would eventually call her home.

But I do not know where I will be buried.
Hoping in the future it won't matter
because my family is always with me.
And the earth is my plaything
connecting everything to everything,
we are interconnected beings,
returning to the earth,
through soil,
through bone,
through airplanes,
through love,
knowing it will remember us.

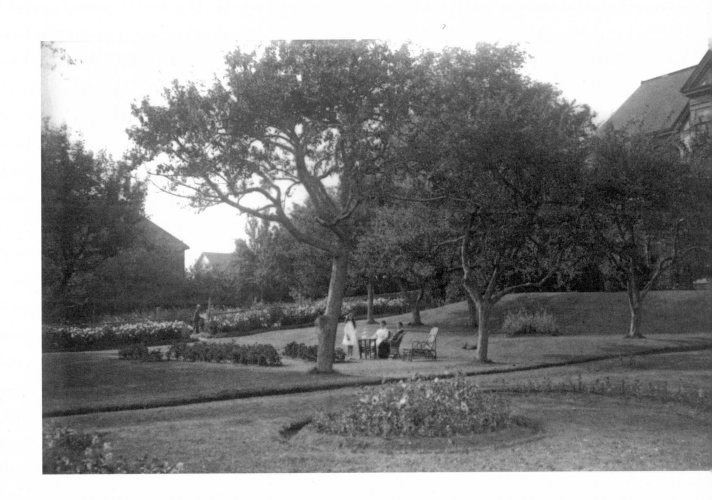

Mrs. D. Doig with her
sister Mrs. Langworthy
and her niece Yolande,
Victoria, 1900s. I-51873.

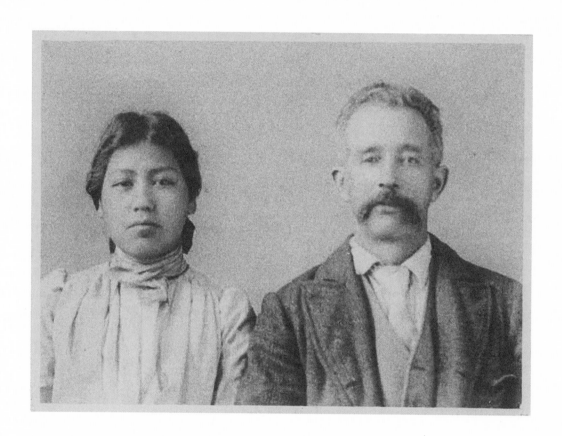

"Portuguese Joe"
Silvey and Shíshálh
(Sechelt) bride
Kwahama Kwatleematt
on their wedding day,
September 20, 1872.
Private family collection.

Luke Marston

family

Big turkey dinners and my parents' house packed
full for birthday parties every weekend—this is
where my memories take me when I think of family.

I AM FORTUNATE TO COME FROM A HUGE FAMILY
ON BOTH MY MOTHER'S SIDE AND MY FATHER'S SIDE.
My mother had three brothers and two sisters, while my
father had three brothers and three sisters. They then
created their own family and I have two brothers and
four sisters. When you come from a big family there
is always something to celebrate and with both of my
parents passionate about art and creative expression, gifts
to honour these celebrations were often handcrafted. Art
was always around us and we were encouraged to bring
out our own expressions in art, which is why I believe so
many of my siblings and I became artists ourselves.

My mother is of (Stz'uminus) First Nations and
Portuguese descent and her great-grandfather—known
as Portuguese Joe Silvey—travelled here from the Azores

volcanic islands of Portugal. In 2010 our family had an
idea to create a sculpture of Joe, an idea that quickly
evolved into the telling of not only his story, but the
story of our family. Joe married twice and his first wife
was Pkhaltinaht, the granddaughter of Chief Capilano.
They had two daughters together but Pkhaltinaht died
from tuberculosis at a young age, leaving Joe to raise
them alone. Joe later married Kwatleematt (Lucy) with
whom he had six sons and four daughters. They lived in
the traditional village site of P'apeyek (Brockton point) in
Stanley Park. It was a time when Vancouver was growing
fast because of the gold rush, mixed race marriage was
largely frowned upon and First Nations peoples could
not own land, have businesses or even process gold.
However, being of Portuguese decent, Joe was able

It's not only blood that ties us together as family; it's the unconditional love that we share as humans that makes us brothers, sisters, parents, grandparents or grandchildren.

to sell his land in Stanley Park and purchase Reid Island where they lived for the remainder of their lives.

We began recording our family history at a Silvey family reunion in 2010 then partnered with the Portuguese consulate and created the Portuguese Joe memorial society. Throughout the next five years I carved the *Shore to Shore* monument that was cast in bronze and now stands in the very spot where Joe lived. I believe this not only speaks to the Silvey family legacy but also to the legacy of Canada and Vancouver's move into multiculturalism.

Within Coast Salish culture we are always taught to know our past and to hold value in who we are and where we come from. I feel grateful that our family history was passed down and recorded over time. I remember my mother's sister Rose telling us stories of Joe and Kwatleematt when we were growing up, stories

of how he travelled here from the Azores and how our family had once lived all together on Reid Island. I love to hear these stories of my relatives and I also believe that it is in sharing the stories of living and working together that I have built on my own values in defining family.

It's not only blood that ties us together as family; it's the unconditional love that we share as humans that makes us brothers, sisters, parents, grandparents or grandchildren. These connections are formed just as my ancestors formed their communities many years ago, in sharing and working together. I have been privileged to have many people in my life that walk with me and carry me through challenging times as well as in times of celebration. They have always been there for me and so, in return, I will always be there for them—that is what you do for family.

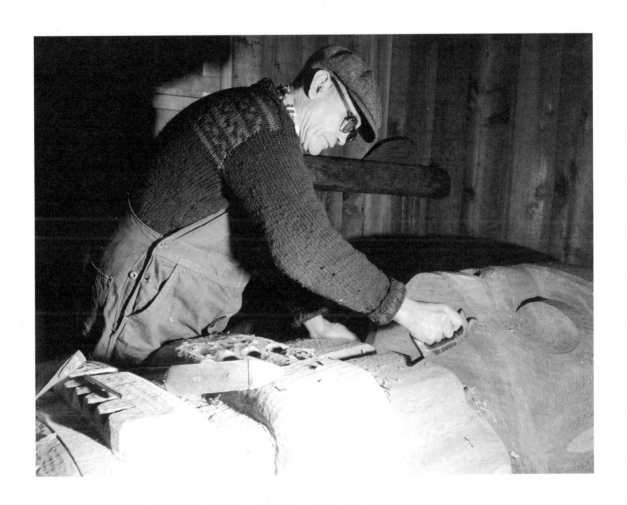

Mungo Martin carving
in Thunderbird Park,
Victoria, 1953. I-26794.

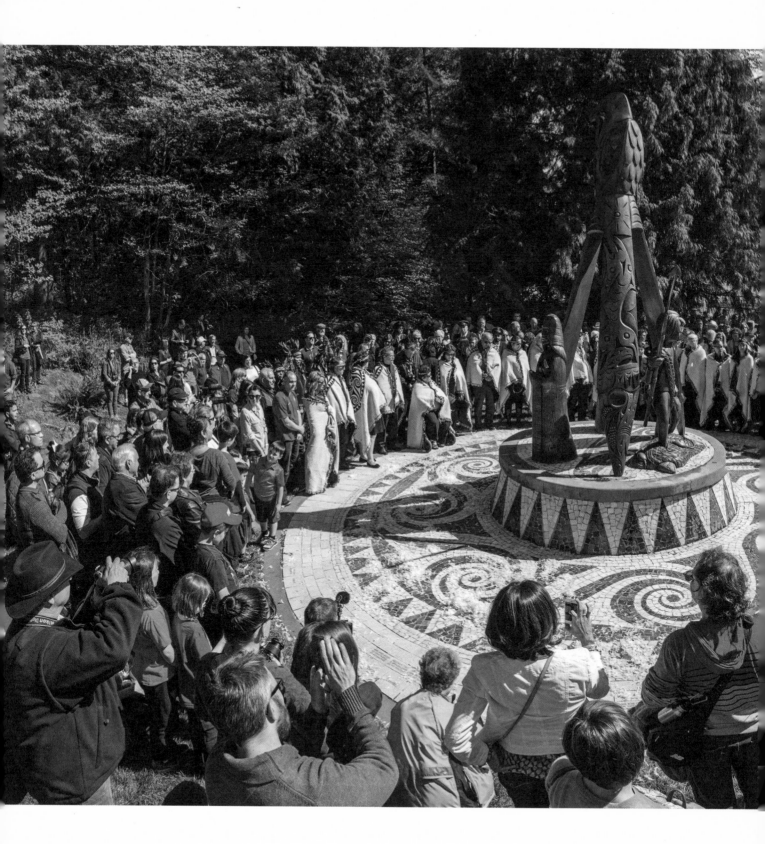

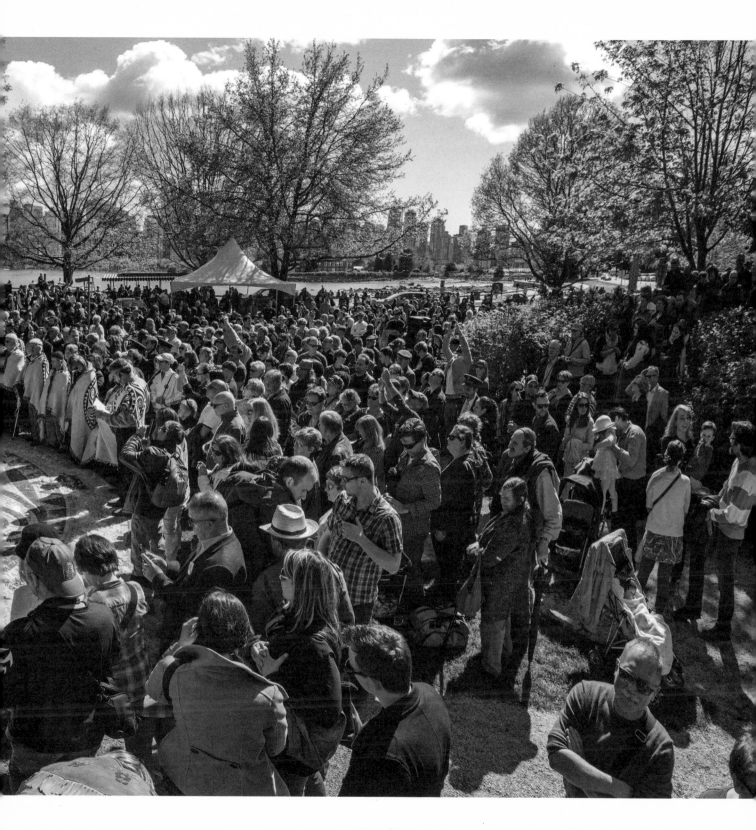

Shore to Shore unveiling ceremony in Stanley Park, April 25, 2015. Sean Sherstone photograph.

One year's
correspondence
from Lindley Crease
to his father. MS-2879.

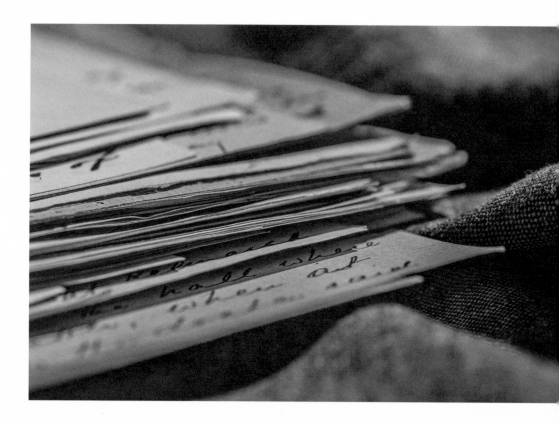

Kathryn Bridge

in the name of education

This essay is extracted from a much larger study of children and childhood in British Columbia and Alberta that forms the author's doctoral dissertation. The dissertation relies on the archival records created by children—diaries and letters—as the primary source material, to provide first person perspectives of their growing up years.

FROM THE MID-19TH CENTURY ON THROUGH THE EARLY 20TH CENTURY, many middle- and upper middle-class settler families in British Columbia especially those of British extraction—experienced disjuncture entirely of their own making.[1] They made what must have been difficult decisions to send their young children—mostly boys as young as ten years old—overseas for schooling. These children, from elite families, families positioned as key players in the social, economic and developmental hearts of growing frontier societies, were separated from their parents, siblings, extended family and home communities for three to eight years. Many only returned home as young adults, having grown up amongst other students and with teachers or staff as the closest adults.

Susan, Josephine
and Mary Crease with
their father Henry,
New Westminster,
1887. A-08314.

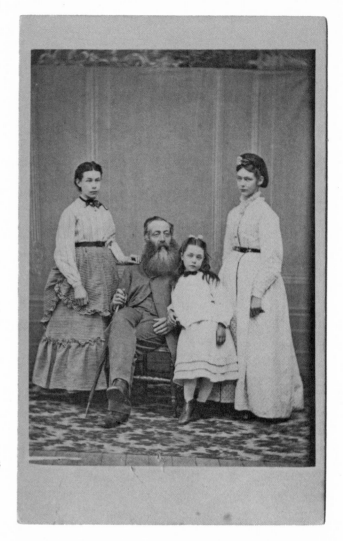

Today we understand that children mature through social interactions with family, friends and community; each category of encounter or 'relationship' is set within ever-changing discourses and individual moments in time. Many complex social interactions enable and direct children in their understanding of selves and their emotional growth.[2] Therefore, the multi-generational pattern of boarding school attendances during which children were separated from their homes and relationships was profound and had lifelong ramifications that challenge our assumptions about both colonial childhoods and adulthoods. It wasn't all about hardy families together forging new lives together in a new land. It was parents separated from their children, lost intimacies and often emotionally challenging years, and repeated in successive generations. And yet, the pattern of their absences may have contributed to the character and direction of the province as it grew and changed in the wake of their adult years.[3]

Why then did parents send their children to overseas boarding schools? The answer is wrapped up in the very best of intentions. Many parents with financial means and motivation felt that the newly created local schools held no caché and lacked the prestige of having taught generations of students. They believed that

sending their children to established boarding schools would ensure perpetuation of the social status quo, and perhaps enable upward mobility. In particular, fathers who had themselves attended elite preparatory schools and colleges advocated that their sons receive similar training, often selecting their own alma mater for the purpose. One father wrote, "I am on the whole more than satisfied with Haileybury and have recommended it to the parents of several promising lads in B. Columbia...."[4]

Parents had the futures
of their children at heart...

Parents also felt that local schools disadvantaged their daughters, falling far short of the established ladies academies and finishing schools in Britain or on the continent that many upper-middle-class mothers had themselves attended. One mother confided to her two daughters at school in England that she was glad "you should see a different way of living to that you have been accustomed to—as well it will help you better to understand people whose homes have been, or are, on the higher social scale."[5] Yet the pattern for sending girls away for fundamental education was less ingrained. Economics may have been a deciding factor, but it was also cultural—it was assumed that girls had less need for academic excellence. Parents knew that the advantages of gender specific academies could come later as their daughters approached adulthood (rather than in childhood) and would benefit from the smoothing of some of their colonial roughness, or 'finishing'.[6]

Parents were also guided by contemporary discourses of colonial family life that stressed the importance of enabling children to identify with the parent state of the colony—Britain. One father wrote, "No one else who is now [in] or who comes to Victoria or B.C. will be able to crow at you for not having been to England."[7] Removal to the metropole was also seen as a counter to the cultural and physical proximity of non-British and Indigenous populations in the colonies.[8] Perceived threats of ethnic and racial contamination[9] and nascent sexuality[10] caused parental worry, as did concerns about the maintenance of class status. Parents had the futures of their children at heart when they made these decisions and it was not without emotional misgivings.[11]

Nineteenth-century boarding school children experienced privations that early 20th-century boarders were spared due to improvements in communication and transportation that enabled families to reunite between terms and during holiday periods. So what was it like from the perspectives of the children themselves? Compelling evidence exists to tell us. Throughout the ages, children wrote letters home while at school; these correspondences with parents, siblings, extended family and friends have often been saved and are available in public archives. They reveal "life in the moment" and can be read not just for their newsy content, but for the evidence of relationship maintenance that was the intention of correspondences. This essay reveals the situations of children in just two families; they are typical, not extraordinary.[12]

Josephine Crease (b. 1864) and Lindley Crease (b. 1867) were very much the middle children. They

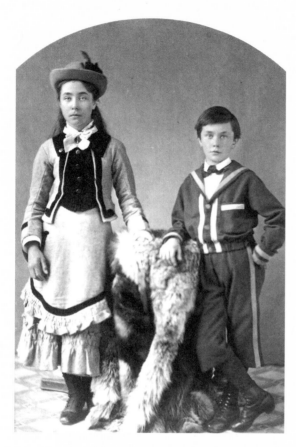

support boys writing to sisters and this was a hurdle that was perhaps the most difficult of all. He relied on her letters and asked her to write more frequently than she did, but shared remembrances became dimmer as new experiences took their place.

They soon had little in common beyond their memories and Josephine cast around for ideas. Once she learned that Lindley played tennis, it became a topic. "I suppose you can play tennis very well. I can't play a bit. I have not played since the midsummer holidays, except once last week. It is so strange playing with the new [racquets] as they are so heavy to what we have been using."[13] Likewise, she wrote about sketching, which they both enjoyed and responded when he described his own activities. "How you must like the paper chases but I don't think they [are] as nice as when you are on horseback. I think I told you I went to one in the autumn on horseback & it was great fun because we had to go through all sorts of places…down steep hills & up them again as fast as you could go."[14]

Josephine knew that being busy was not an acceptable excuse for not writing and let Lindley know that his letters were important to her. "If you have time I wish you would answer this as I like so much to get a letter from you."[15]

were born less than three years apart and they were eight and five years older than younger brother, Arthur (b. 1872). They shared friends, played and socialized together, bonded across gender. But their dynamic was interrupted in November 1877 when Lindley, ten years old, was sent to England for school. A handful of extant letters Josephine wrote document ways in which she and Lindley attempted to maintain their close relationship and the difficulties of doing so given the years of separation, the reality of their own individual maturing and the increasing influence of gendered expectations upon them both. Lindley's situation at school did not

too young. How do you like your school & how do you get on. I have put some-thing in this letter so that you shan't forget me. I hope you know what they are. Now I must say Good Bye from your loving sister & believe me to be your ever true Joffie. Amen

Top: Josephine Crease to her brother Lindley, March 8, 1878. MS-2879.

Bottom: Josephine to Lindley, November 23, 1879. MS-2879.

Two years after his departure, Josephine commented on a series of photographs that Lindley had forwarded to the family of himself. She wanted to remember Lindley as he was when she last saw him—was more comfortable with that recollection than with the new images that showed a boy she might not recognize as her brother.

Mama received your photos last week, & we all think them very good. I think I like the full one of you the best. somehow it seems more like you were when you left.

Lindley Crease's practice of remembering and reliving camping trips and travel with his father helped him through the years of separation, but asking for specific details about home was even more important. "How is my garden getting on & my work shop is the green plot in front of the house very long. I wish I was at home and that thought often makes me very sad."[16] It was important that the pets, peoples and places he connected with still remain. His sister understood this and wrote, "There is positively nothing worth telling you except that all at home are quite well even to the cats & dogs & horses."[17] While separated, the siblings experienced puberty, finished school, had a sister die and friends move away, but Josephine did her best to keep Lindley in the loop. Lindley had a few close friends among his classmates but was selective with his reporting, not able to share the 'boy culture' of the school in a way that was meaningful. Josephine 'came out' in society and formally entered adulthood, as girls did at 18. Lindley missed it all and, when he returned home, it was as an articling student with a law firm.

...each boy wrote to the other, trying
to find some point of commonality that would
enable them to hang on to those few memories
they had of each other...

Arthur Douglas Crease
at the age of four and a
half, 1876. F-08827.

Lindley's relationship with his young brother Arthur was different again. At age five, Arthur's own memories of his older brother soon dimmed and, on his part, Lindley remembered a boy not old enough to be a real companion. Their relationship was consciously perpetuated and developed through letter writing. Each was apprised of the other's activities through various family letters and then each boy wrote to the other, trying to find some point of commonality that would enable them to hang on to those few memories they had of each other or at the very least connect because they were brothers. No letters from Lindley to Arthur survive but there are 10 letters from Arthur to his brother at school. His very first letter, dated a month after Lindley arrived in England, established his connection to Lindley, "I bought this Card for you," he wrote, followed with a line about their extended English family. "I am glad you got safe to England and loveied Aunty Bar." He then let Lindley know he had been allowed to use some of Lindley's belongings, continuing the pattern of male activity with their father. "I have bows and arrows and your yew bow and shoot at a black Crow hung up in a tree, and hit it in the breast. I can make my own arrows, pa puts lead on them which Lancelot got from the *Opal*."[18] As Arthur's literacy improved, his letters became more detailed with his adventures;

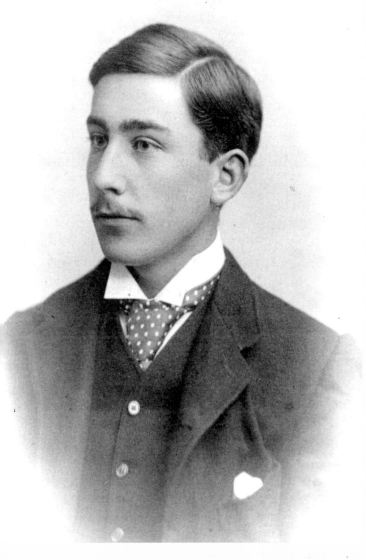

the process of doing so connected him to his brother and
the subject was one that interested him so, by extension,
it should interest Lindley. He connected with Lindley
at the level of gender, which Josephine, who connected
through shared experiences and age similarity, could
not. With an absentee big brother, Arthur made do with
Josephine, but their age difference and gender divide, so
rigidly set in behavioural and emotional expectations,
meant she wasn't the pal he needed. Arthur and Lindley
reunited for less than six months after Lindley's return
in late 1885 at age eighteen. Was it enough to catch up?
Arthur himself left for England and his own schooling
in March 1886.[20] It would be as adults that these brothers
next met and resumed in-person sibling relationships.

finding a humming kite abandoned in the back field,
snowfalls and the novelty of sleighing with friends,
fishing with father, making sling shots, football games
played at Beacon Hill Park.[19] None of Arthur's letters
focus on his own domestic life, or his own schooling.
Nor does he express a desire that Lindley return home,
yet each has affectionate closings. Arthur wrote because

Top: Frank O'Reilly, age 11, on the eve of his departure for England, 1877. I-79799.

Facing page, left: Kathleen O'Reilly to her brother Frank, November 23, 1883. MS-2894.

Facing page, right: Kathleen O'Reilly, August 1877, just prior to Frank's departure. C-03871.

The surviving letters between the O'Reilly children—Frank (b. 1866), Kathleen (b. 1867) and Jack (b. 1873)—exhibit many of the same characteristics as those of the Crease children; they were similar in age differential and in years of separation, and they are also similar in that, depending on the pairings—Frank and Kathleen, or Kathleen and Jack, or Frank and Jack—the relationships were very different.

The conversations within the letters have some constancy—references to each other's activities and to parents, remarks about receiving and sending letters, stories of recent adventures or happenings, questions about friends or acquaintances—but they change as the children mature. They exchange memories, demonstrate shared viewpoints regarding behaviour of the other sibling or discuss alliances for the purposes of a united front in situations with parents. But more than anything else, the letters reveal the strain on family members because of consecutive absences of individual children from the family home and illustrate how attenuated the experiences of being a sibling were.

When Frank O'Reilly was ten, he left home for school and did not see his sister Kathleen for five years. The childhood bonds these two forged through their early experiences and family interactions had to survive through

Arthur John (Jack) O'Reilly, *ca.* 1877. H-02568.

long years of separation. Their shared memories of their younger sister Mary Augusta (known as "Pop"), who was born in 1869 and died of meningitis at the age of seven is evidenced in comments made to one another. Their grief was not something that they could share with Jack because he had been a toddler at the time and had not known her in the same way. On an anniversary of her birth, Kathleen wrote to Frank acknowledging her sadness:

> This is dear little Pop's birth- day & she would now have been fourteen years old. I have been thinking of you all & now you are so much further a way it will be such a long time before I get answers to these scrawls — the letters were only ten days coming from Ottawa. Please give my love to Uncle

Jack's childhood memories of his big brother ended before he was five but, when he was ten and all the children were with their mother in England, they had six months together before it was Jack's turn at boarding school and Frank returned home. The first day of their reunion the brothers fed the ducks in St. James Park and watched the guards change at Buckingham Palace. They had a lot of catching up to do but it was difficult because they lacked shared remembrances; they were essentially strangers. Their time together in England provided a basis of connection, yet it was static. Remembering his own years at school and what it was like to be heart- and homesick, Frank did his best to write to Jack, even writing en route and then immediately on returning to

Above: Kathleen O'Reilly, August 1877, just prior to Frank's departure. C-03871.

Jack O'Reilly to his
brother Frank, April 5,
1886. MS-2894.

Victoria in December 1883. He knew Jack would want
to know about their house, which had been empty
during their absence to enable renovations. "My dear
Jack," he wrote,

> "You will see from the heading that we are still
> at Fairfield for the house is not ready to receive
> us. I was over there every day last week and went
> out rowing once & sailing twice but there was not
> very much wind. The boathouse is in a very bad
> condition for nearly all the posts are eaten away so
> that it will have to be propped up at once … The
> big Arbutus tree that used to hang over the water
> in front of the rock in the lot has fallen down into
> the water & is going to be cut up fore firewood."

Jack's letters to Frank were frequently more
candid on personal matters than those written to his
parents. For instance, he reported his own illnesses less
often to his parents than to his brother. Usually the
information was mixed in with news of his activities,
like when he visited his sister in Kensington and was
turned away because "I have the Hooping cough very
slightly."[21] And then, he was injured playing football.

They exchanged confidences about their sister and enjoyed mocking her interest in clothing and society. Jack reported on Kathleen's pretensions with sarcasm when he referred to her as "The Right honourable Miss. Pussy Cat bath-a-lot bathreen O'Reilly, Member of Parliament."[22]

Soon Frank turned away from childhood towards adulthood. When Jack learned that Frank had begun to smoke cigarettes and cultivate facial hair, Jack sketched images of Frank wearing a top hat and a scraggly beard at the bottom of his letters.

As the years went by, Frank became a civil engineer and his work took him to Argentina and other points. His world became that of adults and the gulf between the siblings, which had narrowed ever so briefly in England and for a short time afterwards, was now widened by their disparity in maturity and continued separation. Jack couldn't fully comprehend; he remembered a boy just out of school, not an adult. He complained to Kathleen, "tell Frank that it is very nasty of him not to write to me,"[23] but he continued to keep the communication going, if for no reason other than as a therapeutic output for his own solitude and struggles. Jack would not see Frank again until he was 18 and Frank was 25.

Apart from a two-year term in England, Kathleen lived most of her childhood at home yet must have keenly felt her own separations from her brothers. When Frank went to school Jack was too young to meet her needs for a playmate, and when she travelled with their mother to England to enroll as a boarder at a London finishing school, she—like Jack—reunited only briefly with Frank before he returned home. She was again left with Jack but now in a different capacity—as a mother substitute who was to oversee him during term breaks, or in an emergency.[24] For Jack, the comfort of having

his sister in England and not far from his school took the edge off his homesickness. The arrangement was not without merit. They shared each other's news in letters home and supported each other in their aloneness. But a 16-year-old girl and a 10-year-old boy saw the world differently. Kathleen, mindful of parental worry, was more reticent in her reporting—Jack, not so. On two occasions he took responsibility to break the news of his sister's ill health. Kathleen "has had the Scarlett fever it is hardly anything"[25] he wrote, followed two months later by, "Pussy was thrown off her horse & has Concussion of the Brain."[26] Jack's reporting was not meant to be sensationalist, his intent was to inform in a responsible manner much as he assumed Kathleen did concerning him. It is difficult to read behind his terse sentences to know if he was worried or had any real sense that the situations might be serious. Perhaps his communication style was influenced by the all-male environment he

now lived within, which was all about maintaining gendered distances. He did not know that his adoption of such outlooks could create strain in his relationship with his sister so when he repeated remarks made by schoolmates that concerned her, he had no idea that she would find them embarrassing.

it. Pussy has got quite angry because I told her that her Phlograph was very pretty and she was pretty and she is a green eyed cat and that the boys say she is pretty so she has not written for three weeks.

In September 1885 parental illness called Kathleen home, but Jack remained in England. A few weeks later he received the first letter from his sister. That same day he wrote to his father:

Top: Jack O'Reilly to his father Peter, September 27, 1885. MS-2894.

Bottom: Jack O'Reilly to his brother Frank, June 8, 1886. MS-2894.

With Kathleen gone, Jack was adrift and did not handle the separation well, or the inconsistent correspondence. Kathleen promised "that she will write bundles if she has time,"[27] wrote Jack to his parents, as if to convince himself that she would. But letters from Kathleen dwindled. He wrote jointly to his sister and mother, saying, "Thank you for having written to me but I very seldom have a letter from Pussy. Once in the Holidays I wrote every 2 weeks."[28] A month later, "I have just received your letter of the 24th it was a long one from you but if you only would write like you used to do but you don't."[29] By April 1886 Jack was angry. "Pussy is a beast. I have burned over her photos so I shall not see it [her face]."[30] He confided to his brother,

The patterns of residency of these siblings as adults reflect the differences each experienced while growing up.

When his once confiding sister became uninterested and shallow in her communications, Jack remarked to her, "You never speak of ... what you do, you say what other people do but not your self."[31] His brother shared Jack's concerns. "Frank told me in a letter I received yesterday that you were all ways having parties and you were the Boss of the shop." Jack continued, determined to shame her. "I have been told that you have the prettiest 100 Dresses in the place. I have <u>two</u> hole suits and a few (1 or 2) old coats and waist coats and one pair of trousers."[32] His entreaties may have had effect, for it appears Kathleen began to write more regularly, leading him to comment, "you have been writing a great deal lately what is the matter with you [?]"[33]

Kathleen was an emotional lifeline for Jack and he did not want to lose her affections, despite his disdain. He also needed her to advocate on his behalf with their parents. His letters often included entreaties such as "Will you ask father to let me buy a fishing rod and things ..."[34] and "Ask Mother if I nead not learn French any more."[35] Whether these were ploys to double-up the pressure or whether Jack believed his own requests might be less effective, is impossible to say. Kathleen's letters to Jack reveal that increasingly different age and gender expectations began to change the nature of their relationship.

Jack placed Kathleen (as he had Frank) in a time capsule. He remembered her as he last saw her, not understanding that she was becoming a young woman with different social activities and priorities. From Kathleen's perspective, she was now home with the benefit of parental emotional support and no longer needed it from Jack. The intimacy they had enjoyed when they both were in England was lost. Kathleen was the only sibling at home as Frank was already on his own and busy establishing his career. With uncertain parental health, she now assumed the role of caregiver for her parents.

The patterns of residency of these siblings as adults reflect the differences each experienced while growing up. Frank, long separated from his family home, had perhaps the least connection. As an adult he lived many years overseas, married and had children in England. Kathleen—the child most geographically connected to her family home and hometown—did not feel the need to leave and as an adult preferred to remain, turning down offers of marriage that would have taken her away. Jack seemed content to live alongside his sister, then marry and raise a son in that family home. His childhood was framed by Kathleen's presence and he chose to live his adult life in proximity to her and to the place that he held so tight in his memory while at school.

Sarah Crease, *ca.* 1867.
Frederick Dally photograph.
A-01217.

Children at school also suffered breaks in relationships with parents. Lindley Crease's letters to his mother remained surprisingly similar over the years, as if he was deliberately maintaining a parent-child relationship rooted in his childhood, almost as a security for them both. He keeps her apprised of news he knew she would want—his daily bible readings, his English aunts, uncles and cousins—but doesn't engage with his own internal emotions. He repeatedly assures her: "I try hard to do what is right".

It was not until the final months prior to his return home that he opened up, sharing his current thoughts and perspectives where, in his previous letters, both had been completely lacking. He provided detail about his

farewells, the formalities of the final week and about what was important to him. "I expect the whole of my last Sunday will be taken up with walks with fellows. I want to take a good farewell ... I daresay this may rather shock you, but I really think that it is a very good way of spending a ... Sunday afternoon. A walk thro' fields & amongst the trees is most enjoyable, especially if it be with someone who appreciates them ..."[36] No mention of church or Bible readings. At the end of this letter he wrote, "Throughout I have spoken very plainly to you as I do only to Father."[37] In this way, Lindley prepared his mother for his homecoming. He opened up the adult side of his personality to her—his new self—and made it clear that he now competently dwelt in the world of men and held his own opinions.

Henry Crease attended a preparatory school not unlike Lindley's Conyngham House and a public school not unlike his Haileybury College, both of which he selected for his son. Crease understood the environments—both academic and social—in which Lindley would become immersed and this made their letters to each other quite different from those between Lindley and his mother. Lindley's letters to his father included small keyed diagrams explaining the various school buildings and proximities; he went to great

Henry Crease, 1878.
F-08822.

lengths to make his world intelligible to his father. He spoke plainly on the male experiences of boarding school, the camaraderie between schoolfellows and lessons and mindset—all matters that his mother and sisters would not recognize or appreciate. This was another result of boarding school life: boys now engaged almost exclusively along gendered lines, losing most of their previous connectivity with female relatives. They lost the naturalness that came from family interactions, increasing the emotional divides.[38]

Lindley's letters to his father also illustrate the importance placed on their shared experiences outside of schooling. Crease had spent time with his eldest son that was not given to the female members of the family but would be mirrored with young Arthur. Lindley accompanied his father on the legal circuit more than once, including a trip to the Cassiar the year he left for England. They also camped with friends at Cowichan and on the islands near Victoria. For Lindley, recollections of these times anchored him to the landscape of British Columbia and to his father and formed significant parts of his letters. It was a very gendered tie, and different from the love he felt for his mother and older sisters, or even for Josephine, his closest sibling.

How your letter made me wish to see you; & called back to remembrance our time in Cassiar which I do not think will ever fade from my memory so full was it of incidents. (The quarter

Are any of those which I tried to make on the Stickeen still extant? I never have been to Yale with you, as you know I went with Mr Rowe of whom I have not heard for a very long time. Are there many changes at New Westminster? and do the blackberries still abound in such quantities? You must be very tired of my for ever repeating my remembrances to you but it seems to transpor

(2)

me for the moment to the places I love to think of. You must be tired too of incessantly having to go so many circuits. How is the railway getting on? The stand "Colonists" which come in tell me a lot of the general news which would not be written in letters. The "Haileyburians" came

Left: Lindley Crease to his father Henry, May 28, 1881. MS-2879.

Below: Where the blackberries grew, Ince Cottage, New Westminster, *ca.* 1869. Frederick Dally photograph. A-08317.

In this letter Lindley requested details of his first home and of the landscape and he confessed to reliving the past, which he did as a means of ensuring connection to family, but also to place. Joy Parr maintains that not only is it the intellect that remembers, that is historical, but that the physical body also remembers.[39] Lindley's connection to his father was bound up in his body's remembrances of the physicality of travel by horse and buggy, of camping out, spending extended time outdoors and experiencing the sun, the rain and the seasons. His body held the memory of the steps and pathway to his garden, the smell of berries. With his brother, he also confided these remembrances, but he did not connect on this level with his mother or with his sisters.

Jack O'Reilly did not hide his unhappiness when he was left alone in England. Over the years the enforced separation moved him from a needy young boy to an angry one and his letters to his parents count the months and years of separation. A clue to his agitation is in his use of multiple underlines—two or three stacked on top of each other for emphasis—which he normally used sparingly.

"I do long to see you if you don't come to England please let me come home, I would like it much better do let me come."[40]

Reunions between parents and children reveal how the years of separation fundamentally stripped both parties from easy recognition. Such was the situation that shocked Frank O'Reilly at age fifteen when, after four-and-a-half years, he did not recognize his mother when he walked into her hotel room. He wrote:

there were two Ladies of that name
just come so up I went to the
number of the room they told me
and knocked at the door and
some one said come in and I
opened the door and saw Mother
and I did not know her. and
so I said that I thought that
there must have been some mistake
and that the Porter had told me
the wrong number. and I was
just retiring again when
Mother said why it is Frank and
then I knew that there was no
mistake and that it was
really Mother. So after we had
cleaned ourselves, for we were
very dirty after our respective
Railway journeys we took I
told mother that she had better
go and see cousin Atherton McCleu
so mother & I went by the train
to London Bridge and we
found Him at his office of which

Frank O'Reilly to his
father Peter, May 8,
1882. MS-2894.

figures from whom they observed and learned behaviours. Child-parent relationships therefore performed differently than we might expect. Children, both at home and away, grew apart from brothers and sisters and often lost their shared understanding of belonging.

These records reveal a world of emotional struggle and aloneness experienced by both British Columbia settler children and their parents—a situation that has been little explored in studies about colonial families or in community histories. Many upper-middle-class families within fledgling settlement societies were fractured because of the decision to send children away for elite schooling. In 1901, 25 years after the Crease and O'Reilly educational separations, the total population of settler British Columbia was only 8,079, with less than half considered urban dwelling. Children under 15 years old represented 25.5 per cent of the total, and family as an entity was still overshadowed in relation to the largely male population. The absence of middle-class boys from the social milieu of towns such as Nanaimo, Victoria and New Westminster would have been keenly felt beyond their homes and surely charged a dynamic that rippled down through the generations. [41]

The burden of education was one that settled on all family members in one or more aspects ranging from practical everyday living to financial and emotional needs. Absent children matured outside the intimacies of parental oversight or observation; they grew physically and emotionally, went through puberty alone and had to learn self-sufficiency amidst other children who were similarly alienated. The function of parents as role models for gendered learning about societal expectations and behaviours became much more difficult. At school, children now had other authority

Larry Wong

the legacy of SPOTA

Once in a generation, there is a moment when someone will look around and say, "This isn't right." In the city of Vancouver, British Columbia that moment came in the mid '60s when urban renewal was the call across North America and, more particularly, in the neighbourhood of Strathcona. And that person was Mary Chan.

AT THAT TIME STRATHCONA WAS A RESIDENTIAL AREA COMPRISING 40 CITY BLOCKS, from Gore Avenue in the west to Raymur Avenue in the east, and from Burrard Inlet in the north to the southern boundary of Atlantic Avenue. It was and is considered the oldest neighbourhood in Vancouver. In 1957, city hall declared it a slum.

There was a population of Europeans and Chinese—all working class—and though they spoke languages foreign to each other they became united in one thought thanks to Mary Chan, who discovered that the words "urban renewal" meant bulldozers.

In 1958, there was a freeze on the property values and no major redevelopment or home improvements were allowed. Area residents were told to sell their homes and move to Skeena Terrace—a public housing development some six kilometres away—or go elsewhere. Soon their former homes at McLean Park were destroyed and new public housing rose in their place.

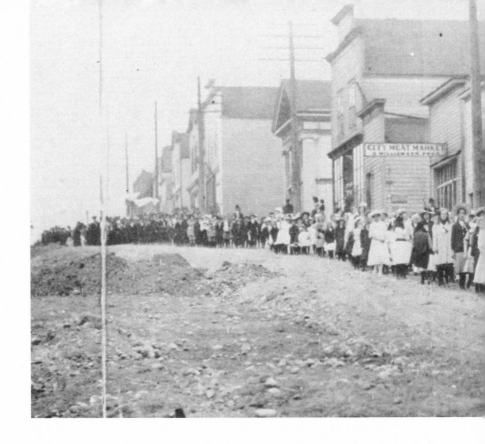

Mineworkers and their
families on parade in
Ladysmith during the
Big Strike, 1913. E-02631.

Alarmed by the sight and sound of the bulldozers
smashing wooden homes to pieces, Mary knew she had
to act immediately to stop the impersonal destruction of
her community. She knew that when the homes were
sold at market prices and abandoned by their owners that
demolition would follow on their heels. It was time to
rally support. It was time to act. Most of the Chinese
had two or more generations in one house and for them,
Strathcona was their home. In the days and years to
come they were united in saving Strathcona. Driven by a
common purpose, individually they cared for each other
not only as neighbours but as family members. They
were not affluent but rich in friendship; they cared for
and valued their community because it was their home.
It was where they lived, where they worked and where
they shopped in Chinatown. Now they had to get ready
to fight city hall and the federal government, so Mary
and her supporters knocked on every door in Strathcona
seeking help. It paid off.

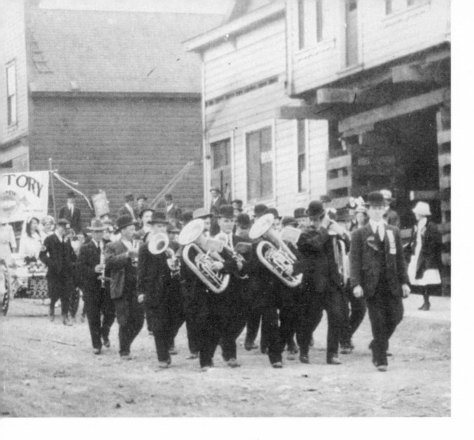

In December 1968, six hundred residents showed up at what became the founding meeting of a citizen-formed group called the Strathcona Property Owners and Tenants Association or, as it became known, SPOTA. Harry Con, Sue Lim and Walter Chan were elected co-chairpersons. Other major players were Shirley Chan, daughter of Mary, Jo-Anne Lee, Jonathan Lau and many others. There was also a storefront lawyer named Mike Harcourt, who later became mayor of Vancouver, and a community worker named Margaret Mitchell, who became a member of parliament. She was later recognized by city hall with the Freedom of the City.

On the city side there was Darlene Marzari, a city social planner assistant and Maurice Egan, the first city social planner for Strathcona.

Mary ensured there were block captains on every block to keep residents fully informed and their interests and community protected. SPOTA played host to politicians by inviting them to Chinese banquets and, in the relaxing environment of a Chinese restaurant, these movers and shakers were slowly convinced that instead of spending millions and millions of taxpayers' dollars to tear down the present neighbourhood, there was a simpler solution.

Why not offer interest-free loans to homeowners who would, in turn, do their own home improvement? It was a bold suggestion but by this time, thanks to the Chinese banquets, SPOTA had seasoned negotiators and the willingness of the politicians who listened.

Thanks to the efforts of SPOTA, who were determined to save their community, Vancouver was the first city in Canada to drop urban renewal. And they also stopped a proposed freeway from going through Chinatown, making Vancouver the only Canadian city without a need for freeways.

SPOTA proved you can fight city hall. Just ask Mary and her family of Strathcona residents.

シルバートン

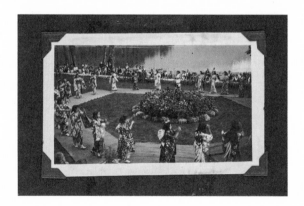

Top: Silverton, BC.
Bottom: Girls wearing
yukata during Bon
Odori? Possibly New
Denver, BC, *ca.* 1942.

Watson G. Funamoto album.

Don Bourdon

at our best

The Photograph Album as an Expression of Family

Each time I open the cover of a family photograph
album and turn the pages I feel a sense of
privilege—even after 45 years of working with
these special documents. The photographs are
both private and public; the whole is greater
than the sum of its parts. It's as if I have been
welcomed, unexpectedly, into someone's home.

IT SEEMS TO ME THE AIM OF FAMILY PHOTOGRAPHS AND ALBUMS IS TO PORTRAY US IN THE BEST LIGHT. They serve as a remembrance of what is real and what is idealized. Their images freeze moments in everyday life—love, pride and humour—arising from a desire to stop the passage of time and from a responsibility to record history. From carefully prepared chronologies or travelogues to assemblages of uncaptioned prints or curated Instagram galleries, albums provoke emotional responses and idealized versions of life and provide glimpses into family life that we could not otherwise remember or fully comprehend. This is aptly demonstrated by two albums—the Haxthow and Funamoto albums—that I will discuss in this essay, and which support this idea in different ways.

But with the introduction of photographic prints,

Albums, home movies and traditional records such as diaries and letters form part of the archival record and may be interrelated. Albums may be offered to archives and museums for donation or may surface in thrift stores, collectibles shows, auctions or antiquarian vendor offerings. Those that complement other records, are content-rich, typical or unusual, and are of significance to British Columbia may be acquired by the Royal British Columbia Museum and Archives. The study of snapshots and photograph albums has intensified lately as part of a renewed fascination with analog photography, seemingly left in the dust of the digital storm, and as new ground for social scientists.[1]

It has become pedestrian to ask: "If your house was on fire, what would you take with you?" The answer, predictably, is "family photographs". Residents fleeing the catastrophic fires in Barriere and Kelowna, BC in 2003 (and more recently in Fort McMurray, Alberta) were faced with exactly that question. When interviewed, evacuees said they scooped up family photographs, albums and laptops while struggling to ensure the safety of people and animals. For many, everything else perished. How did the family album develop into a treasured exhibition and repository of expression?

album *n.* – a blank book for the insertion of photographs, stamps, etc.

Its definition has changed over time, but the origin of the word album, from Latin *album* (white colour, whiteness), suggests a blank page. From the 16th century onward the term was applied first to a book containing signatures, then paper souvenirs and, in the mid-1800s, 'scrap' and photographs.[2] Plain paper volumes were transformed into photographic records and sometimes beautifully personalized works of art. Albums could document a trip, form part of an official record of an expedition or serve as a photographer's catalogue. They might include photographs of landscape and travel, religious subjects, military campaigns, career milestones, art, allegory, architecture or exotic lands and their inhabitants. But with the introduction of photographic prints, 'album' often meant 'family album'.

The earliest accessible forms of photography could not be placed in albums. Daguerreotypes, announced to the world in 1839, and the ambrotypes that followed were intimate, delicate, one-of-a-kind objects encased in the tradition of painted miniatures and silhouettes—housed under glass, within leather cases.

'album' often meant 'family album'.

The wet collodion photographic process, introduced in 1851, resulted in a glass negative from which paper prints could be generated inexpensively and in almost limitless numbers. Photographic prints could be incorporated into the scrapbooks, sketchbooks and commonplace books that had been flourishing since plain paper books had become affordable. These books were an opportunity for creative expression.

The ubiquity of 19th-century photograph albums tells us they were of huge importance to vast numbers of people. For the first time in history one could assemble a visual family register in one or more volumes. Queen Victoria had dozens of portrait albums and a world-wide craze erupted. The family album served as parlour entertainment, courting prop, social register, celebrity portrait gallery and advertisement for photography itself.

When Victorians first laid down hard-earned cash for 'likenesses', they began to create a visual genealogy. Carte de visite portraits—a little larger than today's business cards—were neatly contained in specialty albums, whose vacant slots begged to be filled with family and friends. As the market became saturated, new formats such as the cabinet card created a mania with corresponding special albums to be bought and populated. "The album did more than simply provide elegant and attractive housing for the new collections; with spaces for forty or fifty images, the mere presence of empty pages served as a mute reminder that they needed filling."[3] Where births, baptisms, marriages and deaths had traditionally been recorded in the family Bible, the photograph album began to encroach on that role, with pages for recording vital events to augment the portrait record.

Throughout the latter half of the 19th century consumers were entirely dependent upon the professional photographer. The photographer controlled lighting, pose, expression (to a high degree), background, presentation and advertising aspects of the finished product. Technical complexities meant there were relatively few amateur photographers.

After 1888, power was suddenly transferred to the consumer. Access to photography through roll film, the Kodak camera and photofinishing revolutionized the family album. Nearly everyone could become a photographer. Control over the means of production and the results shifted. Of course, there was still a role for the professional's technical and artistic skill, but sensitizing plates and processing on the spot were no longer required. Box and folding bellows cameras became affordable and portable. Instantaneous hand-held

Is this album the vehicle for telling a story or explaining a lineage?

photography became a reality. You could read a manual, join a camera club or just press the button and have Kodak "do the rest". The snapshot was born.[4]

Snapshots were casual and candid, the results sometimes unintended. The proliferation of snapshots demanded more flexible albums with modern covers, posts and cords to expand or reorder pages, and gummed photo corners to accommodate different sizes of prints. In the 20th century, conventions emerged and a look was created. The family album typically had black or grey paper pages with, more often than not, white ink captions describing collected photographs. Dark pages gave photographs a theatrical character.

Family albums now contained clusters, sequences or collections of images rather than simply a portrait gallery. They provided context for the photographs they contained. Aggregations of images build a story. Biographies of the album's creator and inhabitants emerge over time. Family albums provoke questions such as: Who is the photographer and who created this album, when and for whom? Who is the family depicted? What is the significance of what is and is not included and why in this particular sequence? Is this volume part of a series? What can we learn from the album, its photographs and documentation? What can be inferred and have we made assumptions?

If there are no captions—or if they are concealed —is this an *aide memoire*? The creator of the album knew who these people and places were, their relationship to each other and their significance. Is this album the vehicle for telling a story or explaining a lineage?[5]

Two very different sets of British Columbia albums, created by Eilif Haxthow and Watson G. Funamoto, provide insights into two very different families. One documents an evolving nuclear family at work and play from the 1930s through 1952. The other delivers complex messages of family separation and cohesion, the result of the internment of people of Japanese origin during the Second World War. Assembled under very different circumstances, the intent of these family albums is similar: capture, create, collect, present and preserve; this is us at our best. But both make us consider: What is a family?

Facing page: Helen Mae Haxthow shortly after her marriage to Eilif. Haxthow family album, volume 2.

the Eilif Haxthow family albums

EILIF HAXTHOW (1905–1966) had an amazing life. As a young Norwegian immigrant, he sought his fortune in Canada in 1923. He laboured on the Prairies, pioneered skiing on Hollyburn Mountain in West Vancouver and mastered diamond drilling, which became his career. He was a flyfisher, painter, winemaker and beloved father. He was a family man in the fashion of the 1930s through 1960s, with a steady though unusual work career that brought stability and security to his family. His three family photograph albums, immigration diary and personal papers are important to the study of immigration and especially of hard rock mining in BC. His daughter Peggy Massey of Nanaimo and her husband Mel recognized this and approached the Royal BC Museum and Archives about these treasures. Peggy and Mel Massey were high school sweethearts, so Mel has been part of the family since 1955. They have four children and nine grandchildren.

The Haxthow family albums are made up of photographs taken mainly by Eilif, who systematically organized, mounted and captioned them. They bear his imprint. Nevertheless, they are family albums, documenting the growing Haxthow family and treasured by his children to this day. The three volumes include a black-covered album—typical of the 1920s—that documents Eilif's journey: leaving Norway, seeking his fortune, finding various types of employment, batching in a downtown Vancouver boarding house and falling in love. It covers the years 1923 through 1932 and dovetails with his terrific little immigration diary, which is written in Norwegian and humorously illustrated, covering 1923 through 1928. The album and diary chronicle Eilif Haxthow's life as a carefree, resourceful young man who falls in love with Canada and with a beautiful young woman he meets on the ski slopes.

The second album is much larger. It documents Eilif's marriage to Helen Mae Taylor (1910–1976), their first home in West Vancouver, the birth of daughter Grace in 1936 and a mine posting in Field, BC. It concludes just before daughter Peggy is born in 1939.

Facing page: A 'family' of bachelors celebrates Christmas. Their shared vehicle is also depicted. Vancouver, 1927. Haxthow family album, volume 1.

Top: The young family's temporary posting to Field, BC, in 1936 was the result of Eilif's work at Base Metal Mines. Haxthow family album, volume 2.

Bottom: The youngest and eldest children set off on new adventures. Haxthow family album, volume 3.

The third album documents the family's life in Kirkland Lake and Port Arthur, Ontario, where Eilif was a manager for the Boyles Brothers Diamond Drilling Company. He flew into mining camps to lend his technical expertise while Helen cared for the children. Son Rolf arrived in 1948. This volume records the family car trek to their new home in the Cowichan Valley, where Sally is born in 1950. The album ends in 1952 as youngest child Sally takes her first steps and Grace, the eldest, leaves home to study at business college. There are over 900 photographs in the three albums.

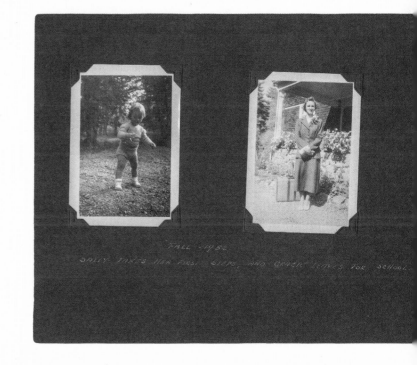

Left: "My father [Eilif Haxthow] was born in Oslo, Norway ... he came over here when he was 18, on his own. My dad was very industrious. ... And I would say he was a kind, intelligent, funny man ... he was lots of fun." Haxthow family album, volume 2.

Right: "My mother [Helen Mae Haxthow] was beautiful, elegant. Great mother. [She] was born in Vancouver. She was a hairdresser. She took the training in Vancouver, as a young woman. And married my father. I don't know if she ever worked [outside the home] after that. I don't think so. Women didn't in those days. My mom was one of four daughters. My grandma was widowed early and she brought up four girls in Vancouver, all gorgeous and all skiers. One of them played the violin in the Vancouver Symphony. One was a telephone operator. My mom was a hairdresser. They were very busy in early Vancouver life."

Haxthow family album, volume 2.

PEGGY & GRACE

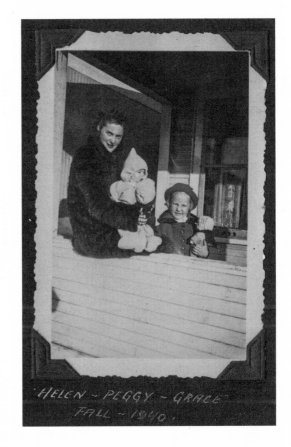

HELEN ~ PEGGY ~ GRACE
FALL ~ 1940.

"There were four of us. My older sister, myself, my younger brother and the baby … Grace was born in Vancouver. I was born in Kirkland Lake in Ontario. Rolf was born in Port Arthur. It was called Port Arthur then, it's now Thunder Bay, Ontario. And Sally was born in Duncan. Grace was four years older than me, so she got to do everything first. She was the first one to have boyfriends and do that sort of thing. She was a great older sister. I always admired her. She died of cancer about nine years ago. And my brother, Rolf, was much appreciated to be a boy in the family. I can remember that so clearly. My dad was just ecstatic to have a son. And Rolf, unfortunately, when he was in his thirties got MS. He lives in Cumberland. And I've come to admire him. He's no longer a little nuisance brother. He's very admirable. He's put up with that disease all his life. But he still gets around. He's an amazing person. And Sally is living part time in Prince George and part time in Parksville." Haxthow family album, volume 2.

"[Growing up] I thought we were very rich. … Sure, when my dad was working, because he would go to work wearing a suit and tie, driving a big car. He liked Nashes. We had quite a few of those. … My mother dressed very nicely. She had a fur coat. Of course, we were [in] Ontario so she had a squirrel coat, I think it was, Russian squirrel. So I had the feeling … which is a lovely feeling to have as a child … we had everything. [*laughs*] And my dad was hard working." Haxthow family album, volume 2.

STOKER HILL, DUNCAN, – AS WE FIRST SAW IT
JUNE 1951.

QUAMICHAN LAKE

"My father retired from Port Arthur. I believe it was a health issue. Parents didn't talk. They used to be quite private about their life. He was 45. So he hadn't been working a very long time. But I would say one of the words to describe him would be thrifty. So he was able to retire at 45. And my mother was expecting her fourth child.

"We came from the city. Port Arthur was, at that time, what I would call a pretty big city. And out into the country, onto five acres into a beautiful old house on Cowichan Lake, out of Duncan. The house was called [Stoker Hill]. We've discovered since then, I don't think we knew it at the time, that it was built by the brother of Bram Stoker.

"I was just twelve, so for me it was just wonderful. Surrounded by woods and trees I could climb … for a few years, [*laughs*] until I became a teenager and didn't do it anymore."

Haxthow family album, volume 2.

"We didn't have as much family time when we lived in Ontario.
[Father] was busy working. But when we got to Duncan then
he was around all the time ... and he was as happy as a clam,
because he loved to fish and he loved to paint. He was doing all
the things he loved to do. And he looked relaxed. You can tell
from the pictures the difference ... well, it's all the same today
of the working man, the man who retires. He's lucky he retired
at 45 because he died at 60. He had fifteen years of retirement
and they were good years for him ... good years for all of us."
Haxthow family album, volume 2.

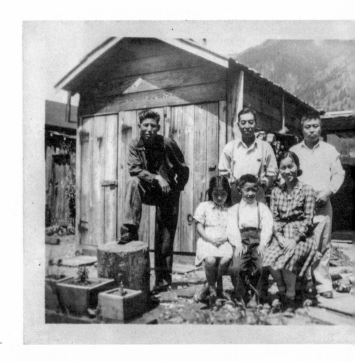

Unidentified family, possibly at New Denver, BC, *ca.* 1942.
Watson G. Funamoto album.

The Haxthow albums provide a linear narrative
about Eilif's extensive work travels to drill sites and his
career path from driller to office manager, but they also
include the arrival of babies and recurring winter and
summer activities. The family takes several vacations
to Florida and Mexico and endures separations when
Eilif works in remote places, but family life is rooted at
home and centres around winter sports and summer trips
to family cabins with lots of beach fun.

These albums can be more fully appreciated
because family members fondly remember their home
life and are happy to share it, as I discovered through
conversations with Peggy and Mel as we looked through
the photographs.

The Haxthow family's experience supports the idea that if a family had one parent with a steady, salaried job through the Depression and war years, they could live in relative security. More than that, if parents provided a loving and supportive environment for their children, they created and fostered genuine happy memories to be captured and reinforced with photographs.

the Watson G. Funamoto album

IN SEPTEMBER 1974 A FASCINATING ALBUM ENTITLED "'Watson' G. Funamoto and his album" was offered to the Provincial Archives of BC by William Hoffer, bookseller, Vancouver.[6] Hoffer described the red-covered album in a letter with detail surmised from the volume's contents and offered to forward it on approval. Although there was no further information about the album's creator and few tools to track Mr. Funamoto down, the album was purchased for its 168 exceptional photographs of Japanese internment camps and internees at Tashme, Slocan City, Lemon Creek, New Denver and Sandon. It also includes photographs of work camps and crews, seemingly incongruous scenic views and pre-war snapshots of whaling, fishing, family, friends and leisure activities in Vancouver.

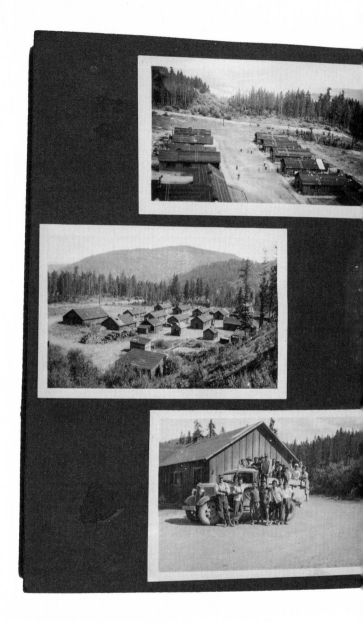

Possibly Red Pass, BC, road camp, *ca.* 1942.
Watson G. Funamoto album.

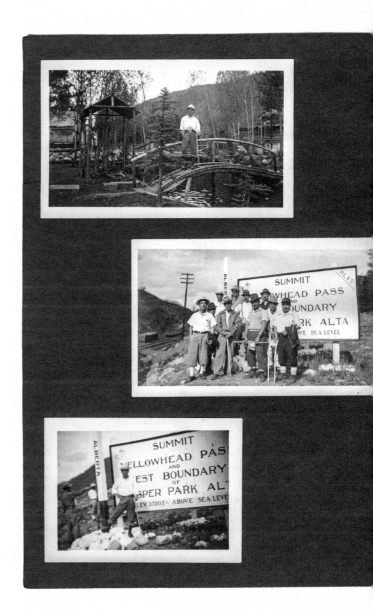

Who made the album? Early research has failed to determine which Mr. Funamoto created this remarkable document or if there may have been more than one owner or creator over time. Some photographs are missing, some have been removed or obscured by later additions of scenic postcards and captions have been erased, adding to the mystery. The album is not a chronological narrative. Internees were forbidden to own cameras, so how did the photographs come into being? The snapshots seem to have been taken by several different people in several different formats. I have no doubt that researchers will solve these puzzles by studying this evocative volume, not just as a container for individual images, but as a powerful document in its own right. I only wish someone could have interviewed the maker of this album and recorded his story.

What is it that makes this a family album? The Funamoto album is all about the separation that families of Japanese heritage experienced when, in early 1942, the Canadian government systematically removed them from their homes and businesses on the coast and sent them to internment camps. Men aged from their teens to their 60s are depicted engaged in manual labour at remote work camps near the Yellowhead Pass. Not only were they far from home, they were separated

Bridge and garden at camp; party at summit of Yellowhead Pass, *ca.* 1942.
Watson G. Funamoto album.

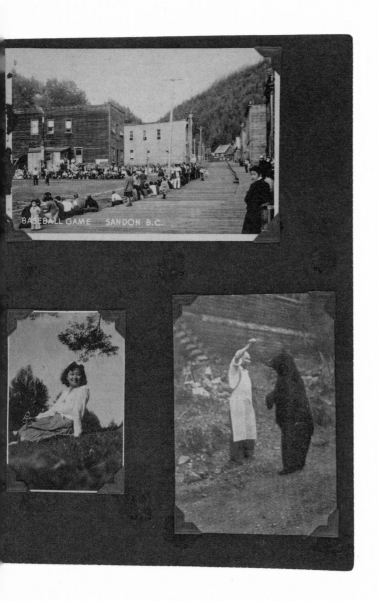

BASEBALL GAME SANDON B.C.

Watson G. Funamoto album.

from families and friends who had been uprooted to internment camps in southern BC interior. When pondering this album one can't help but think of the homes and livelihoods taken when internees were removed to purpose-built camps and derelict towns in the Princeton, Arrow Lakes and Kootenay regions.

The Funamoto album conjures emotions around forced removals and loss of rights and freedoms. It also shows people making the best of a bad situation. Internees are depicted as families of shared experience and families of necessity. Their photographs attest to the strength of people and families—posing with workmates, building Japanese gardens adjacent to tarpaper camp buildings, playing baseball on the main street of Sandon (until then, a virtual ghost town), gathering in front of a shack at New Denver, dancing in traditional clothing or sitting down for a rustic banquet.

The Funamoto album opens a window into the lives of the people on its pages, their blood families and their families of association, brought together by circumstances beyond their control. But, unlike the Haxthow family albums, we can only imagine what kind of narrative the album's compiler would provide. There is no one to share the memories of the people, places and activities portrayed in these photographs. At least, not yet.

the family album today

IN 2013, ERIK KESSELS OBSERVED:

Family or personal photographs are now taken to be shared with everybody whereas in the era of photo albums they used to be much more private.... We used to be the designers of our photo memories, not just someone who makes a slideshow on a computer. We don't even have them in albums any more. The function of a photograph has shifted completely....

New creative outlets for the accumulation, selection and presentation of family photographs will emerge.

It's extraordinary to think that photo albums have only been in existence for roughly one hundred years, and now they are virtually dead.[7]

Is the family album dead? Or has something else taken its place in the 21st century? Will rich albums like those of Eilif Haxthow and Watson G. Funamoto exist in the future? With the world-wide compulsion for genealogy and people constantly looking for insight into their past, family photograph albums should be cherished. However, context and continuity of custody is often lost as traditional family albums become dissociated from families and other types of family records. In a digital photography world, what is the future of the family album?

I can't agree with Kessels' grim declaration. I see beautifully choreographed custom printed 'photo books' being generated through all kinds of online services offering flexible, professional-looking layout, high quality digital reproduction and tasteful bindings. They are the modern version of engagement, wedding or new baby albums. There are still designers of our photographic memories making creative albums. The modern scrapbooking phenomenon of the 1990s and 2000s involved elaborate memory books and spawned a huge industry devoted to specialized craft supplies.

Scrapbookers create elaborate volumes of ephemera and images primarily devoted to family.

Billions of digital images are made every day. Many will be consigned to oblivion as hard drives crash or meaningful images drown in a sea of dross. Though a high level of thoughtful selection goes into some Instagram presentations, without a tangible volume much of this album activity is ephemeral. And the Google Photos platform now automates the selection process by selecting "the best photos and videos".[8] To some this is a sad state of affairs but, in a world awash in images, it might salvage photographs that would otherwise be lost.

New creative outlets for the accumulation, selection and presentation of family photographs will emerge. Whether these creations will survive is another matter. Archives and museums will continue to preserve and make available the traditional family photograph albums of the 19th and 20th century, like those by Eilif Haxthow and Watson G. Funamoto, which will no doubt inform, delight, puzzle and inspire for years to come. But today our sense of family goes beyond blood to families of choice, association, time and place. Our challenge—may we rise to it—is to capture, create, collect and present the family photographs of today and tomorrow in some meaningful and enduring way and continue to show our families at their best.

Patrick Lane

fathers and sons

I will walk across the long slow grass
where the desert sun waits among the stones
and reach down into the heavy earth
and lift your body back into the day.
My hands will swim down through the clay
like white fish who wander in the pools
of underground caves and they will find you
where you lie in the century of your sleep.

My arms will be as huge as the roots of trees,
my shoulders leaves, my hands as delicate
as the wings of fish in white water.
When I find you I will lift you out
into the sun and hold you
the way a son must who is now
as old as you were when you died.
I will lift you in my arms and bear you back.

My breath will blow away the earth
from your eyes and my lips will touch
your lips. They will say the years have been
long. They will speak into your flesh
the word love over and over
as if it was the first word of the whole
earth. I will dance with you and you
will be as a small child asleep in my arms
as I say to the sun, bless this man who died.

the word love over and over

I will hold you then, your hurt mouth curled
into my chest, and take your lost flesh
into me, make of you myself, and when you are
bone of my bone, and blood of my blood,
I will walk you into the hills and sit
alone with you and neither of us
will be ashamed. My hand and your hand.

I will take those two hands and hold them
together, palm against palm, and lift them
and say, this is praise, this is the holding
that is father and son. This I promise you
as I wanted to have promised in the days
of our silence, the nights of our sleeping.

Wait for me. I am coming across the grass
and through the stones. The eyes
of the animals and birds are upon me.
I am walking with my strength.
See. I am almost there.
If you listen you can hear me.
My mouth is open and I am singing.

Mr. Pinkerton and
one of his children,
Barkerville. C-09490.

Mo Dhaliwal

the language of family

family friends

I GREW UP IN ABBOTSFORD DURING AN INTERESTING
PERIOD FOR THE PUNJABI COMMUNITY.

The 1970s was a time when Punjabis were few,
so everyone knew each other. They greeted each other
on the street and stopped to talk in the grocery store.
There were those families that came earlier in the
century and some that came far later. When I reflect on
it now I realize that my family sort of sat on the cusp.
We arrived a generation too late to be thought of as
one of the 'pioneer' families and too early to be a part
of the great Punjabi migration to Canada in the 1980s
and beyond. By the time I was born in 1978, the pace
of growth for the Punjabi population in Abbotsford
was accelerating rapidly.

Growing up, there always seemed to be a lot of
people around. I recognized a few of these to be my
parents, others as uncles and aunts and, dearest to me,
my grandparents—all from my mother's side who had
followed my Nana (maternal grandfather) to Canada.
My immediate family members worked a variety of jobs,
often taking anything and everything that was available to
them, which meant that summer months were frequently
spent on farms and with the families of farm owners.
Mr. Miyagi's farm and family were as familiar and dear
to my clan as any of the Punjabi coworkers on that farm,
or any other Punjabi farm owner they worked for.

During the school year, I was passed around
my parents' community of coworkers and friends for
babysitting and, over time, these employers, colleagues
and friends became as familiar as my blood relations.

Facing page: Hélène Cyr photograph.

73

The bonds I formed with new circles of friends came at a formative time. We seemed to spend every waking minute together. So much so, that the lines between friendship and family were fundamentally blurred. Every key moment

Later in life these people were referred to as 'family friends'—a term really only relevant to those who formed these sorts of relationships with other families—and they formed a random and rich environment in which to grow up. These bonds are old and deep, going beyond simple ties of blood.

For birthdays, holidays and Christmas these people represented far more than surrogates. They represented a relationship that began because of the environment they were in: the working class immigrants of Abbotsford, all at the beginning of their journeys and fighting hard to make a place for themselves and their children. It was this bond of common cause that fostered their solidarity, their empathy for each other, their willingness to collaborate, give generously and provide support when and where it was needed. My fondest memories and feelings of closeness, of family, are conjured when I think of the many faces that were simply referred to as "auntie" or "uncle" when I was growing up.

My family was this tight-knit network of people who worked together but, more importantly, who experienced their emotions together. The happiness of one was the elation of the other. Sadness and grief were distributed and carried together—to lessen the burden.

assumed family

AS MY AUNTS AND UNCLES GOT MARRIED, MY UNDERSTANDING OF FAMILY EXPANDED. This new family definition had less to do with common cause and more to do with structures. The marriages took place when I was young enough that stitching the new aunts and uncles into the fabric of family came about quickly. From swimming lessons to dressing me up, the new family members took quickly to their roles—it helped that I was the only child in the family for a few years. I never did have any siblings, but my cousin Brian later provided a convenient surrogate. He was as incredibly adorable and ridiculously annoying as a little brother should be. We were left together to play, fight and form a special bond. As other cousins were born, the family grew, but as it grew we also seemed to move away from the one nucleus that everyone had been a part of. It seemed that there were new gravitational forces at play, pushing and pulling bodies into new orbits.

It wasn't until my paternal grandparents and uncle arrived from India in the early '90s that my notion of family was re-written with additional deference to new players. I was in high school and these were people who I had only encountered on a few prior trips to India.

They were great people to visit, but ... family?
That assumed a great deal. My connection to them,
our relationship and their roles in my parents' lives
were the most well-defined features of family—socially
and culturally. However, the emotionality of this
connection wasn't immediate. I felt connected only
because I knew we were connected through a physical
bond of genealogy. I knew that we carried the same
blood and that I came from a long line of people
from the village of Cheema in Punjab. I knew that
these people played important roles in the lives of my
parents. This knowledge formed our first connections
but we were then left to fill the gaps in the relationship
as time went on. Some of these gaps filled beautifully
over time, but some never did and still others just
became wider.

chosen family

OVER TIME MY NOTION OF FAMILY again became
singularly focused on my maternal grandparents, uncles
and aunts. My cousins grew older and I formed new
friendships and relationships with like-minded people
in high school and beyond.

The bonds I formed with new circles of friends
came at a formative time. We seemed to spend every
waking minute together—so much so that the lines
between friendship and family were fundamentally
blurred. Every key moment and memory was shared
with these people. They were there for every up and
down and, to me, this was the bond of family. The
only type of bond I could comprehend was the bond
of shared history and understanding.

As I continued to meet new people there were
certain qualities—I can't put my finger on what and
maybe it's an only child thing—that would appear and,
as a result, our connection would almost automatically

My approach to these new family members was one of familiarity, vulnerability and generosity.

become easier, more fluid, more familiar and more comfortable. These are the relationships that didn't require a lot of maintenance, seemed to never grow cold, and could always be picked up again after long periods of time and distance. Some of these relationships were even fraught with conflict! But it didn't seem to matter because there was an undeclared accord that we were meant to be together, and a congruency that continued to draw us closer.

I came to form new professional connections, new friendships and, ultimately, add new family members to the fold. Acquaintances with similar tastes in music, culture or who, like me, loved dancing on the weekends, began to get closer, more intimate, and ultimately became extensions of my family. They were present for important events in the lives of my immediate family. Their care and concern extended beyond me and began to encompass my mother, my father, my grandparents. My approach to these new family members was one of familiarity, vulnerability and generosity. This was reciprocated tenfold by those who I now consider to be my loved ones.

This attitude towards people and approach to family is really the influence of my mother. Her approach has always been to shower people with a raw, powerful type of love—a force that isn't saccharine or even pleasant at times, but always emanates from a place of caring and familiarity. I've seen my mother direct this love towards people who recognized her, people who betrayed her and people who chose to reciprocate her love and become members of her chosen family.

Spread: Hélène Cyr photograph.

MY CHOSEN FAMILY CONTINUES TO GROW. I've created bonds with people that transcend typical friendships—bonds that may have started out in some common cause or activity but grew with the realization of a deeper empathetic connection. In many ways, I feel like I've come full circle to my childhood understanding and appreciation of family when our tribe was the early Punjabi community of Abbotsford, the working class who were trying to establish themselves. Today, my tribe includes community builders, and people from business and the arts. However, much like my childhood, it's the unspoken, empathetic connections,

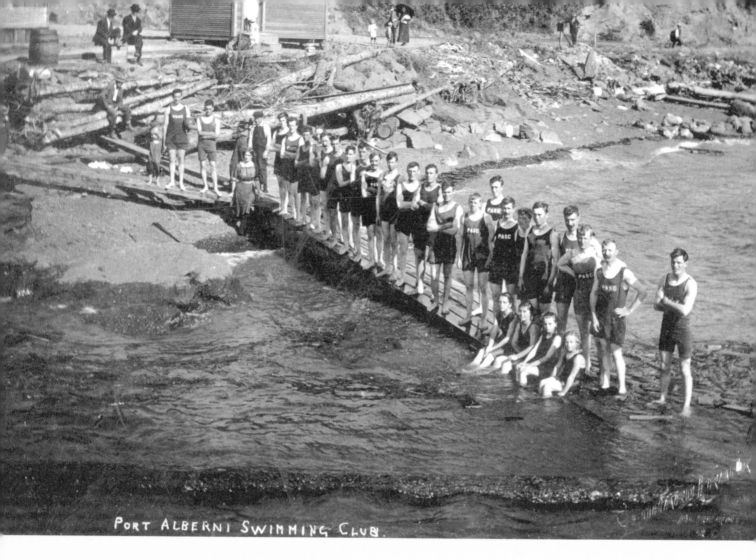

PORT ALBERNI SWIMMING CLUB.

the relationships that seem to persist and grow deeper on their own and the relationships that are familiar at the outset, that form my chosen family.

My blood family continues to grow as well. My cousins are getting married, new children are being born and, again, in some ways it's a repeat of what I experienced as my aunts and uncles got married and ultimately gave birth to my cousins—the very ones getting married and having children today. I've also come to realize, however, that my 'chosen family' isn't just an additive activity. It can also be a reductive one.

I now consider my family to be those who are there for me in time and in spirit, those who are common to me in bond if not in blood, who are kindred in their hopes and dreams if not in lineage. This has brought me closer to some of my blood relatives while, inevitably, allowing some distance to form with others.

As I've become clearer about who my family is and what my family means to me, so too my relationship with my mother has become more focused and deliberate. For years ours was a relationship of guilt and conflict, but I've become increasingly understanding of her positions as

Family is a feeling of interconnectedness, based on deeply embedded commonalities. I get a sense of family when I'm with people who feel like they are a part of my larger whole; that part of my self that is defined by nuances.

well as her preferences for how she wishes to live her life and who she chooses to associate with. Growing up there were many difficult years with my mom. I often couldn't understand her approach to some of her siblings and she wasn't great at articulating how she was feeling or why. I came to realize that what I was dismissing as erratic or emotional behaviour was actually based on deeply entrenched gaps of empathy and understanding—some that could never be bridged. The beauty lies in how my mom has transcended these gaps and created a family of empathic connections, of people who have shared similar trials and tribulations, carried similar pains and joys and can relate on a level that would take others a lifetime to achieve, if ever.

Family is a feeling of interconnectedness, based on deeply embedded commonalities. I get a sense of family when I'm with people who feel like they are a part of my larger whole; that part of my self that is defined by nuances, hopes and fears, and shaped by a litany of experiences. There's a language that exists beyond even the most emotional exchange that speaks volumes between people. It is this common tongue that defines my family for me today. With some the formal connection of family was created first and then this language was learned over time. With others the language existed first, and there has been no way or need to formally recognize the depth of this connection. Perhaps this is my contention even with the word 'family'. In some contexts it illuminates the depth of a relationship, while in others it falls far short of capturing the empathic connection that can exist between people who belong together.

Facing page: Port Alberni Swim Club, *ca*. 1915. Frank Leonard photograph. D-07378.

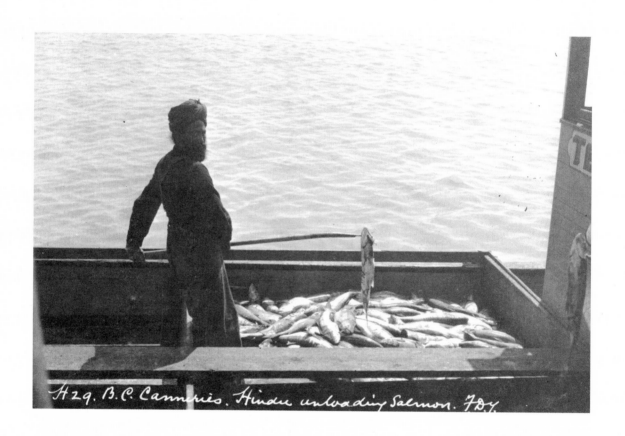

H29. B.C. Canneries. Hindu unloading Salmon. FDT

Working on the Fraser, 1913. Frederick Dundas Todd photograph. E-05027.

Sadhu Binning

river relations

In societies such as Canada, the modern
concept of family is generally limited to
the basic unit—parents and their children.

THAT IS NOT THE CASE WITH PUNJABI SOCIETY. While it is true that Punjabis living in Canada are beginning to reside in separate dwellings and in smaller family units, they continue to maintain traditional bonds and relationships through family ties. The full realization of these traditions is seen during special occasions such as weddings, births and deaths in the family. These are the times when one understands that family is *not* limited to a basic unit—large or small—but rather to an idea, a feeling. It covers so many different types of connections that one makes with other human beings during the course of one's life. The family, in this sense, is spread across space and time.

Our immediate family has been in Canada for more than half a century now and, like most first generation immigrants, we were able to help many relatives and friends settle here over the years. One constant in our family was my mother, whom we called Bibi. She recently passed away at the age of 90 and her death was an occasion where our 'family' and its history in Canada came into full play.

Bibi spent the last six days of her life in the Richmond General Hospital where staff kindly moved her into a private room as relatives and friends flocked to her side in overwhelming numbers. During those days there were always several people with her and, at night, her youngest grandson insisted on staying with her. When she took her last breath, there were close to a dozen of us surrounding her bed. Throughout the seven days between her death and the funeral, day and

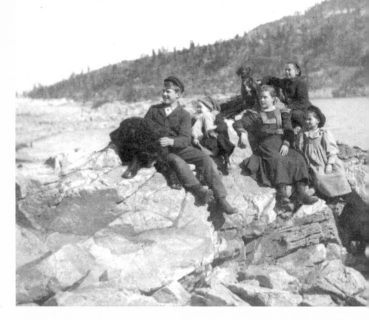

night, a large number of relatives and friends visited my brother's Richmond home where our mother had lived. Every visitor was served tea and sweets. Food was prepared by various family members and served by Bibi's nieces, nephews and grandkids. People came from all over British Columbia as well as Alberta and California. Phone calls of condolence came from around the world, including the rest of Canada, the US, Europe, India and Australia. Since Bibi had lived a long, relatively healthy and happy life, her death was not treated in a tragic or entirely sorrowful way and the visitors—men and women sitting in separate rooms—would convey a few words of grief to the family and, depending on how close they were to Bibi, would share memories of special moments with her. This was in line with tradition. In Punjab, the death of an elderly person who had lived a full life was naturally treated as a loss to the family but was also celebrated by inviting village folk to share a meal with the family. The occasion is called *katth*—a gathering.

This gathering included many people who became part of our family over the years, through different circumstances and situations. For example, a large number of young people migrated here as 'visitors' from Punjab between 1970 and 1972. The law at the time was that one could come to Canada as a visitor and then apply to become a permanent resident if one wanted to stay. Many people took advantage of this, including some of my ex-schoolmates who came here at that time. Often they needed an address and a place that they could connect to in their new and often hostile environment. My mother was always there to offer food and a feeling of home away from home. A friend who had experienced my mother's warm welcome spoke at her funeral and told a story of one of his friends who came to Vancouver and didn't know anyone in Canada. Bibi welcomed him with open arms and gave him the food most Punjabis love more than any other food—saag and makki di roti—a green leafy vegetable with homemade corn flour bread.

He was so touched that he has never forgotten that moment. Last year he came to Vancouver from Toronto after 44 years. He visited Bibi, gave her a bouquet of flowers and thanked her for the unforgettable experience he had upon his arrival in this country, an experience that made him feel like he belonged in a country that was otherwise so foreign to him.

Canada has been, without a doubt, a great place to live and grow. As a family we have experienced all that life has to offer, including interracial, interfaith and intercaste marriages, and these experiences and challenges have made us better, stronger human beings who respect and accept all others. Some of us have moved away from belief in a higher power while others have become stronger in their faith. We feel a strong sense of gratitude towards Canada for giving us the sense and strength to make these changes and still allow us to love and rely on each other despite the differences in how we live our lives, differences that would never have been accepted in village society in India.

Like most Punjabis who immigrated to Canada, our family came from an agricultural background. We were keenly aware of our strong relationship with the land and the waters of Punjab—the name itself means five

Children with their
dogs, Pilot Bay, 1899.
B-07195.

Overleaf:

Hélène Cyr photograph.

waters/rivers—and, traditionally, this relationship didn't
end with one's death. Bound by the ancient mythology
of the land it was considered the prime duty of surviving
family members to take the ashes of the departed to one
of the rivers. Many Punjabi/Indian families still do this
regardless of where they live in the world but, when my
father passed away in 1986, we decided to take his ashes
to a river in BC. Though he had no formal education,
he was acutely interested in intellectual matters and
held a deep passion for debate. He felt a special sense
of freedom to do this here in Canada and for that he
often expressed his feelings of respect and love for this
place. We felt that he would be happy here and Bibi
understood this and gave her consent.

I wrote a poem at the time of my father's death.

river relations

On our way to the randomly chosen spot
where we could see the towering glaciers above
the memory of Gunga Jamna and Sutluj
was not easy to quell

With my brother standing beside me
slowly I dropped the ashes of my father
into the icy water

Now whenever I remember my father
it is the Squamish River I think about
one rupturing relationship
giving birth to a new one

The strangeness of the place melted
a personal image now flows in memory
perhaps that's what my father meant
by relations of rivers to men

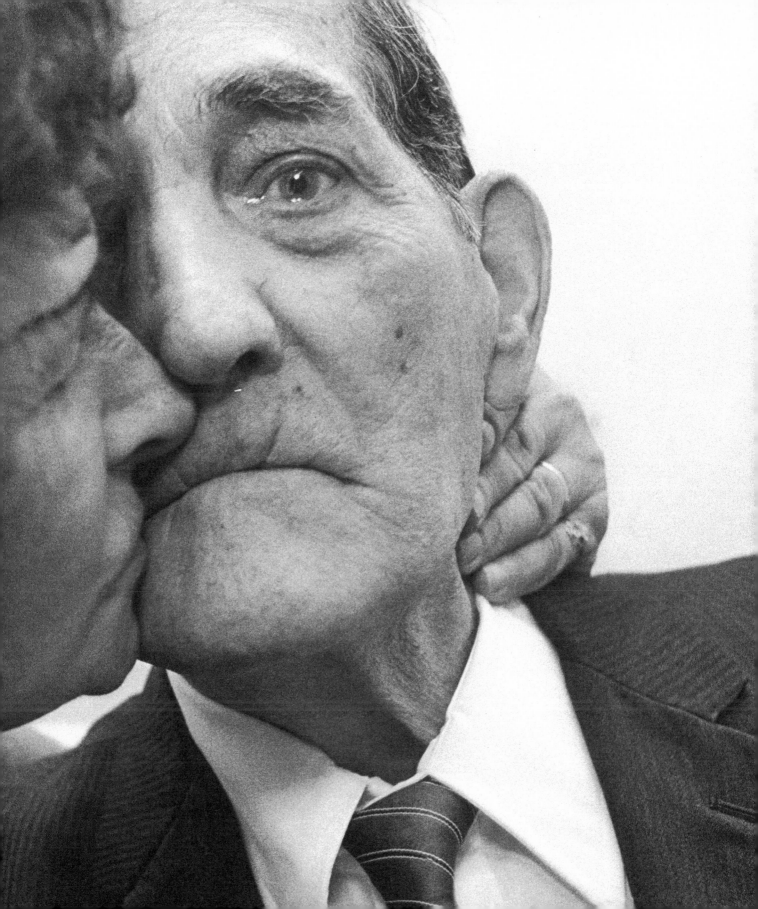

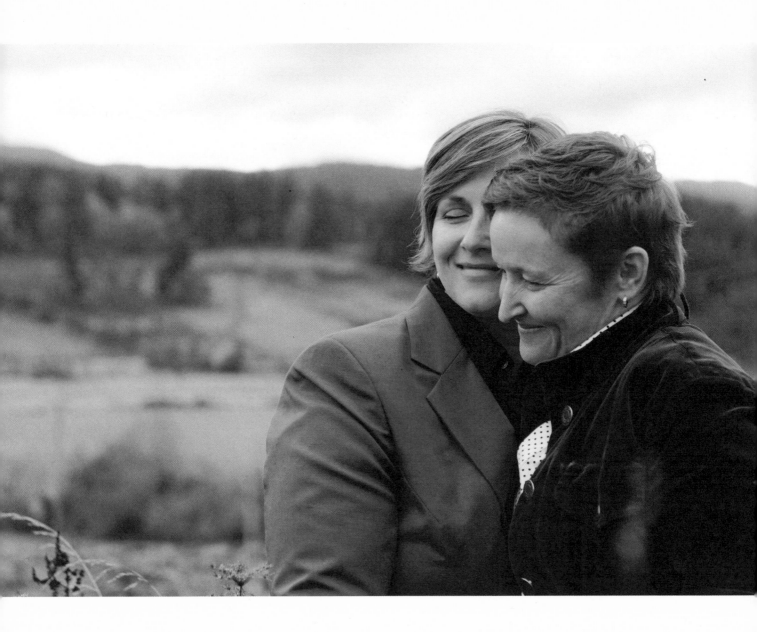
Hélène Cyr photograph.

barbara findlay

queer as family

Family.

I don't have a family.

At least, not in the sense that most people do.

I AM A FAT WHITE 67-YEAR-OLD CISGENDER LESBIAN WITH DISABILITIES, RAISED CHRISTIAN AND WORKING CLASS, THE ELDEST OF FIVE, IN REGINA.

* * *

My experience of exclusion and marginalization as a lesbian was not shared by my family of origin. Unlike children of parents of colour, or Indigenous parents, or Jewish parents, whose marginalization is a fact of family life, I am a stranger to them.

Other folks share that disconnected experience: Indigenous kids in the '60s scoop or currently in foster families, raised by non-Indigenous parents; kids who do not 'look like' they belong to their parents of colour or their white parents; trans kids. I couldn't ask my mom how to deal with homophobic bullying or take a broken heart home for solace.

* * *

We dykes used to offer each other the common wisdom: watch out for weddings and funerals. Places where family formations matter.

Our lesbian friends were what we had

When my sister married, I wrote to my mother months ahead of the date and suggested that since my sister was planning a very small wedding in Regina, it might be a good time for her to come out to her friends about the fact that I was a lesbian. My partner Sheila's presence would be otherwise inexplicable in a wedding party of 35 in Regina in the dead of winter.

Mom called me weeks before the event. "Your father and I have discussed this," she began—always a harbinger of a serious message. "We don't see that there is any need for you to introduce Sheila as your partner."

"How should I introduce her?" I asked.

"Just say she is your friend."

My 'friend': a word for people who by definition are not part of the family. A word that hides more than it discloses. The polite erasure.

My 'friend': a word for people who by definition are not part of the fa...

* * *

I practiced law for 15 years before I had any human rights as a lesbian. I could be fired, denied a tenancy, turned away by storekeepers, be humiliated by doctors, without recourse.

* * *

Our lesbian friends were what we had for family. We turned to each other for recognition, for support, for solace, for healing.

But the lesbian community was a fragile one.

We refused to recognize anyone who was not like us. We were suspicious of bisexual women.

Two of my close lesbian friends told me I was no longer part of their families because I was the lawyer for trans women who sought to access women's crisis services. I was regarded as a traitor.

The families we formed with our partners and, often, with children from a heterosexual marriage, had no legal recognition or social validity. So when lesbians with children broke up with each other, it was standard for the 'bio mom' to deny access to the 'non-bio mom', with impunity. Courts regarded the non-bio mom as a legal stranger to the family.

for family.

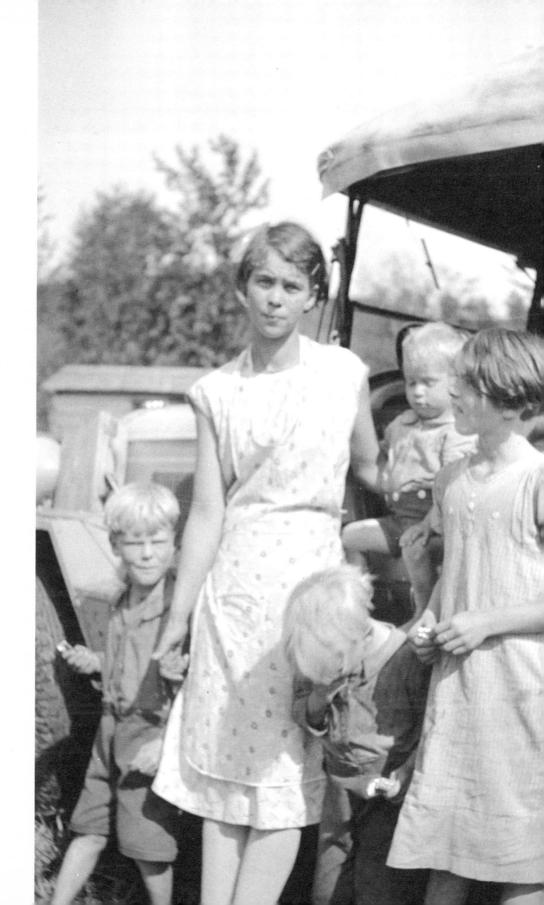

The Westergaard
family at their ranch
on Halfway River, 1934.
C-08436.

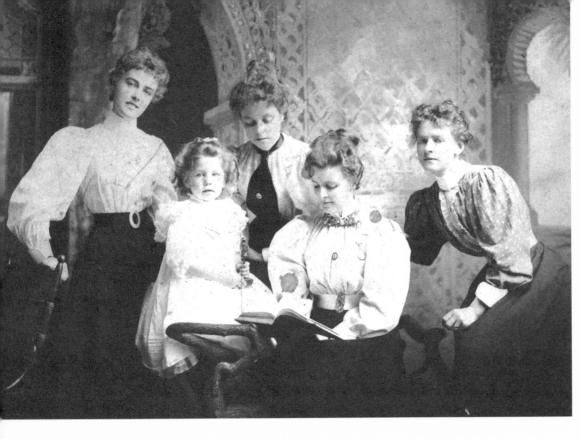

Richard Wolfenden's daughters (*left to right*): Kate Cooley, Madge, Mabel Mary, Nellie F. and Roberta Elizabeth, 1896. B-02769.

* * *

It was not as if my being a lesbian was a secret. By the time of my sister's wedding I had several times been on the front page of the *Globe and Mail* or on national radio or TV as an advocate for queer communities. It would have been impossible not to know.

And by the time of my sister's wedding I had been with Sheila for several years.

My parents took an annual winter holiday to Hawaii and always stopped to visit with us en route. They both loved Sheila.

But, as my father told me, it was lucky we didn't live in Regina where he would have to deal with the fact that I was a lesbian.

* * *

Twenty-five per cent of the laws of BC explicitly discriminated against queers and our partners.

You could not adopt your partner's child or adopt a child together.

You did not inherit from your partner if she died before you.

You could not put your partner on your benefit plan at work.

You could not complain.

It was 1992 before there was provincial human rights protection; 1995 before we could adopt children; 1999 before we were recognized as parents of the children we had or raised with our partners.

Lesbians of colour and Indigenous lesbians had no safe place because of the racism of the largely white communities of lesbian feminists.

* * *

When my sister had her baby, conceived with IVF and anonymous sperm, it was a very big family moment. Of my mother's three daughters, hers was the only grandchild who survived.

Sheila and I were overjoyed. We welcomed my sister and my niece, who lived only a ferry trip away from us, as often as they could come. We were the only family my sister had in BC. My niece and I had a deep connection.

One day I asked my sister who she had appointed to be the guardian of my niece.

She had chosen her neighbour, whom she saw only very occasionally. When I questioned her choice she said she would never let her daughter be raised by us.

* * *

The world has completely changed since I was a baby dyke. There is no more legalized discrimination. Lesbian families are recognized and protected. Lesbian weddings are ordinary. Lesbian co-moms are both on the birth certificate as their child's only parents. Their child has the right to come out and be protected from bullying in their schools. Canadian queers can sponsor their partners to immigrate.

Though discrimination persists it has become largely socially unacceptable.

* * *

In the year before my mother died of cancer she had a change of heart. She embraced Sheila and proudly introduced her to strangers on the street as "barbara's partner". My father bought Sheila a plane ticket to come to Regina for their anniversary celebration.

I asked my mother before she died if she knew I was a lesbian before I told her. "Oh yes!" she said. "For years!" Before I went to university? I asked. Before I knew myself? "Yes."

In my life I had no grandmothers to teach me, either in my family of origin or in my family of lesbians. The generation of lesbians ahead of me were even more deeply in the closet, even more terrified of coming out, even longer had hidden till it had become a habit. We terrified them with our defiance. They were the ones who had stood down, who were rounded up in police raids while they were having a drink, who lost their jobs or were cut off from their families. They were fierce and they were fierce survivors. But they were not my mentors.

These days we do better at that. We work hard at connecting our communities of elders with our young ones, making sure that they don't have to walk the paths that we walked, that there is someone who would stand up for them if they were bullied or taunted or ostracized.

And these days our circles are wider, our communities stronger. We cis ones stand with our trans and gender-variant friends; we white ones work against the racism in our communities.

* * *

And we are invited to their weddings.

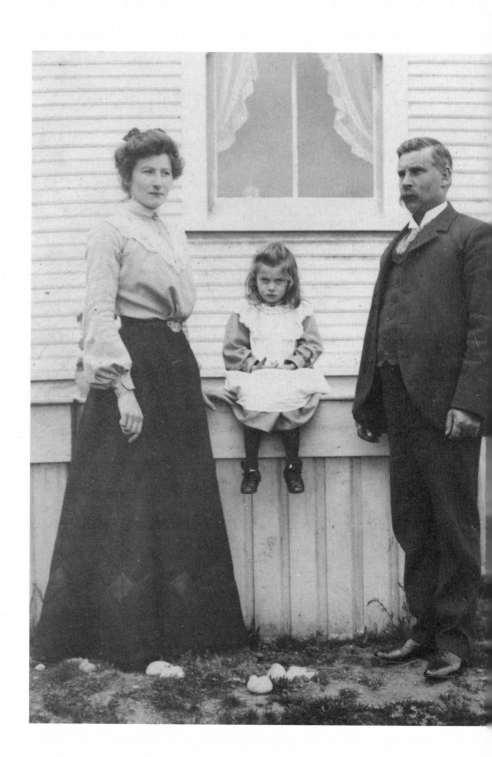

Mr. John Stephen
Muir, his wife Eliza
Isabella (Isobel in some
records), née Throup,
and unidentified child,
possibly their daughter,
ca. 1905. D-08040.

Lorne F. Hammond

museum collecting with families

For almost two decades I have been learning how
to work with families as a history curator at the
Royal British Columbia Museum. But every family
is unique, despite the universal commonalities
of life, so I am still learning to this day.

IN THE LITERATURE OF MUSEOLOGY I FIND MUCH
THEORY BUT NOT A LOT ON THE PRACTICE OF
THIS KEY ACTIVITY. We are not anthropologists, nor
are we observational academics standing to one side.
As public historians we are participants immersed in the
society around us. We are also part of the mechanism
through which things deemed of significance and
of historical value join our museum's collection.
We function in a partnership with donors in which
the nature of power and decision-making is very
much a shared enterprise. As a curator you bring
knowledge of the mandate of your institution and
of your existing collections.

Collecting with families is filled with emotion and
ethical responsibilities. It involves trust, and respect, for
both the living and the dead. The curator is a supporting
figure in how a family deals with memory, grief and the
internal and external preservation of the family's history.
Just as the world is made up of diverse human beings and
diverse personalities and cultures, working with families
is filled with tremendous variation and variety.

The ethnology, archaeology and natural history
collections at the Royal BC Museum go back to the
early 19th century. In contrast, the modern history
collection was only assembled in 1965 and the creation
of dioramas and exhibit galleries for the new BC

. . . only 50 per cent of the value of our collection

Provincial Museum required additional representative collections for many subjects. Many collections were purchased from private collectors of hats, shoes, purses or textiles, and while some came with family histories most, like the objects on eBay today, did not. What would be needed to accurately portray a store, a farm, a blacksmith shop or a hotel?

One answer was found in the acquisition of the Crossroads Museum—part museum, part antique shop—in Ladysmith. Over the years Mr. J. Watson had acquired many of the 4,401 objects at auctions when the old homes and farms of European, Chinese and Japanese pioneer families on Vancouver Island were sold.[1] His collection represented everyday life over a century and he was interested in selling out and retiring. Mr. Watson was a storyteller and had a great memory. As he toured museum staff through the shop that was his home the familiar objects reminded him of places and events and he provided the provenance of clusters of objects, naming the family farms where he bought them and when. Museum staff walked with his memories as they went from room to room.

Acquiring this collection seemed the perfect solution. A price was agreed upon. The objects with family histories were brought to the museum, sorted by type and set out on long tables in the new—empty—galleries. Staff began the process of cataloguing them into the collection. Mr. Watson had agreed to come down and share his knowledge and a stenographer was hired to record the histories. All was ready. He walked in, looked around at the rows of objects and recognized nothing. He did his best, but all he saw were things without stories or connections, just variations of form. It upset him. The objects had lost their meaning and their connection with his memory. The relationship, the way he had arranged them in his own living space, his shop, was broken. So were the memories.

When I began working at this museum twenty years ago this was the first informal teaching story I heard, and from it I learned that it is important to interview families in their homes. Objects have a context. Memory has a spatial and a tactile dimension that is fragile. Memory does not sit well with the clinical state of good collection storage. Nor does it accept disruptions, chaos or an unfamiliar context. Memory is a comfortable home, a family space.

When families speak about their objects they should be comfortable, not just with you, but with the objects whose story they want to share. The 'family home' is more than the objects you see and more than

is in the object.
The other half is the human stories attached to it.

just memory; the meaning is tactile and visual and one layered with emotion. When children return home to visit their parents or their grandparents, the context of their identities is an arrangement of photographs on the wall, a certain order of disparate knick-knacks on the mantle, a dated fabric, a worn chair, a cigarette burn on a dining room table where a relative sat during family dinners. The intangible memory and the emotion-laden objects are critically linked.

For collectors, enthusiasts of eBay and those seeking out this and that in excellent condition at a flea market or a collectibles fair, these are objects severed from provenance. They no longer have their human story attached. As I tell students, only 50 per cent of the value of our collection is in the object. The other half is the human stories attached to it. The human story is as important to record as your object storage location. Without both halves, the object is lost. Your ethical responsibilities as a curator is to record as accurately as you can a family's history of the things they entrust to you.

Collecting with families usually begins with a telephone call, an email or a letter to the museum. To a family the internal bureaucracy of a museum is a black box. And the curator knows little about the family's history. Clear communications are important right from the start.

There are two primary reasons that people will reach out to a museum and a curator about a family collection. The first is to simply preserve an important family object. But the most intense reason is a death in the family. Someone of importance, whether much loved or neglected, has suddenly died. Suddenly many unexpected things need to be done. People are grieving and yet too busy to grieve. They are not professionals at dealing with death.

This is the world the curator steps into. It is an ddly supportive role, examining a past life through its material culture and asking for permission to become the steward of objects associated with a life, all the while working quickly and making the bureaucracy of the museum as smooth and simple as possible.

The curator asks inane questions: do you remember what year they bought that bathing suit? I see this toy in that Christmas morning photograph, what year was that? The family will not know. They will know how old they were or what grade they were in; the curator does the math. And it takes the family out of the chaos of grief into a positive memory, just for a brief moment. This helps both of you.

These kinds of family collections are eclectic by nature and depend upon the curator knowing the diversity and gaps in their museum's collection. The curator is also

Some family objects are imbued with great
weight and inherited responsibilities.

looking for the human connections in the home they have
been invited into: objects of a life lived as well as family
objects connected to a handed-down thread of family
history such as "that was a wedding present" or "our family
built paddlewheelers when grandfather first arrived in BC".

There are times when the curator may have to say
no to something cherished by the family—a delicate
task. Faced with disposing of things that hold family
memories, people become filled with guilt. Earlier in my
career I found this emotional interaction so intense that
I took things into the collection I should not have. I was
shocked when an older more experienced staff person
said, "Every day in this city another sweet little old lady
passes away. And they all have basements full of things."
At the time I thought this a cold, flippant statement.
But it is a hard truth.

So, what advice can the curator offer to help the
grieving family deal with objects the museum cannot
take? It is okay to let things go. Decide without guilt.
Keep this, give that to the museum, this to charity,
sell this one and throw those away. Would the person
they lost want them to worry about such small things?
Probably not.

At times the grieving process crawls slowly
and painfully. Timothy Lyons, the youngest of two
boys, was about to enter first year university when
he was diagnosed with acute lymphocytic leukemia.
On December 26, 1986, at the age of 27, he died of
complications after a bone marrow transplant from
his older brother.[2] His mother Mary simply closed his
bedroom door. Seven years passed before she could bring
herself to deal with his belongings. Our registrar at the
time, Terry Eade—a mother, with a deep understanding
of our textile collection—took on the responsibility for
perhaps the most sensitive donation I have ever known.
The two women sketched out important activities in
this young man's life and built a collection around things
he loved: school, skiing, mountain bikes, rugby and so
forth. When Terry retired I inherited the relationship, and
it was my privilege to continue to work with the family.

Some family objects are imbued with great weight
and inherited responsibilities. The Shandley family
wrestled with what to do with an indivisible singular
object—a bowl in which their father had kept his car
keys and change; a bowl that had sat in their front hall
since the 1930s, when it was given to them by an artist
friend. That friend was Emily Carr who, though mainly
known as a painter, also made hand-decorated pottery.
The bowl had been on the *Antiques Roadshow* for valuation
and could be sold, the monies divided. But what about

Emily Carr and her
brother Dick, 1891.
I-60892.

The David Spencer
family, Victoria,
ca. 1885. B-02243.

in that group knows that their family treasure is at the museum, safely preserved and available to them and to their children.[3]

Sometimes decisions about family objects have a very personal focus. My retired colleague Dr. Robert Griffin worked with the portrait artist Myfanwy Spencer Pavelić (1916–2007). Mrs. Pavelić grew up in a privileged circumstance. Her family, the Spencers, established the largest department stores in British Columbia, later acquired by the Eaton's chain. Myfanwy studied art with Emily Carr, married diplomat Nikola Pavelić—whom

the family history represented in the story of this object and their connection to their now-famous neighbour?

As a museum curator the consensus of the family matters. You are an outsider with no legal status seeking an object of high value for your collection. You move slowly, transparently. You explain all of the issues involved. If the object is owned jointly then everyone has to agree. For the curator, the hardest part is waiting.

In this case the family's solution was brilliant. They held a spring BBQ celebration to mark the 80th birthday of their father and grandfather and eleven family members came to the museum for the presentation of the bowl. We had a Carr exhibition, *The Other Emily,* on at the time and the bowl was temporarily installed in its own case near the entrance, to showcase the family gift. The photograph documenting that event is also part of the celebration of life, and of closure. Every person

Myfanwy Spencer Pavelić based her family self-portrait, *Mother, Daddy and Me*, on an original Spencer family photograph from 1916–17. Oil painting. 2000.19.3.

Below: The Bossi and Geiselmann grocers on the corner of Johnson and Store streets, Victoria, 1880s. A-03470.

Lombardy region of northern Italy—arrived with the 1858 gold rush. For several generations the Bossis were shopkeepers in Victoria, but subsequent family arrivals worked in construction and education. Their home became an object archive for the story of the family, which eventually came to an end with Miss Anita Bossi after the loss of her sister Olga L. and their brother Albert. Both sisters taught elementary school and Albert was a plasterer. Miss Bossi, as Anita was known, began to make donations to the museum in 1988, and her last

she met in New York—and became the foremost Canadian portrait artist of her era and a member of the Limner Group.[4] As the end of her life approached she worried, not about her artistic legacy but about family objects with personal emotional meaning—a painting based on a photograph, mother's best hat, her favourite evening dress—each a unique memory of childhood and her family. These are what mattered.[5]

Some families keep everything. Carlo Bossi and his brother Giacomo—from Lake Como, in the

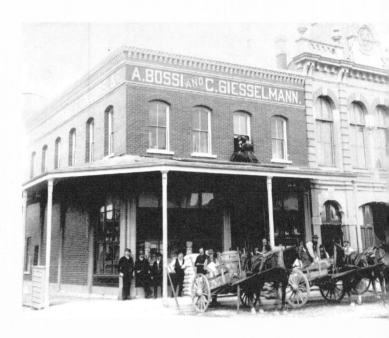

Sometimes you find something that fits
no guidelines or it may be too early
 to know its future significance.

donation came after her death on January 11, 1998. Her donations included family objects, 19th-century business records and letters in Italian.[6] Interestingly, it was the seemingly mundane or recent material that presented the most curatorial discussion. Miss Bossi had no children of her own, just her students. She did not want them spending too much on presents or competing for her attention so for Christmas they were encouraged to select a small inexpensive embroidered handkerchief, in a department store gift box. She kept and treasured every one, never used, providing us with a wonderful personal part of her teaching life and her family of association—her students. When the school year ended she and Olga took vacations, inspired by a trip to Italy with their mother, and documented their travels in a collection of slides of exotic locales such as Hawaii and California. These non British Columbia slides sparked intense curatorial debate, but they do provide a glimpse of two sisters travelling abroad in the 1950s and 1960s. Sometimes you find something that fits no guidelines or it may be too early to know its future significance. The curatorial decision here: trust your instincts. We kept them.

A few European families have even longer relationships with the museum than the Bossis.

Some span parts of three centuries, such as those of the Helmcken and Douglas families. John Sebastian Helmcken was a fur-trade physician who married Cecilia, daughter of Sir James Douglas. He entered colonial politics and negotiated British Columbia's entry into Confederation in 1871. His father-in-law rose through the Hudson's Bay Company to become the second governor of Vancouver Island and first governor of the mainland colony of British Columbia. Both men married Metis women; Lady Amelia Douglas's mother was Suzanne Pas-de-Nom, a Cree woman born in northern Manitoba. Suzanne married William Connolly in 1803 and it was the court case over his estate that established the rights of Metis fur-trade children in Canada.[7] In 1921, Dr. Helmcken's daughter Dolly chose to self-identify with her mother and grandmother's ethnic heritage, proudly describing herself as "Indian" to the census taker. These are our founding families.

Their family collections in the BC Archives include early fur trade papers and some of British Columbia's oldest family photographs. The museum's history collection includes items from Dr. Helmcken's time in medical school in London in the 1840s, the couple's 1852 wedding presents, Cree embroidery and even the original family home—still in its original location beside

our museum.[8] Another part of our museum stands on the same ground where the Douglas home stood a century ago.[9] As caretakers of these material histories, we have connections with the descendants of these families that continue today. Even our oldest family collections are not static—they continue to grow. Since 1965 there have been nine more Helmcken family donations and nineteen relating to the Douglas family. These relationships, like the collection, have lives of their own, and we continue to learn from them.

Sometimes the definition of a family can include something inanimate. My favourite example happened when I was contacted by a woman who announced firmly that she was over 100 years old and said: "I won't live forever, and it is time I found a home for Theodore." Eleanor Stewart arrived escorted by a caregiver and introduced me to Theodore, a very rare and valuable Steiff teddy bear. Steiff of Germany invented the teddy bear and collectors seek them out, using the brass emblem in a bear's ear to establish its age.

But the real value of Theodore was in the donor's close relationship with him.

Eleanor's father worked for CP Railway in Kamloops and they lived in a small house near the tracks. When she was five or six she contracted tuberculosis of the hip and the doctor ordered total bed rest. To get fresh air she was carried out to the porch. Her mother's sister, Annie Parker, bought her a gift —one of the first Steiff bears to arrive in British Columbia. In addition to Theodore himself, Eleanor brought photographs of her 100th birthday party at the Empress Hotel with Theodore and one of herself as a little girl with her bear.[10]

Her memory of her age when the photo was taken and the date on the button in Theodore's ear disagree by a few years, but that is the nature of memory. Or perhaps factory production records are not as accurate as invested collectors insist. Eleanor is gone now but Theodore remains a central character in a beautifully documented story of family love,

Sally Pankratz discusses the pattern for a garment she made. Lorne Hammond photograph.

relationships and childhood. The collector value is somewhat unimportant.

Sometimes when working with everyday families you discover a world you did not expect to find. Sally Pankratz's parents and aunt were English immigrants. Both mother and aunt loved sewing and fashion so sewing became a sensible economic strategy when the sudden death of Sally's father left them to raise the young children on their own. Sally learned to sew from her mother then later met her husband in an athletics program and went on to become a high school teacher, teaching history. She contacted me about the family textile collection. [11]

I brought a camera and a digital recorder to help with documentation and sat on the sofa filling out collection receipts as she produced patterns, fabric swatches and finished clothes, recounting the when and why of each garment. She spoke about how she tried to reach the level of expertise of her mother who could look at the latest Vogue or McCall's pattern then glance

at a fabric and say whether a combination would or would not work. As we went along I began to realize that there was something beyond fashion in this family story. It was about global economic change: not just new types of fabrics but inexpensive imports, malls replacing department stores and the disappearance of fabric and pattern departments. It was about mothers and daughters, about passing skills between generations of women. It was about the disappearing culture of making clothes for your family.

I asked about sewing tools and her Mason sewing machine, which led to an interview with an elderly neighbour who dropped by. [12] Mr. Mason arrived in Vancouver after the Second World War, looking for a small mechanical business. He found the Singer sewing machine franchise was, pardon the pun, all sewed up. But he did learn that Japanese sewing machine factories were anxious to find overseas markets during the Korean War. He went over and signed an agreement to have machines delivered, branded with his family name,

and so began a multi-generational family business. He sold them to immigrant women on easy monthly payments in the low rent neighbourhoods at the end of Vancouver's tramlines. Mason's hired women to teach other women how to sew as each machine came with free basic lessons. From a simple task such as making clothes with a sewing machine, a window onto the lives of many families had opened.

Some immigrants come to British Columbia for what they see as a greater purpose. Some come to establish utopian or religious communities. Early in my career I worked with members of the Doukhobor community, a diverse group of Russian-speaking pacifist immigrants. They sought religious freedom through toil and a peaceful life, living each day communally with respect for the presence of God within them and in the world around them. Materialism and private property were considered temptations placed before them. Beliefs, along with the practise of cleansing the earth of materialism with fire (by burning a house, for example), or facing evil—including the state—with the only thing you truly own, your naked body, were practises that put them in conflict with the state. They came to Canada with the help of Leo Tolstoy and the Quakers, first to

Sally's Mason sewing machine. 2012.121.297a.

what became Saskatchewan. When the newly created province asked for oaths and the individual registration of property, many left for British Columbia, living on communally owned lands around Grand Forks and Castlegar.

In the 1950s the presence of communalist Russian speakers became a cold war political question.[13] A deeply divided community founded on peaceful toil became torn apart by external pressures and internal conflicts. Some abandoned their heritage and anglicized their names. Others sold their traditional cultural objects to antique dealers collecting primitive folk art. In the 1960s and 1970s some of their simple communal furniture, such as rough tables and kitchen cabinets, ended up painted bright pastel colours and used to display expensive sweaters in fashionable Manhattan.

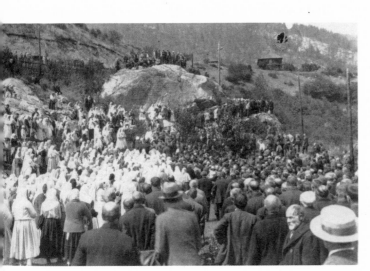

Gathering of Doukhobors, Brilliant, BC, ca. 1935. C-01405.

Life on the street is also part of British Columbia's story.

I worked with Peter and Liz Fillipoff, an older couple raised in the communal way of life who left the bankrupt communal lands in the 1950s and bought their own farm at Winlaw. Here even the act of planting a garden to feed your own family outside of the community became a political act and caused them and their children to be shunned by those they had grown up with. Their family collection shows a family moving between both ways of living.[14]

There are also families of association, without the biological bonds of traditional families. I worked with one such group, a loose association of homeless people in an illegal protest camp. In 2016 the lack of housing for street people had reached a crisis in our province's capital and Tent City sprang up on a provincially owned park beside the Victoria Courthouse.[15] At any given time about 120 people lived there in small four-person tents set on pallets, walled with plastic fabric and banners in a density that alarmed health and fire officials. Concerned neighbours grew angry at the presence of crime, drugs, rats and garbage in their formerly sedate neighbourhood. At first the nearby cathedral supported the protest for "homes not jails" but they too grew concerned over the safety of the children at the cathedral's school. The situation accelerated—all of the worst conditions of

street poverty became condensed and visible in one location. It tore the neighbourhood apart.

But something else happened. Supported by poverty activists, Tent City residents formed an association to control the increasingly diverse and chaotic situation. They became a family of association—living together, sharing and helping each other with their problems. Life on the street is also part of British Columbia's story.

As the injunction to close Tent City came down, we considered this newly visible definition of family as part of the continuing evolution of BC families. I did not want to be another 'poverty tourist' so I talked with poverty activists and sought out advice, making it clear to everyone that I would do nothing without the consent of the residents. The situation was complex. Every stakeholder had a perceived agenda, including me. Everyone was on edge.

Less than 48 hours from the court ordered shutdown I was escorted into the camp. The hazmat crew was emptying the tents of those who had already left, hosing them down and shovelling needles into disposal containers. Some residents wanted nothing to do with me but as they talked I listened. Their attitude softened. One resident, who had created all the slogans on the banners that hung around the camp, offered some of her

Tent city residents,
August 6, 2016. No
names, by request.

Lorne Hammond photograph.

Families hold the meaning
of the objects in our collection.

work to me. It was her way of communicating with the world about their difficult lives. The residents selected small things to represent their community and agreed to a few photographs.

As in other more traditional collecting events, I found strong emotions here. I asked about a memorial made for a young man who had died of a fentanyl overdose on Boxing Day. "What would become of it?" I asked. "Probably be tossed in a dumpster," was the answer. One said he felt guilty that he knew so little about this young man whose death had shaken them all. They helped me take the memorial.

I intended to keep a low profile, but I did not expect the act of collecting would evoke such a strong public and media response. A reporter asked me to confirm if the museum was collecting in Tent City. I answered and went back to work. Wednesday my answer was a front page story, quickly followed by radio interviews and call-in programs and angry and positive emails from the public. A museum's collection and action needs to reflect the society it serves, the good and the bad. Our past is imperfect, as is the world in which we live.

Thinking back on Tent City, perhaps collecting helped the residents cope with the pressure of its final days. If it did, it was unplanned. They had achieved something together, built trust in each other, lived and faced problems together and taken back control of their own lives. Like any other family they trust our museum to preserve their story.

A few days later I was driving down the street and I looked over. On the sidewalk I saw Dennis, a Tent City resident, with a woman I did not recognize. They had a flat cart and on it they were pushing her possessions, including a 1950s blue chair. Perched on the cushion was her small dog, staring forward. They were laughing. That is my fondest memory of Tent City.

The relationship between families and curators is just that, a relationship. Each is different but all require trust, listening and understanding. When all is said and done, a good collection reflects that understanding. Families hold the meaning of the objects in our collection. They are the context for our collections. The objects are simply symbols of our work together.

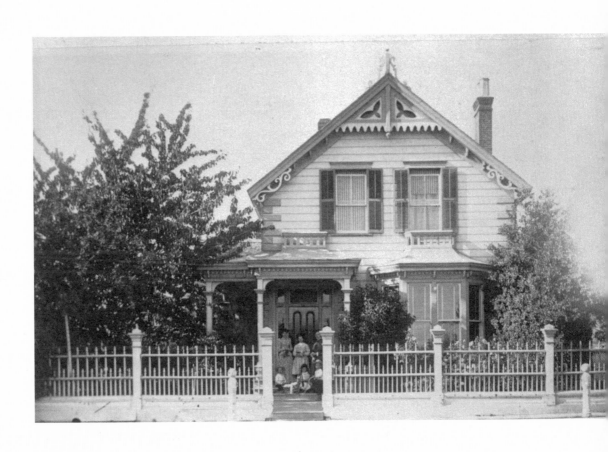

The J.H. Todd
residence at 196
Johnson Street,
Victoria, *ca.* 1890.
D-00092.

On belonging to the forest,

Zoé Duhaime

the watchmaker's coast

On belonging to the forest,
on the forest not belonging to me,
on the forest having many names:
The lungs of BC have generously and welcomely started to breathe for me
like a well-raced horse. I am from the land but not of the land. I have arrived. I have grown. I
have been the oldest apple tree. I have been a column of imported oaks. I have been the spider
between them. I have been looking for autochthonous names. My name sounds an awful lot like
the first earthquake I recall. I am not certain, but I suspect that means that there is a sense of
readjustment between myself and the land. I have been recognized as a river god with a Catholic
father. It is only the quail that has noticed. The quail was released. The quail is not from here.
I make the sound "quail" if kicked in the stomach, but it is mostly breath.
In the forest, there is a tree of hand mirrors
for people like me to approach
so that we might see ourselves in the land.

If there were a watchmaker
and if the watchmaker were perfect
and the watchmaker curious
about what would happen if she left a coast in the sun and rain
and then introduced people capable of euphoria *and* ennui
she would have left her watch here, in the Salish sea.

(it is that beautiful)

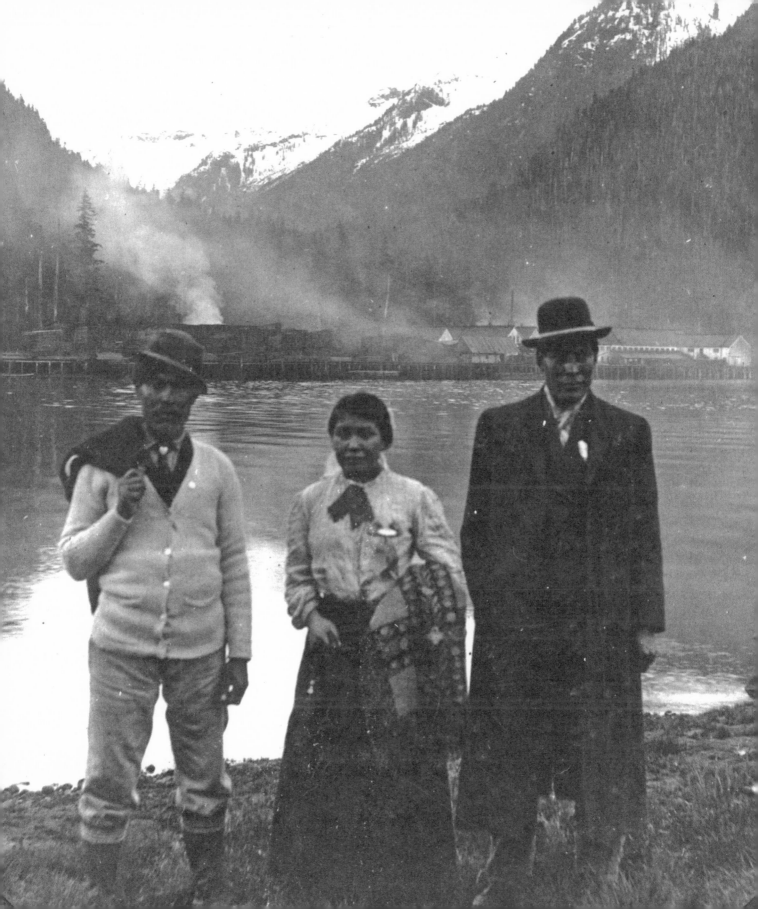

Joy Kogawa looks out
from her bedroom window
on April 24, 2008, at the
cherry tree she played in
as a child. John Lehmann/
Globe and Mail photograph.

Joy Kogawa

a moment by a cherry tree

MY DEEPEST SENSE OF BELONGING AND CONNECTION
is not with my biological family, or with the people of
my ethnicity, country, communities or friends. It comes,
rather, during an overwhelming 'I-know-not-what',
an utter belongingness that arises unbidden from time
to time.

One such moment happened in the fall of 2003.
I had come across my childhood home in Marpole in
Vancouver, British Columbia. I will quote here from
my memoir, *Gently to Nagasaki*.

*2003 was a year of drought. The air was dry. The house too
looked parched. The sidewalk led past the sunroom's wrap-
around windows to the backyard and the high back porch, now
wider than before. The door to the playroom was exactly where
it had always been, just steps from the garage where the sawdust
for our furnace had been kept. I was enthralled.*

*As I stood taking in the backyard, I noticed an old tree
by the high back fence, its thick branches lush with leaves. A
sudden inexplicable attraction between people, an eye-glancing
spark of recognition, is called love at first sight. Something like
that is what I felt towards that gnarled tree. Later, in my diary,
I described it as "the incredible tree…the weeping tree, its rust-
coloured sap and its new transparent sap congealing, its open
wounds, its scarred bark flayed." A cross-shaped trestle held up
a heavy branch that reached out and hung over the roof of the
garage. Thick gauze bandages tied with blue twine were wrapped
around the tree's worst wounds. Someone had cared for it.*

*A few days later I returned to visit the tree. What
happened then is something I will not forget. I put my right
hand on the rough bark of the trunk and looked up. A
sensation, not as strong as a jolt but distinctly warm, coursed
through my right arm, and I was suffused with awe. What
struck me at that instant was the sense of the Presence. That
is, it's not that I was known in the way people know each*

A cherry tree planted
by Sir James Douglas.
D-07023.

know that all is known and that love underlies everything

*other, nor was it that the tree knew anything, but Knowing
was somehow there and being made manifest. The life of which
I was a part, my family's life, my community's life, everything
that was done to any of us or by any of us—everything—all the
good, all the evil, all the shame, all the secrets, all the kindness,
all the sorrow, all all all was fully known. A tide within me
surged forth and I acknowledged the Knowing as the Presence
of Love.*

*There's a song that goes, "Take, take, take off your shoes,
you're standing on holy ground." In the surround of the tree,
as at a burning bush in an ancient time, a Voice had
acknowledged that our sorrows were known.*

*The moment by the tree, the warmth down my arm, was
not to be repeated. My sureness, however, of a knowing Presence
did not diminish. To be known fully was to be loved fully.*

The power and the rapture of such moments remain
inextinguishable in my life. And I know that all is
known and that love underlies everything.

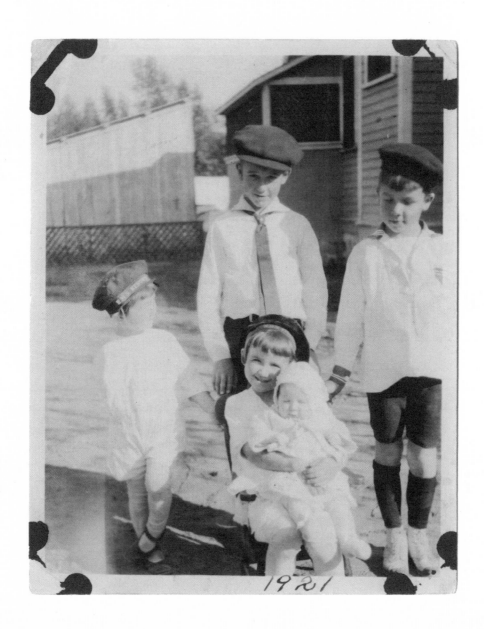

1921

Lawrence and Gertrude
Guichon's children:
Charles, Gerard,
Urban, Ruth and baby
Marcelle, 1921. J-01167.

Judith I. Guichon

stewards of the land
through many generations

How our definition of family has changed
in just my lifetime.

GROWING UP IN EASTERN CANADA, the youngest of six in a middle-class Montreal family, meant going to the big church up the street and Christmas dinner with siblings and cousins. That changed when my folks bought a farm to retire to and Christmas now included in-laws and grandbabies. Being the youngest I was always seated at the children's table, which left nieces and nephews somewhat confused. That wonderful intergenerational carryover of family values became somewhat a thing of the past with family planning, which is, I believe, a loss to sustaining family connections.

After driving from Montreal to Whitehorse, Yukon, with two friends as a way to experience Canada, we all settled in Whitehorse. Family there included everyone from anywhere who didn't leave

for the holidays. While there I met and married Laurie Guichon, a commercial pilot who had grown up on a ranch in the interior of British Columbia. As the oldest of eight children it was always assumed by his dad that Laurie had the right of first refusal to become the rancher in that family. Gerard believed only one son could run the operation as previous generations had gone through much tribulation with large families on the land.

The first generation of Guichons in Canada had travelled here in search of gold and adventure. In 1878 Joseph Guichon moved to the south end of Mamit Lake where his brothers Laurent and Pierre had pre-empted adjoining lots, keeping the family all close by. That same year Joseph married Josephine Rey, the youngest daughter of a newly emigrated family from Savoie,

France, while Laurent married her sister Peronne Rey, strengthening family ties even further.

Joseph's first child Lawrence was born in Keating, and the trip back to Mamit Lake with the baby involved travelling by steamboat, stagecoach and saddle horse. Joseph and Laurent sold the Mamit Lake property in 1879 and moved their families east to Chapperon Lake, where they developed a ranch and built up a herd of some 1,400 head of cattle and a substantial number of horses. Change came again in 1882 when the two brothers split: Laurent moved to New Westminster and later settled at Port Guichon, where his descendants continue to be involved in agriculture. Joseph and Josephine moved down to what is known as the home ranch on the Nicola River.

Joseph started over with only a herd of horses and a registered Clydesdale stallion named Charlie, but over the next 20 years he built up his land holdings. The family grew, and in 1894 he brought the first registered Hereford cattle to the Nicola Valley, all the way from Quebec. One of these heifers—Francis—gave birth to a bull calf that became the first registered Hereford sire in British Columbia—Nicola. Joseph expanded. He bought a stopping place on the wagon road that was replaced in 1908 by the Quilchena Hotel, still operating today.

Joseph transferred title to all his property to the next generation, including some 30,000 deeded acres, and in 1933 it was incorporated as The Guichon Ranch Limited. From 1918 the ranch was managed by Lawrence Guichon, oldest son of Joseph and Josephine, while two other sons, Johnny and Joseph, managed the cattle, the store and the hotel until once again, in 1947, there were changes to the share structure. The operation was reincorporated

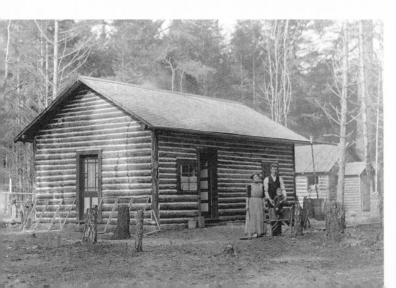

as the Guichon Cattle Company and Gerard Guichon, one of the six children of Lawrence Guichon and Edna 'Gertrude' Bilodeau, took over as manager.

Lawrence was a long time justice of the peace. He had received very little formal education but was awarded an honorary doctorate of science degree by the University of British Columbia, in recognition of his many contributions to the cattle industry. Gertrude, meanwhile, managed their growing family and grieved mightily as children were sent to distant schools to be educated. Family was important to Lawrence, and although he had a large family of his own he looked out for his siblings and tried to keep both generations happy. Things were not always easy though, and family tensions arose as members required greater opportunities. These were large Catholic families, and the incomes of family living away from the ranch were supplemented by the ranch, which placed hardships on the producing partners.

In 1957 the Guichon Cattle Company again faced major restructuring as family members made demands. The assets of the ranch were now sold to two cousins: Guy Rose, son of Virginia Guichon (a sister of Lawrence) and Matt Rose, and Gerard Guichon. Once again there was much tension and a painful separation as Gerard and his wife Ruth relocated their very large family, including Gerard's father and six of their eight children, to the northern portion of the property—the Beaver Ranch. They moved into the only house on the ranch and, as his grandparents had done before him, they started over with a few head of cattle and the ranch's flock of sheep.

Gerard quickly built a bunkhouse to accommodate large crews and a new home for Lawrence; Ruth cooked for them all. Things were very tough but the family grew and Gerard went on to be a leader in the ranching industry, later receiving the Order of Canada for his work on introducing the intergenerational rollover

To outsiders it may appear that farming families own great fortunes—but the wealth is the land.

clause for families in agriculture. This important piece of federal tax legislation allows one generation to purchase from the previous generation without triggering capital gains tax thereby allowing property to remain within the family.

By the time the family moved to the new location at the Beaver Ranch, my husband Laurie, then 13, and his 12-year-old sister Rae were already working alongside their parents. They had vivid memories of the difficult times and the hard work it took to rebuild. But rebuild they did, and Gerard and Ruth went on to raise and educate all eight children and build the ranch into a productive unit once again. By the time Laurie and I returned to the ranch in January 1972 it was a 700-cow unit and the family had a new home, completed in 1962. We moved into the old cookhouse and now I, like my mother-in-law before me, became the cook for the ranch crew.

Laurie and I adopted four amazing children and became involved in holistic land management, a philosophy that led us to become a grazing operation that no longer turned the soil over with a plough. In 1979 we began to purchase the ranch. In 1999 we lost Laurie to an accident. My children and I carried on although, once again, not without family disruption. And there are those family members with whom we

are not involved today. My two oldest children, Allison and Michael, are on the ranch and learning to manage, hopefully without interference from me.

This is only part of the chronology of the Guichons in the Nicola Valley. These strong resourceful men and women started out with only the land and developed herds of cattle and horses through trade with their First Nations neighbours and with Americans south of the border. They survived fierce winters, challenges getting cattle to market, grasshoppers and droughts from which they learned to put up winter forage and store water from the spring runoff, amongst other lessons. The first dams were built at the headwaters of the creeks, creating many of the fishing lakes enjoyed in the interior today, and the '30s brought the return of the rains and snow. But then the markets crashed. Fat steers brought only three to four cents per pound.

To outsiders it may appear that farming families own great fortunes—but the wealth is the land. Very narrow margins mean families often survive on slim pickings and, as their living must come from the land, retirement for older generations has traditionally been difficult. Several generations have had disruptions, family disputes and pain. But these men and women were first and foremost stewards of the land, and this

John and Alex Pringle.
B-08286.

is where they raised their families, through good years and bad. Respect for and intimate knowledge of the land was handed down within the family, generation to generation. No text contains that primal understanding.

But there were costs. For many generations children were sent away to school. In wartime, some enlisted. But always someone had to be in charge of the land and this led to family altercations and separations that went generations without healing.

Today the pressures have changed. We still experience droughts, weeds and grasshoppers. Markets go up and down. Families expand and contract. We have fewer children on the ranch with each generation. There are presently only two little girls at home in the sixth generation. It is very hard to envision what the decade ahead will bring in the way of climate change, invasive species and changing water cycles.

New highways bring urbanization closer and our actions on the land are continually under scrutiny.

Now we are subject to the criticism of family *and* of those who believe they are experts, but perhaps know only part of the story. We hear about the role of trees in sequestering carbon but grasslands also provide hope for sequestration. Cows are the tool we use to harvest sunshine stored in that grass, converting it to a healthy protein product for burgeoning populations. Through this process we build healthy soils to sustain healthy communities and all the various family units that form today's society.

Throughout the generations in the Nicola Valley we have had an ongoing relationship with our First Nations neighbours. In the early days all children in the valley were sent away to school—there was no local choice. But then Gerard purchased a school bus in the early 1950s and a school was opened at Douglas Lake where both the ranch and the reserve students flourished for some years. We have purchased hay from our reserve neighbours for generations and First Nations cowboys make up many of

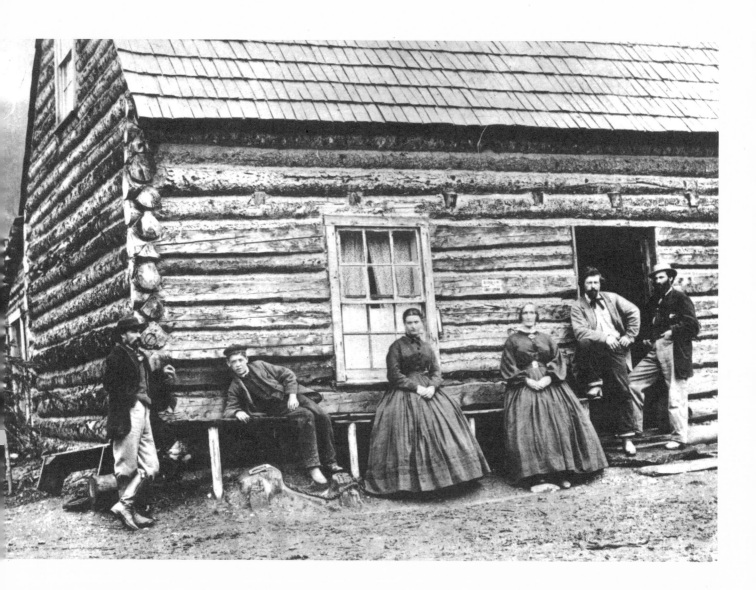

The Hamilton family at their ranch on Lightning
Creek in the Cariboo. *Left to right*: John Hamilton Jr.,
daughter Elizabeth Muir, Mrs. John Hamilton
and John Hamilton Sr. Frederick Dally photograph. A-02194.

Mrs. Ken Burley and
her sister, *ca.* 1910.
D-00957.

the top crews on the ranches in the area. And while the early '90s brought some tension to the area, the man who was chief at that time is now our top cowboy.

French families came to Canada looking for opportunity. Many came for the excitement of the gold rush. Some persevered and formed an attachment to the land where their families prospered. Communities have changed with succeeding waves of immigration and new technology now brings untold advances. But the basis of our communities and the foundation for all families is still healthy land.

My own family of origin is now scattered from Vancouver Island to Halifax, with six siblings still alive and many more in the next cohort. Families have evolved and include folks of every creed and persuasion. On the ranch, our annual family Christmas dinner now includes my new husband who hails from Quebec, my four adopted children, an Australian daughter-in-law, one Metis granddaughter, one adopted First Nations granddaughter and my little part-Maritimer grandbaby, our crew—both Indigenous and non-Indigenous—as well as close neighbours.

We may appear very different but our love of the land unites us. We hope to continue learning how to better manage the land for the future families, of all descriptions, who will succeed us.

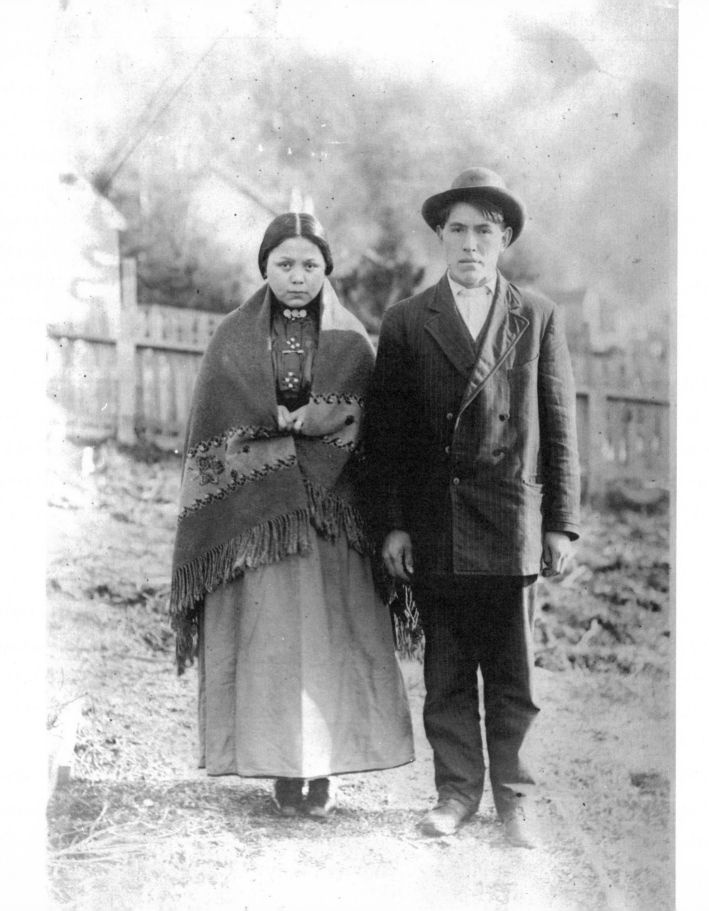

a quiet connection

To an Indigenous person, family is more than
their immediate family or even their distant
cousins. Being born into an Indigenous nation
means that if you are related, no matter how
far removed, you are simply family—which
can be a bit overwhelming.

FIRST COUSINS ARE CONSIDERED BROTHER AND
SISTER, most of the older ladies in the community are
called 'aunties' and the men are 'uncles'. Indigenous
youth, once they realize how many relatives they
have, have a difficult time keeping track of all their
connections into the different Indigenous nations.

It was forbidden to marry blood relatives. That
is why many Indigenous tribes had clan systems to
prevent inbreeding and, in days gone by, they would
raid other tribes for young women to get new blood

in their lineage. Some tribes sent their surplus young
men away with all the supplies they needed to find and
marry someone outside the tribe. They were not banned
from their tribe but were simply extending the family
relations to another tribe.

Today, if you ask an Indigenous person where they
are from, almost always they will name their home
community or the tribe they are from. Even if a person
has lived in Vancouver for thirty years they will identify
with their territory—even if it is in Nunavut or on the

Facing page: Rachel and Edward Whonnock,
Alert Bay, 1910s. F-04167.

Families at Fort
Grahame. F-00332.

We speak the same 'language' because we have similar values

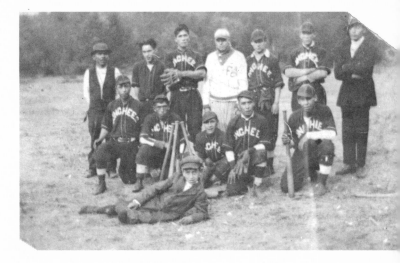

Songhees Baseball team, 1918. *Back row, left to right*: Jimmy Fraser, unknown man, Elliott Williams and Percy Ross in white. *Kneeling*: Sammy Joseph beside Fraser Joseph holding a bat. *In front*: Art Albany. PN 23059.

east coast of Canada—and not where they happen to be living at that particular time. They will identify their tribe and if they know the clan within that tribe will identify that as well. That is their immediate family. The family they find in places other than their traditional territory is their Indigenous family.

In 2016 I was at a Pacific National Exhibition (PNE) concert along with a few thousand other people who were enjoying the music of A Tribe Called Red, an Indigenous group. The place was packed with Indigenous people from all across Canada so when one of the band members hollered out during the concert, "If you're my cousin, raise your hand!" the many Indigenous people in the audience sent a collective yell back and raised their hands. I am sure this surprised a few non-Indigenous people who were there to enjoy the show. Of course not every Indigenous person in the audience was their blood cousin but we like to think we are all related in some way. The thought is that if you look closely enough you will find someone that you are both related to so that makes you cousins.

To an Indigenous person, family can reach across countries and continents. When I was in Lima, Peru, in 2013 and Honduras in 2016, I connected with the Indigenous people there in a way that was very familiar

to me. We understood each other, regardless of whether the words were in Spanish or English. We speak the same 'language' because we have similar values that are closely connected to the land and because we share a common history of colonization. It is similar to the thousands of Indigenous peoples who have gone to residential schools and are able to talk amongst themselves about the schools. We don't have to explain to each other all the painful emotions resulting from our time there—we all know the pain we carried and we know the reasons why. The situation is the same for Indigenous peoples who share a very painful history.

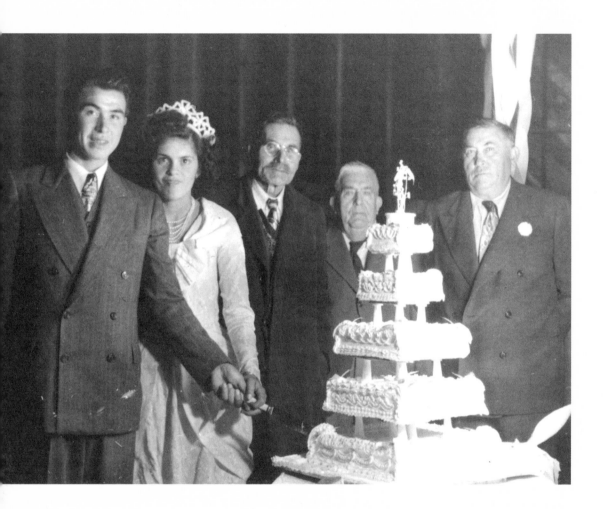

When I was in Lima and later Honduras I was referred to as a 'sister'. Even people in Australia and New Zealand have a connection to the Indigenous people in the Americas, and those connections are strengthening with the ease of travel. Our cultures are very similar and our common history is one that we understand. These are the family ties that bind us, no matter where we are.

When I recognize an Indigenous person from anywhere, even if we are just passing each other on the street, words are unnecessary. A smile, a nod; even just locking eyes in acknowledgment is sufficient. This quiet connection makes you feel good in knowing that, for that brief moment, your family is with you. For an Indigenous person, family extends further than the conventional definition. While all Indigenous cultures are unique and different we feel more comfortable in the presence of other Indigenous people. Families are like that.

Facing page:

A wedding in Alert Bay. E-07345.

Below:

Nuxalk people in front of Chief Clellamin's house at Bella Coola, 1894. D-04111.

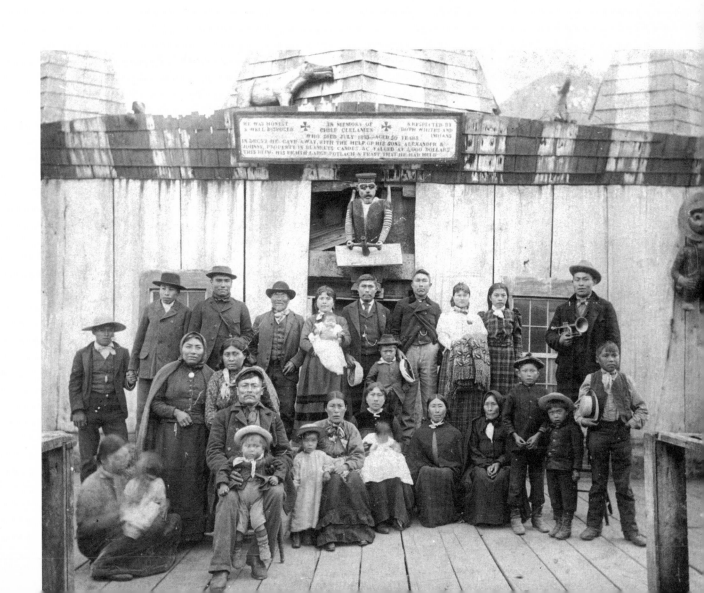

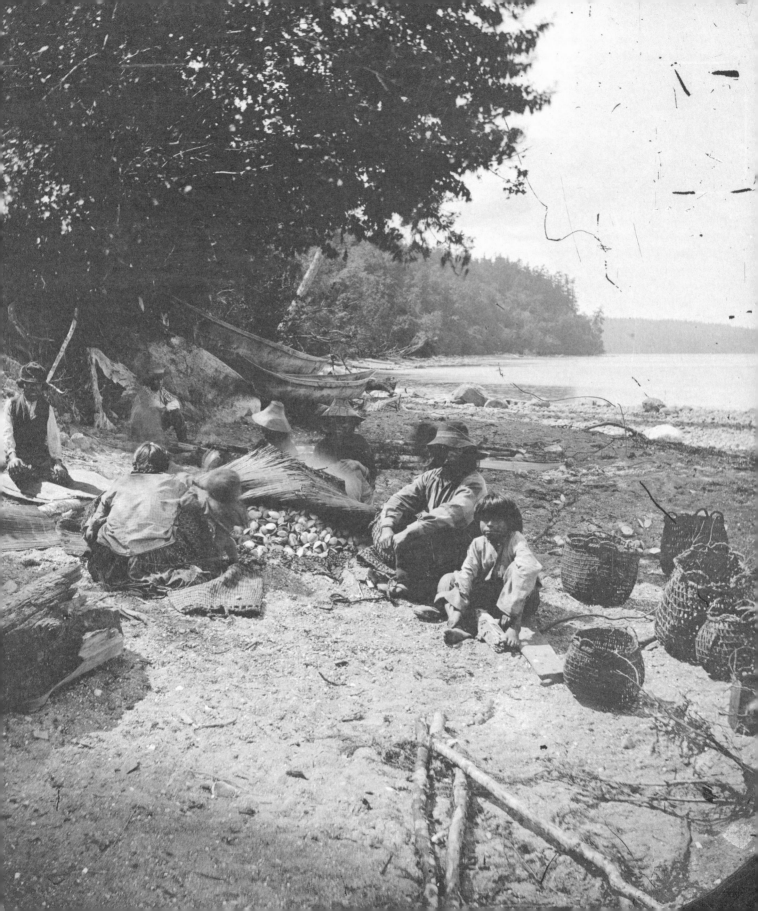

Shushma Datt

a sense of belonging

My family has lived as immigrants on three
continents. My parents, my siblings and I
have lived on four continents. My birthplace
is Africa.

WHEN WE LEFT AFRICA, WE WENT TO INDIA. We are of Indian decent so we should fit in okay there, thought my parents. But we failed miserably. We then moved to Europe and tried to 'mingle' with the British. It was not our 'cup of tea'. Our final resting place is Canada. I think I feel at home here. I wonder why?

When we leave our homeland to emigrate to another country, what do we think about? Do we really understand what we will leave behind? Are we really ready to leave everything that has been so close to our heart, leave it behind and go to a foreign land?

I think that most of us have this adventurous streak in us that pushes us to leave everything behind and set out to face new challenges in a new country with new customs. We leave behind our friends, our favourite places, our favourite fruits and that other thing we all leave behind without realizing—our sense of belonging.

In the initial years of our immigration some of us feel that we don't belong to the country we have left behind and we don't belong to the country we have adopted.

That feeling of uncertainty is pushed back by the demands of a new work place and environment. When we are young nothing in the world matters to us, just the closeness of our family. A new immigrant works very hard to achieve a decent life for their family, working over 12 hours a day so that their children who are born in this new country can have everything their hearts desire.

Facing page: Clam bake at Gordon Head, 1880s. Maynard photograph. J-00093.

The most important thing for a family at this junction is the feeling of belonging. We all have this very strong desire to belong: belong to someone, something or some place.

Because of my work, I felt I belonged in England. There, I had a satisfying job as a studio manager and, here in Canada, I needed three jobs to survive. The memory of time spent in England always felt happier. When my son was ten years old I felt I should take him to England to see if he would like it over there, and then I could move into my old position at the BBC.

It came as a shock that the England I had left behind was no longer there. The people were different, the feel of the place was different—it was not like it was in the '70s. The young people in the underground train seemed very rambunctious and rude, with safety pins in their ears. I looked at my ten-year-old son and thought, "I don't want him to be here." Leaving the calm and serene atmosphere of my adopted country—his birthplace—and dragging him into an unknown world would be unfair. That night I lay awake in the hotel and thought about Vancouver. What is it that I love about it and would want to go back to? It is the people—our neighbours, my co-workers, my son's school, his grade three teacher who had become a good friend of mine—my own house, the mountains, the Fraser River. Everything. I missed it all.

I came back to Vancouver, and I knew I was home.

Hélène Cyr photograph.

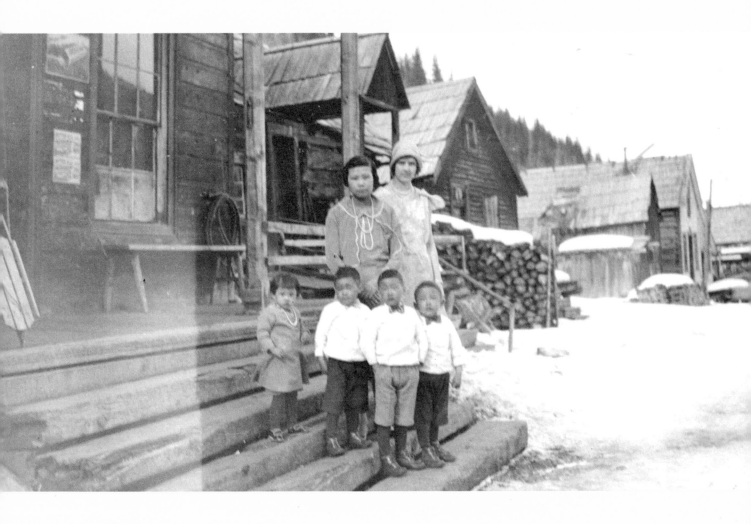

The Hong family,
Barkerville, *ca.* 1910s.
C-09725.

But first you must belong to each other, as in our house where three generations lived in harmony. Then you must belong to the community you live in and, finally,

Looking back, I can see how our family has evolved through migration. My mother was born in Nairobi and so was I, but my son was born here—in Canada. Canada is welcoming. It is a land of immigrants. It is like a canvas, waiting for us to draw our home and let our family tree root itself here. It is vast; it is open and it is engaging. Was it like that 150 years ago? No, but it is slowly becoming one of the best places in the world to 'belong' to.

But first you must belong to each other, as in our house where three generations lived in harmony. Then you must belong to the community you live in and, finally, true belonging happens when you become a citizen of the amazing country you now call home and take an oath to protect it.

We are *all* proud Canadians.

Monique Gray Smith

the voices of our ancestors

Those voices, you know them...
They dance in the mist
They come when the morning sun lights up the land
They sparkle in the snow
They leave goosebumps on your skin.
Those voices ... the first cry of a child as they announce their entrance into the world
They come from the kraa of a Raven, inviting you to transform, transform, and transform again.
They come like a warm chinook, blanketing us in our darkest hours
They run deep in our blood, connecting us to generations who were here long before us.
Those voices ... they encourage us to use *our* voice, even when we are afraid and our body trembles.
Those voices ... they remind us we have a responsibility to hold each other up with kindness, love, and respect.
Those voices, you know them, they are your Ancestors.
Are you listening?

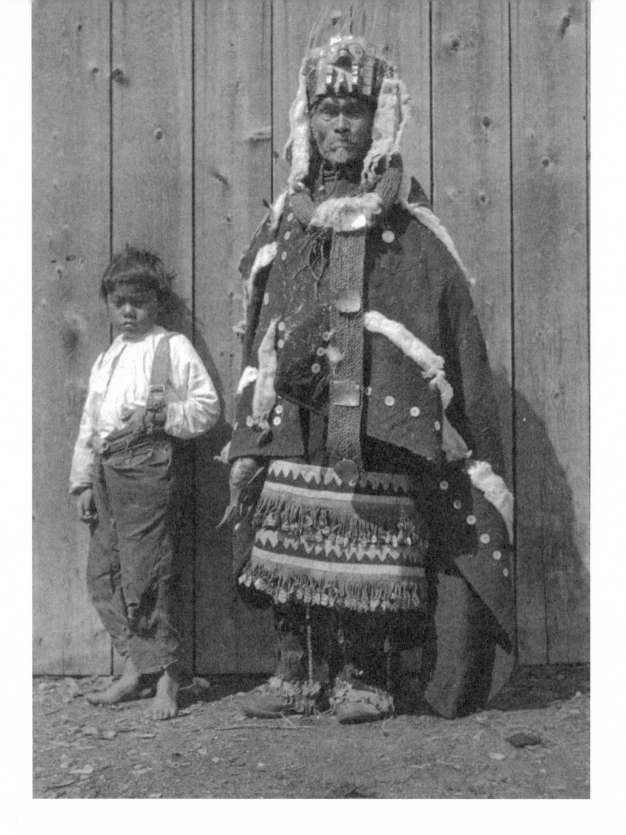

Kitwancool chief and son, 1910. A-06912.

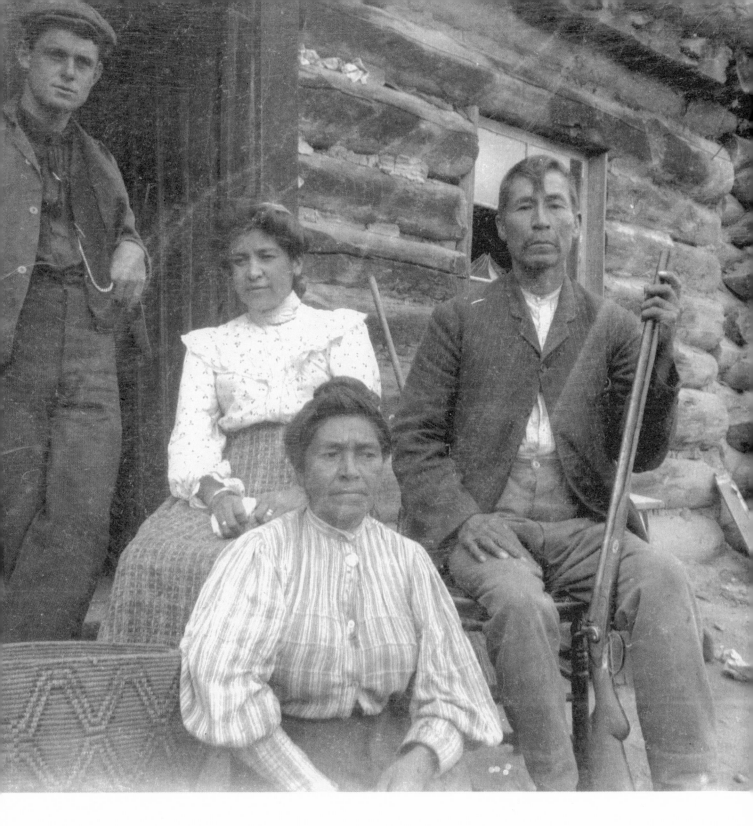

John Tetlanetza and family of Lillooet, 1907. Frank Swannell photograph. I-33130.

Mr. Henry Emanuel
Levy and his wife Eva,
née Rostein, 1882.

A-07727.

Lynn Greenhough

a story of being odd and finding one's bashert

WHILE DISCUSSING WHAT WE SHOULD REVEAL (with the attendant implication of what not to reveal) in this piece, my husband Aaron quietly remarked, "You are the weird one in this relationship." Many people, knowing his journey, might think this an odd comment to make, especially about his beloved —me! That said, it is perhaps more apropos than I initially allowed.

In many ways, those of us who stay in marriages for decades *are* weird. We are odd. We all have our reasons for staying with our partners, some spoken, some unspoken. We are known in the world by our social personas, and those personas may line up with how we know ourselves—but not always. With this as background I will acknowledge a resistance to trying to write about our family because really, who are we?

Recently I was typing up my 92-year-old father's memoirs about his service in Sicily and Italy during World War II, and about his life growing up as a boy in Vancouver, on Bowen Island and on Galiano Island. It has been a delight to type up excerpts from his life, those snapshots of memory he wants to share with us. We all hold these snapshots in our own memories. But what about the memories we don't share? How do we want to be remembered, known?

I love Elizabeth Barrett Browning and consider her and Mary Webb two of English literature's finest writers. But beyond the "How do I love thee? Let me count the ways…" E.B.B. is barely recognized. She has had one famous verse memorialized in Hallmark cards and yet her entire oeuvre is otherwise ignored, unknown, seemingly petrified on paper.

Words allow all of us
to encase our remembering.

Both Browning and Webb brought their passions to their pens and were feminist before the word was much in use, never mind sullied. They were both brilliant and minutely observant and both were beloved writers in their day. Part of my weirdness is that I love these writers—and many more. I live to read. My breath is so linked to word that I cannot imagine my life without books. I bought three books with my very first paycheque. I am a little obsessed. I love Fackenheim, Akenson and Bloom. I love writers who startle me with their sense of humour as they write in erudite sentences about seemingly dull, dull, dull subjects.

Words allow all of us to encase our remembering. (I particularly love finding typos and my most memorable to date was in a book about the development of Christianity after Jesus, where Christians were offered immorality. Yes, not immortality.) I read obituaries every day. I read fiction, non-fiction, newspapers ... I love to study, and learn, and fall into books. Books saved me as I was growing up in the small farming community of Happy Valley, only a few miles west of Victoria. I was growing up on a farm, in a very small house, and could only dream about life beyond—dream and imagine the New Yorker I would marry one day.

And I did. My guy is literally a New Yorker. Would I have married him if he were from Chicago? Hmmm. Not sure. Aaron took me to New York, to Long Island, to Brooklyn, to Barney Greengrass Deli on Amsterdam and 86th and to Zabar's, and always to the Met. He took me to the Roslyn Museum and to visit his best friend from grade one who lived out on Long Island Sound. He took me to Penn Station and drove me through Midtown at rush hour. He gave me reason to love the city, as I knew I would.

After his mother Janet died, Aaron and I fell together into a bed of dry autumn leaves in a Great Neck ravine. When the *frum* black hat guy next door came over to pay a condolence call and offer a daily *minyan*, we challenged him by asking for women to be counted in that *minyan*—he declined. So we held *shiva* our way, which meant one of Janet's friends offering us a bag of potatoes and a package of frozen fish. It was all very odd as we were, by then, accustomed to the *haimishness* of the Victoria Jewish community, where *shiva* meant food overflowing the counters and women being included in a *minyan* and stories about the deceased being shared.

But death brought change, as it always does. Janet's death allowed Aaron to open a window within, to ask himself questions about how he saw himself proceeding

Lynn and Aaron
at their wedding.
Courtesy of Aaron Devor.

into middle age. Being a woman was not who he saw in his future. We talked. He said to me, "Only if you can come with me." What could I say? How can a person hold back another soul from being the person they are meant to be? Had not all those years of novels and stories taught me anything? So we said yes. And he began to emerge: voice deepening, legs hairier, temperament calmer. And I wept as my identity disappeared. I had loved women—especially those bold, butch women who all seemed to be disappearing into the gentle masculinity of trans manhood. I ached for that lost frisson of recognition between butch and femme, that electricity that was the particular purview of those sexual borderlands. I wailed. I fell into the arms of those I barely knew. I became invisible to lesbians who no longer recognized me. I was bereft.

Aaron had a changing-of-name ceremony in Beacon Hill Park, on the bridge. Many of our friends came—babies, elders, men and women, students, straight, gay and who knows. I walked Aaron halfway along the bridge and then let him go forward on his own to meet our rabbi at the apex, where the rabbi proclaimed Aaron's new name and status. He then led Aaron to the circle of men who awaited him, and the women sang. But I was silent. In tears. It was done.

Today, I can hardly recall those days. I can hardly remember a day where Aaron wasn't Aaron. He has always been my guy from New York. And as he became my guy, he became a dad to my son Ben, and Zeyde to our grandson Jacob and granddaughter Zoey. My dad wept when Aaron told him he was transitioning, from *rachmanes*, utter compassion. And then Dad directed all of his stories at the table to Aaron instead of to me, his beloved eldest daughter! Yes, I was some miffed!

At the very beginning of our now almost three decades together, Aaron and I talked about God, about our spiritual pathways, and I spoke with him about my desire for many years to become Jewish. This was my calling. We started going to *shul* every Saturday morning and began the weekly ritual of stressing over the meaning of what constituted being 'on time'. It took me a long time to reconcile with the fact that sometimes 9:00 am is just 9:00 am. My father's insistence on punctuality collided regularly—and still does—with the more relaxed Jewish notion of time.

And so I learned. I dreamt myself into my Hebrew name and my new identity as a Jewish woman, an identity that I had longed for since I was 12. I learned to read Hebrew and loved learning the earthy yet nuanced words of Yiddish as I visited over tea with my Jewish elders. Twenty-five years later I know each of us has a journey. That journey can be both demanding and commanding; it will compel us with the desire to act in ways beyond our initial imagining. Individually and together, Aaron and I have asked people to stand with us, learn with us, witness with us—and they have. We have received support and love and friendship. We share language and rituals and hold each other up to "soar on wings like eagles," as my dear friend Lindy loves to say.

For years now, I have learned and taught about Jewish perspectives about death and about our ritual caring for the dead. These days I also write and teach about caring for our trans people who live amongst us. I love these rituals. I love reading about death and how rituals have changed and adapted over the years in different communities. Invariably—inevitably, some would say—our dinner table conversations turn to death, dying and mortuary practices. Death is everywhere. I don't fear death. I believe we are all dying even as we live. Death can open doors and it can close doors. I write this on the eve of *Kol Nidre*, where we enter a period of time, sunset to sunset, to reflect in no small part on our mortality (and our morality).

Aaron and I share a life together. We are both odd. He notices when I move a pen on his desk. I notice the

Lynn and Aaron, 2015.
Courtesy of Aaron Devor.

shmutz on his shoes. He thinks my cooking is fabulous even when it is truly very simple and just laughs when I tell him I have followed a recipe, because we both know this is not what I do. If I did I wouldn't have married him and then married him again.

These days I have the great honour to conduct not only funerals but weddings too. It is such an honour to be at the cusp of these lives—of people taking leave of each other and people saying yes to each other. Because family is those everyday acts of witness, of eating the food in front of you, of building the patterns of companionship. Marriage is much less about gender and much more about loyalty and integrity. It is about being hurt and trying again. And, in the end, it is about holding each other's memories; however faded that remembering may become with age. In this marriage Aaron and I have the gift of being on our bridge again—the blessing of reflecting back over nearly three decades together and the blessing of, God willing, looking forward. To tomorrow.

Mask from the Kitty
White collection. 4050.

Martha Black

all of the related people

Family Connections in the Ethnology Collection

WHEN EXPLAINING THE ICONOGRAPHY OF HIS 1999 CARVING, *Ma-iił-pa-tu (How We Revere the Family)*, the Nuu-chah-nulth artist Tim Paul noted that "the side post represents *tlumma*, our domain, which is metaphorically a house—all of the related people. Everything rises up from the foundations and no one can act alone."[1] For First Peoples the idea of house, clan or lineage—all one's relations—is fundamental to social and personal identity. It is the governing principle of culture. This is articulated by the words *All My Relations*, often said by Indigenous peoples at the end of speeches and prayers and written at the end of emails; it is the theme of the 2012 Sydney Biennial co-directed by Canadian Cree artist/curator Gerald McMaster and the title of an anthology of contemporary Indigenous writing edited by esteemed author Thomas King. Derived from a Lakota phrase meaning 'for all my relatives', it refers to the connectedness of everyone and everything; Indigenous ways of listening and knowing; respect; all things about living together in the right way. It is about family.

Yet families and their complex interconnections are rarely expressed in the organizational and labelling conventions of museums, especially those that began in the 19th century like the Royal BC Museum. The connections that lineages form and articulate through time and space have been erased by anthropological classifications. Language classifications, referred to as language families—with definite boundaries drawn on maps—have come to stand for aggregates of actual families, even though First Nations marriages and the overall movement of people transcend those boundaries. Museum objects themselves can have

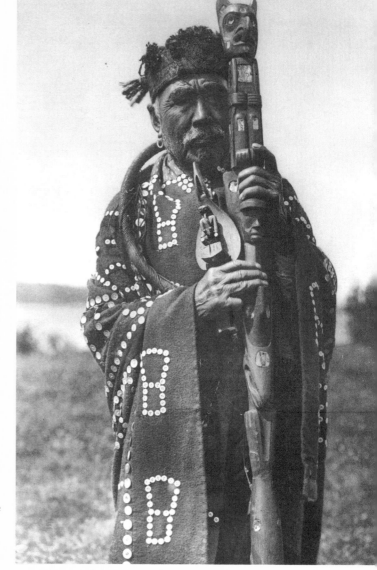

Kwagu'ł chief holding
a speaker's staff that
originated at Bella Bella
and has been attributed
to the Heiltsuk artist
Daniel Houstie, 1912.
Edward S. Curtis photograph.
PN 2006.

similar boundary-crossing family connections that
disrupt labelling conventions. For example, a speaker's
staff carved by Kwagu'ł artist Richard Hunt, who has
family connections to Tsax̱is (Fort Rupert), 'Yalis
(Alert Bay) and other Kwakwa̱ka̱'wakw communities
as well as ancestral heritage from Alaska and Britain,
was copied from one shown in a photograph taken at
Tsax̱is by Edward S. Curtis in 1912. The photograph
shows a Kwagu'ł chief of the Lakwilayla tribe holding a
staff that had been presented to him by a member of his
extended family who was Heiltsuk from Bella Bella. The
original staff became part of a Kwakwa̱ka̱'wakw family's
regalia and was eventually purchased by the Museum
of Anthropology at the University of British Columbia
where it is catalogued as Heiltsuk and attributed to
Daniel Houstie, an artist at Bella Bella. For Kwagu'ł and
Heiltsuk families, this staff signifies a lineage history
that crosses time, place and language. Like many people
of Tsax̱is and Bella Bella, it embodies layers of family
connections that make assigning a single provenance
problematic.

The staff's history, in the museum context at least,
is a product of recent research and information.[2] In
the late 19th and early 20th century, names of owners,
sources and makers were often unknown or not recorded

by collectors; cultural objects were made anonymous
and therefore ownerless. What names were recorded
were typically those of individuals—without mention of
their family or lineage context—reflecting a European
concept of personhood, ownership, nuclear family
and linear time. This way of thinking is embedded in
museum cataloguing conventions and extends to the
rather paradoxical concept of the First Nations artist

...cultural objects can illustrate lineage
histories and express Indigenous rights
and responsibilities.

as both a stand-in, or synecdoche for their extended family and an individual creator standing apart from it. But while individuality might be foregrounded in its catalogue entries, the Royal BC Museum's ethnology collection—like all comprehensive ethnology collections—is actually full of family connections, full of connected people. Like the aforementioned speaker's staff, cultural objects can illustrate lineage histories and express Indigenous rights and responsibilities. Basketry, carvings and textiles embody Indigenous ways of teaching and the legacy of skills through generations of families. Although records typically name an individual as source or vendor, concepts of clan, house or family ownership can be glimpsed beneath that provenance.

Because ethnographic collections are storehouses of memory, symbols of cultural loss and carriers of profound emotions, the objects themselves can be agents for bringing dispersed families together to reclaim heritage and maintain or activate connections. The concept of family connections through the agency of objects can even be extended to interactions between First Nations and colonial families, between the collectors and the collected. This essay presents a small selection from the many hundreds of cultural objects in the Royal BC Museum's ethnology collection:

objects that are about family teachings, families lost, families found, family histories known or waiting for reclamation.

family teachings

FIRST NATIONS PEDAGOGY IS BASED ON OBSERVATION AND PRACTICE; knowledge is passed on from generation to generation. Skills, techniques, patterns and subjects are passed down from mother to daughter, father to son, uncle to nephew, aunt to niece, grandparent to grandchild. Thus, many singular objects are actually segments of sequences spanning generations. Art-making is a family business in the sense of an occupation and, for artists participating in art exhibitions and the art market, in the commercial sense as well. Even though European-derived museum classifications privilege individual artists, the key role of the collective—of family traditions—can be perceived. There are many examples of these artistic dynasties, the descendants of Charles and Isabella Edenshaw of Massett and of Robert and Mary Ebbetts Hunt of Tsax̱is being two of the most renowned. These two lineages have provided a foundation narrative for modern Northwest Coast

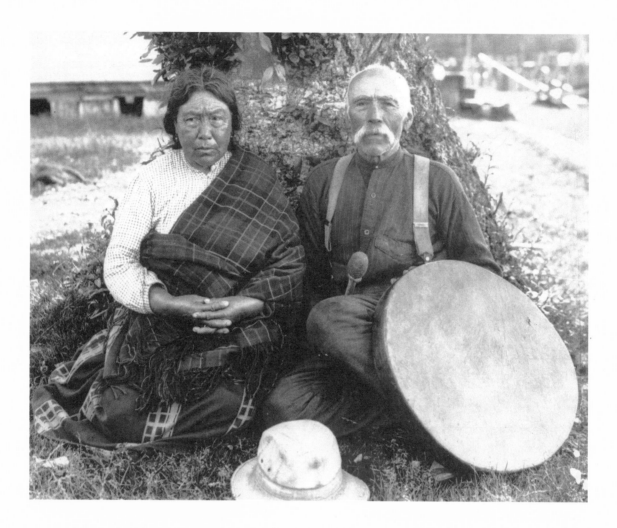

art: a direct line from the works of late 19th- and early 20th-century master artists to contemporary Northwest Coast forms and styles.[3]

In a dynastic reading of Kwakwa̱ka̱'wakw artistic modernity, the foundational lineage descends from Mungo Martin through the Hunt family. Robert Hunt, an English employee of the Hudson's Bay Company, and his high-ranking Tlingit wife Anisalaga (Mary Ebbetts Hunt) moved in 1871 to the Kwagu'ł community of

Tsax̱is where they ran the Hudson's Bay Company store and raised a family of 13 children. Their son George Hunt was the key figure in the written documentation and publication of Kwakwa̱ka̱'wakw language and cultural traditions, working as a translator, research collaborator, guide and advisor to collector Adrian Jacobsen, photographer Edward Curtis and anthropologist Franz Boas. Anisalaga, a weaver, made a number of Chilkat-style robes and aprons that represented her family's

Facing page: Tsukwani (Francine) and George Hunt at Tsaxis (Fort Rupert), 1930. PN 9533.

A family of carvers: (*right to left*) Mungo Martin, Henry Hunt and Henry's son, Tony, in Thunderbird Park, 1961. I-26830.

Tlingit prerogatives. George Hunt's wife, Tsukwani (Francine) taught skills such as cedar-bark processing to family members. Henry Hunt, their son, was married to the influential artist Mungo Martin's adopted daughter Helen. He accompanied Martin and his wife Abaya when they came to Victoria in 1953 to work on a totem pole restoration project at what is now the Royal BC Museum. The project transformed Thunderbird Park, taking an eccentric conglomeration of monumental carvings and turning it into a more authentic expression of Northwest Coast cultural traditions.[4] Generations of the Hunt family have sustained and developed contemporary Kwakwaka'wakw art, contributed to a thriving Northwest Coast contemporary art market and built bridges between First Nations and non-Aboriginal people in BC. Robert Hunt and Anisalaga's descendants today number over 1,200 people. Many are important artists—Tony Hunt, Richard Hunt, Calvin Hunt, Stanley Hunt, Donna Cranmer, Corrine Hunt and Tony Hunt Jr., to name just a few—and a distinctive Hunt family carving style has developed.

In the European discipline of art history, artistic individuality is a fundamental value. The foundation narratives of Northwest Coast art emphasize individual style over the family collective. That an essential role of the scholarly connoisseur is the restoration (or sometimes the creation) of a distinctive artistic persona has been taken for granted[5] and techniques of attribution are part of the intellectual history of the West.[6] Edenshaw attributions have been a preoccupation in Northwest Coast art studies,[7] exemplified by curator Bill McLennan's 2011 exhibition, *Signed Without Signature: Works by Isabella and Charles Edenshaw* at the Museum of Anthropology at the University of

British Columbia. That exhibition presented Charles Edenshaw and his wife Isabella, an accomplished cedar bark weaver, as Haida people with English names in the colonial world of missions, canneries, souvenir markets and anthropologists whose works are still sought by collectors today, and also as Qwii.aang and Da.a xiigang, strong sustainers of Haida traditions who continue to be cultural touchstones for contemporary Haida artists. It is with the latter personae that the family connections are most apparent and the emphasis on individuality lessened. For example, the first objects entered into the Royal BC Museum's anthropology collection are two house posts collected by James Deans at Skidegate in 1892. Entries in the handwritten catalogue book say both were made by C. Edensaw [*sic*]. Deans' descriptions are unreliable, however, and where this information originated is not clear. Considering the authorship of these posts, Robin Wright, a scholar of Haida art, leans toward Albert Edward Edenshaw as primary carver for one of them but allows for the participation of Charles.[8] That the poles are connected to a lineage house and an artistic lineage rather than a single carver disrupts ideas about individual style and confounds ambitions of attribution.

When talking about families in relation to First Nations cultural objects, we are not talking about nuclear and patrilineal families. First Nations families are structured and understood differently from those of European societies. For the Kitsumkalum Tsimshian, for example, "Most, if not all of the people who belonged to the Galts'ap [community or town] could trace their connections through some form of kinship with everyone else," thus "kinship was the basis of Tsimshian society, and still is to a significant extent."[9] Northern coastal First Nations like the Tsimshian and Haida have matriarchal kinship structures. In Tsimshian society, "a Waap is a family defined by each member's relationship through the women—the matriline. Physically, the Waap was represented by a number of material objects. . . . [including] ceremonial properties and crests, such as crest (totem) poles, headdresses, dancing blankets, button blankets, or drums."[10] In other words, the kind of objects found in museum collections. In museums, though, these kinship-based meanings have been covered up and obliterated by new layers of classification based on different understandings of family.

In her study of Haida repatriation, Cara Krmpotich described Haida kinship structure:

An individual is just one part of a cycle of being and has ethical responsibilities to the ancestors, one's clan and those still to be (re)born.

Haida society is composed of two k'waalaa, or moieties, Raven and Eagle. Each k'waalaa consists of a number of matrilineages. In the Haida dialects, matrilineages are called gwaay gaang (Massett), gyaaging.aay (Skidegate), and gwáayk'aang (Kaigani). At birth, a child's social identity is derived from his or her mother's gwaay gaang/gyaaging.aay and the k'waalaa to which her lineage belongs. Today, Haida colloquially refer to both lineages and k'waalaa as "clans."[11]

Krmpotich's study focuses on the repatriation of Haida ancestral remains and argues that this work, and by extension all Haida endeavours, is about family in the Haida sense:

> I learned that understanding the repatriation process, the people and objects that are part of it, and Haida political identities requires viewing objects through the lens of kinship. Kinship is a powerful force on Haida Gwaii: it is the basis of personal and collective identities, social obligations and relationships. It undergirds value systems. I believe it even shapes how Haidas remember, know history and reckon time. It is structural and constructive.[12]

The Haida concept of family extends to a belief in reincarnation within the clan. An individual is just one part of a cycle of being and has ethical responsibilities to the ancestors, one's clan and those still to be (re)born. This concept of family nuances the idea of a single and singular creator. As Irene Mills explained,

> We have people who are reincarnated into grandparents, or aunties or uncles or brothers or sisters ... when those people [whose remains are repatriated] are able to be reincarnated, we're going to have more of the old knowledge come back. ... We're going to have children being born with memories ... I was told since I was little we're all reincarnated into somebody and sometimes it comes through strong and we know. Like my daughter, both my kids actually, are natural weavers.... So it's that stuff that we inherit from those reincarnations, that we're so lucky for too.[13]

A simple list of carvers and weavers who are Edenshaw descendants and who developed their skills and artistic values within that kinship structure—Florence Davidson, Primrose Adams, Isabel Rorick, Selina Peratrovich, Delores Churchill, Evelyn Vanderhoop,

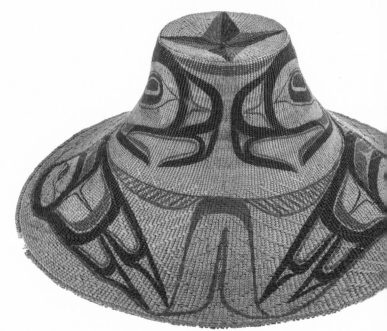

Top: Spruce root hat by Isabella Edenshaw with painted Eagle design by Charles Edenshaw. 18972.

Bottom: Spruce root hat by Isabel Rorick, great-granddaughter of Isabella Edenshaw, granddaughter of weaver Florence Edenshaw Davidson, daughter of weaver Primrose Adams, 1989. 18972.

April Churchill, Lisa Telford, Holly Churchill, Robert Davidson, Reg Davidson, Jim Hart, Christian White, Michael Nicoll Yahgulanaas, Guujaaw, Gwaai Edenshaw, Jaalen Edenshaw (there are many others)—reveals the power of familial knowledge through generations and the importance of learning within the family or clan. There are other Haida artistic dynasties as well. For example, the family tree of the carver skil kingaans (Simeon sdiihldaa) includes Freda Diesing and her nephew Don Yeomans.[14] An exhibition at the Douglas Reynolds Gallery in Vancouver in 2012 featured works by Yeomans, his wife Trace, and their children Kyran and Crystal. Its title, *Modern Family*—referring to the contemporary ambitions of the works—also signals a Haida concept of collective authorship.

There are many such examples of family-based learning, cooperative work and artistic production. Secwepemc birch bark basketry, Nuu-chah-nulth basketry, Cowichan knitting and Coast Salish weaving are familiar art forms specific to place and associated with generations of makers within the same families. In fact, it may be that families, rather than individuals, should be considered 'authors' in First Nations material culture studies. When First Peoples point out that there is no word for art (in the European sense) in Indigenous languages, this is part of what that different way of knowing and making might mean.

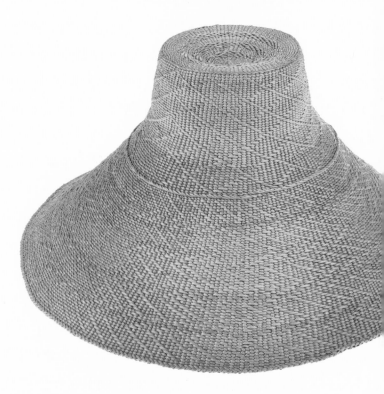

families lost

MARRIAGE CERTIFICATES AND DEATH NOTICES are the kinds of documents that might be preserved by a family as remembrances. A baptismal certificate is this kind of document. One in the Royal BC Museum's ethnology collection is a printed certificate bearing the names of two people, Istahdiga Dekully and Stuguhlet Kahgolthea, who were baptized at Telegraph Creek by William Ridley, Bishop of Caledonia, on St. Barnabas Day (June 11), 1900. The printed page is encased in a fancy frame made of yellow ribbon and off-white lace backed with black velvet with a loop of ribbon for hanging. Above the space where the names, place and date are written in ink is a circular image of Christ teaching a group of children surrounded by the legend "Suffer the little children to come unto me"; below is a printed prayer. This evocative document was transferred to the ethnology collection from the museum's history collection in 1982 with no information about its source. It records a rite of passage of family members within the Christian tradition (which often uses the metaphor of family to describe church congregations) while simultaneously signifying a cultural transition, perhaps away from a Tahltan lineage's ancestral beliefs. It provides no information at all about Istahdiga Dekully and Stuguhlet Kahgolthea, though. The space for date of birth is blank. So until more research is done, until someone from the Tahltan Nation claims Istahdiga Dekully and Stuguhlet Kahgolthea, this is a family record without a family. Many cultural objects in the ethnology collection, although not overtly documents, are actually these kinds of records. Some have known family ties; many do not.

families found

IN JANUARY 1924, FRANCIS KERMODE, director of the Provincial Museum of Natural History (now the Royal BC Museum), Charles F. Newcombe, who collected for the museum, and J.L. White, the deputy provincial secretary of BC, went to see Mrs. Kitty White, an elderly First Nations lady who lived near Sooke. The previous month, Kermode had received a letter from John A. Murray, the justice of the peace for the Sooke area, saying, "An old Indian woman Mrs. Kitty White whom I have known well for 30 years, called upon me today saying that she had in her possession three or four Indian masks which, out of gratitude for favours received

Baptismal certificate of Istahdiga Dekully and Stuguhlet Kahgolthea, baptized at Telegraph Creek, June 11, 1900. 17032.

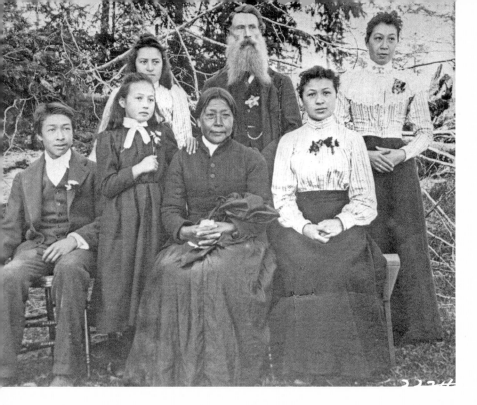

Owechemis (Kate
White, known as Kitty),
with her husband,
Aaron Denton White,
and children John
(Jack), Alice, Mary
Catherine, Ida and
Abba at Sooke. B-03636.

from the Government, she would like to give to the
Provincial Museum at this time, as a Christmas Present."
Mrs. White also had "an Indian box which as the
property of her grandfather, second chief of the Indians
at Ahateset? near Nootka [probably Ehattesaht, north of
Nootka Island] and it is supposed to be about 200 years
old."[15] The museum's 1924 annual report explains that
as a young girl Kitty White had been "stolen away" and
taken to a community just north of Port Renfrew.[16] She
lost all touch with her family but years later her brother
found her and carved a large mask for her and a mask
for each of her children. She stored the masks in her
great-grandfather's wooden chest. Anthropologist Erna
Gunther interviewed Kitty White in the 1920s and tells
this version of Kitty White's story:

> Mrs. White is a Nootka [Nuu-chah-nulth] from
> Exatisit [Ehattesaht], a village just north of Nootka
> Sound. She was captured by the Songish [Songhees]
> and belonged to a chief named Stxai'aks. He sold

her to Yo'kum, a Klallam from Port Angeles. When
she was eight years old the Klallam group at Port
Angeles moved to Beecher Bay, taking her along.
When Yo'kum's son married he was given this slave
woman by his father, and she lived with him until
she married an Englishman.[17]

Not so, said Mrs. Ida Jones, the wife of the
Pacheedaht Chief Queesto (Charles F. Jones). Kitty White
was given in exchange by her father, the chief, to end a
war between his and another First Nation: "they knew
what it meant when the girl was lifted up high like this …
peace offering – stop the fight – not sold! not slave!"[18]

The government favours that John A. Murray
referred to in his letter may have been in the nature of
support and social services during a difficult period in
Kitty White's life. In 1902 he wrote to Superintendent
of Indian Affairs A. W. Vowell on her behalf, saying that
"Mrs. White … made a complaint against her husband
Aaron D. White, of continued unkindness…"[19]

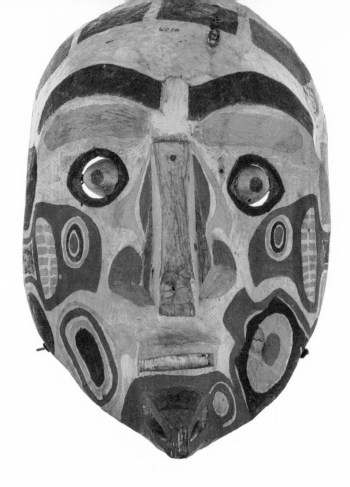

Large mask from the
Kitty White collection.
4050.

Kitty White's native name was Owechemis. The masks that she gave to the museum are versions of traditional Nuu-chah-nulth regalia: a mask with an Eagle head on top, a large human face mask with articulated eyes, a frontlet in the characteristic Nuu-chah-nulth form and a pair of Eagle headdresses. Roughly carved and inexpertly painted, they approximate but do no replicate Nuu-chah-nulth artistic conventions. The red and blue geometric designs appear to have been applied over an earlier layer of paint but the surface of the wooden chest is probably original, which supports the story of the collection's origin.

Kitty White (Owechemis) died in 1930, but many of her descendants regularly visit the Royal BC Museum in family groups to look at the carvings and pose for photographs with them. They often end up sharing stories and discovering new aspects of their own heritage through the unique and unusual objects that were made for Owechemis by the brother who found her for just this purpose: to illuminate a family history and ensure those connections would not be lost. We have a list of Owechemis' descendants who allow us to give their names to other relatives looking for connections with their extended family; in turn, they put the museum itself more in touch with the objects it holds. One woman who visited with her family showed us a picture of a framed bead-and-shell necklace, explaining that Owechemis had made such necklaces for each of her daughters. An identical necklace in the Royal BC Museum's collection was acquired in 1965 from a lady who said it had been made by her parents, but their names were not recorded. The necklace was misleadingly catalogued as Ditidaht from Nitinat but is no doubt one of Owechemis'. Just as her long lost brother made versions of Ehattesaht regalia that would reopen a connection to her birth family and their ancestral traditions, Owechemis made Nuu-chah-nulth style necklaces to pass those connections onward. The museum collection has become a nexus of those family relationships.

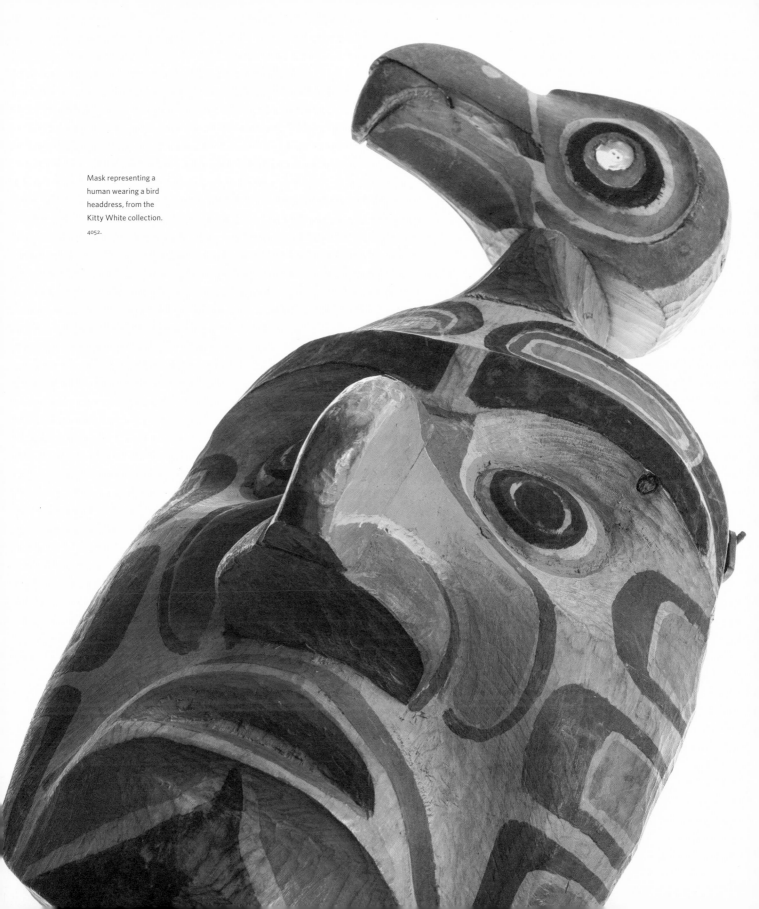

Mask representing a
human wearing a bird
headdress, from the
Kitty White collection.
4052.

Left: Charles Nowell's wife's blanket, purchased from the artist Mildred Valley Thornton in 1965. Detail. 12357.

Facing page: Charles Nowell with his wife and mother-in-law, photographed at 'Yalis (Alert Bay) in 1899 by Charles F. Newcombe. Mrs. Nowell (*left*) wears the blanket that is now in the Royal BC Museum. PN 994.

The Kitty White collection epitomizes the ability of museum objects to bring families together and reminds us that the entire ethnology collection is comprised of fragments of family histories, even though those relationships are not overt. Several years ago at a get-together in Vancouver, I was chatting with a young Kwakwa̲ka'wakw man and noticed that he had a familiar design tattooed on his arm—an image that appears on one of the most beautiful button blankets in the ethnology collection. The blanket had been purchased along with a Killer Whale headdress in 1965 from Mildred Valley Thornton, a Vancouver-based artist and journalist with a particular interest in First Nations cultures who is known for her portraits of Aboriginal people in western Canada. There is no information in the collection record about the origins of the blanket and headdress, but we know from historical photographs that they were once owned by Charles Nowell,

a Kwakwa̲ka'wakw chief originally from Tsa̱xis and his wife, the daughter of the 'Na̲mgis Chief Lageuse, from 'Yalis. Nowell was an influential consultant to anthropologists such as Franz Boas and the subject of a famous biography, *Smoke from Their Fires.*[20]

In her painting titled *Chief Charley Nowell*, Thornton painted Charles Nowell wearing the button blanket and headdress and, in a separate portrait, she painted Chief Herbert Johnson wearing what appears to be the same button blanket.[21] Thornton herself posed dramatically wearing the button blanket for a photograph that was published in the *Vancouver Sun* in 1949. A disconcerting image of cultural appropriation, the photograph graphically illustrates the button blanket's shift from Kwakwa̲ka'wakw lineage property to exotic non-Aboriginal costume—that is, from a symbol of belonging to one of not belonging, from family membership to exclusion. Despite their alienation, though, these objects' connection with the descendants of Charles Nowell clearly continues. The crest designs express ancestral connections that have been passed down through the generations and appear on new versions of regalia and also, as I discovered, as tattoos signifying family belonging and belongings.

Regalia like Charles Nowell's family's blanket and headdress make lineage histories and structures visible through the display of crests that commemorate family

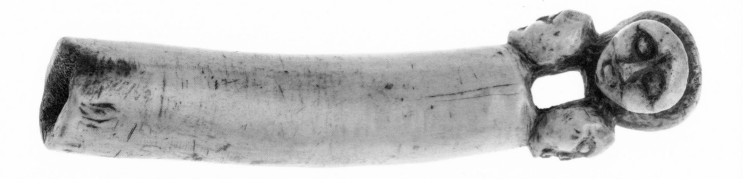

histories, territories, responsibilities and privileges. They are demonstrations of family heritage. The rights they express do not expire when the crest objects are physically alienated from the family and end up in a museum or private collection. Objects like the Nowell family blanket and headdress will be kept current and made anew by contemporary Kwakwa̱ka̱'wakw artists to be shown at potlatches by Nowell descendants. One of the museum's primary responsibilities is to ensure access to collections for First Nations artists and others, to support such continuities through the agency of objects.

family connections

NOT ALL OBJECTS IN THE ETHNOLOGY COLLECTION are pieces of Northwest Coast regalia. Small seemingly domestic objects can express complex family connections and histories, too. An example of large stories in small objects is an ivory or bone tube just 13.9 cm long, with four carved faces at one end—a knife handle that was given to the Hudson's Bay Factor at Kamloops in 1858. The carvings are said to represent Chief Paul, his wife and his two daughters.

Who was Chief Paul? Museum records do not say, but Chief Paul, Chief St. Paul, Mr. Captain St. Paul or simply St. Paul are other names for the famous Jean Baptiste Lolo, or Leolo, a prominent figure in fur trade history. We have another image of Chief Lolo his wife and two daughters—a photograph taken by Charles Gentile at Thompson's River Post (Fort Kamloops) in 1865. These two very different representations express an interface between First Nations and settler society in the

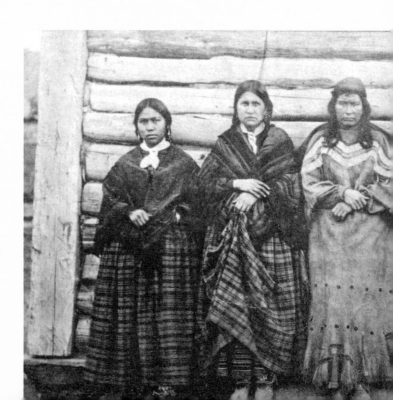

fur trade, an interface that was personified by Chief Lolo himself and his mixed family, epitomizing the complex dynamics of colonial British Columbia.

Possibly a Metis man of French-Iroquois descent or the son of a chief named Okanase and an Assiniboine woman, Lolo was nicknamed St. Paul by missionaries and given the title of chief by the Hudson's Bay Company, for which he was an employee, interpreter and unofficial Aboriginal liaison at various posts.[22] At the Fort Fraser post on the Nechako River, Lolo became associated with Scottish fur trader John Tod. When Tod moved to Thompson's River Post (Fort Kamloops), where he became chief trader in 1842, Lolo went with him. Although Tod left Kamloops eight years later, Lolo stayed on in Secwepemc territory. This colourful personality appears in many fur trade era accounts, including that of Lieutenant Richard Charles Mayne of the Royal Navy, who describes visiting him at Kamloops in 1859 and meeting his wife and "two handsome-looking" daughters. Lolo was bedridden with a leg injury at the time but nevertheless accompanied Mayne on a surveying trip from Kamloops to Pavilion.[23]

Chief Lolo was also John Tod's father-in-law: Sophia Lolo, one of his daughters, married Tod in 1843 in what was referred to as a 'country marriage' and again, in 1863, in an official marriage ceremony. They would have seven children. Sophia was much younger than Tod, who had been married twice before in the manner of the country and once before in a formal marriage and had a number of children by these wives.[24] The Tods eventually settled permanently at Oak Bay near Fort Victoria and the house they built there is now one of Victoria's oldest. The Honourable John Tod was a member of the Legislative Council of Vancouver Island from 1851 to 1858. His children became part of the colonial community. Chief Lolo lived in Kamloops until his death is 1868. His land was designated an Indian

[Museum objects] take on layers of meanings, to and across places that are not obvious from conceptions of identity, history and place.

reserve in 1862 and is now part of Secwepemc Nation territory; his restored house is part of the Kamloops Museum. A number of places in British Columbia are named after Chief Lolo, including Lolo Mountain, Lolo Lake, Lolo Creek, Paul Peak (called Mount St. Paul by Lieutenant Mayne), Paul Lake and St. Paul.[25] Thus this small carved knife handle is linked to an expansive historical narrative of interwoven fur-trade and colonial families. It is also linked to places on the landscape, just as families are.

families collected

THE ROYAL BC MUSEUM RECENTLY RECEIVED THE GIFT OF A MODEL CANOE, painted with a formline design, from the granddaughter and great-granddaughter of collector Bernard Filip Jacobsen, whose name and the location "Bella Coola" are written inside the model canoe's hull. For this family, the model canoe was a keepsake from their forebear and a link to the family's Norwegian roots and long history at Bella Coola, where Jacobsen settled in the late 19th century. In the ethnology collection it has become a link to one of the museum's first major acquisitions: a large collection of Heiltsuk and Nuxalk objects purchased from Jacobsen in 1893.[26] The model is so similar to another Heiltsuk model canoe in the ethnology collection that we think it originated in Bella Bella and that the designation Bella Coola refers to Jacobsen's home community, not the maker's. In the museum the model canoe retains a connection with Jacobsen's descendants while taking on new connections to families who descend from the Heiltsuk maker. This single object, like so many others in the collection, can be understood as a focal point in a wide network of different kinds of family relationships.

In her study of the Haida's repatriation of ancestral remains, scholar Cara Krmpotich found that looking at repatriation in terms of kinship and clan responsibilities, rather than from a political perspective, led to new understandings. Seen through the lens of First Nations family structures and obligations, museum objects appear differently, too. They take on layers of meanings, expanded narratives, and connections to and across places that are not obvious from catalogue records based on quite different conceptions of identity, history and place. When considered in this light, the reasons why museum objects engender such strong emotions—a circumstance familiar to all who visit and work with

expanded narratives, and connections
catalogue records based on quite different

the collections—and act as powerful catalysts for human connections are obvious: they are about family. These emotional connections do not happen solely within and between First Nations source families, either; they are also part of a network of relationships produced by anthropological collecting and the troubled legacy of colonialism that is clearly evident and strongly experienced in museums.

Indigenous understandings of families—concepts such as lineage structure and histories; the presence of the ancestors, responsibilities within clan and society; the meaning of artistic style; forms of authorship; how names, songs and regalia move within and between extended families; *All My Relations*—highlight the problematic nature of anthropological classifications that draw hard boundaries around territory, language and ethnolinguistic groups. Thinking in terms of family and family connections through time and across territories undermines these anthropological classifications.

What would this theoretic reconceptualization mean in practice? How might it change the concept of source and ownership? Would it have ramifications for repatriation through the treaty negotiation process where inventories of 'artifacts' for potential transfer are essentially based on place defined as specific territory, and for the idea of nation-to-nation repatriation in general? Would it change designations such as Kwakwaka'wakw (Kwakiutl in the old anthropological terminology) from Fort Rupert or Tsimshian from Fort Simpson for objects that may have different or additional associations when seen through the lens of families rather than just place or language group? It is understood that the conventions of anthropological classification and the terminology of non-Aboriginal languages in museum catalogues are instruments of alienation. What would happen if the classifications were based on families instead?

Tzu-I Chung

generations

A Case Study of Two British Columbia Families

All immigrant families come with an extensive range of stories, though not many first-person stories from the mid-19th century were recorded or survive to this day.

MOREOVER, IN BRITISH COLUMBIA the first major spurs to immigration—the 1858 gold rush and the railway building of the early 1880s—created a largely male society with few established families and even fewer families where we can trace direct descendants through the generations. At the time of the first census in 1881, the non-Indigenous adult male to female ratio was about three to one, with proportions much more skewed in remote towns.[1] That gender imbalance remained until 1921 when it was 58.5 to 41.5 per cent, and only in the 1970s did it almost reach a balance.[2] This imbalance partly reflected common immigration patterns in which men were more likely to go abroad in the early years, and was partly the result of Canadian immigration laws which severely restricted immigration from Asia.

In the province of British Columbia the prominent presence in the colonial and initial provincial political system was British and was comparatively better-documented. Nevertheless, there are descendants of some early immigrant families who are active in the province and elsewhere today. This essay draws on two of these families that have been settled here for generations—the Guichon family[3] and the Louie-Seto family. With both families it was their persistence, access

to marital choices, emphasis on education, intercultural lives and generational continuity that sustained them. Their stories also reveal immigrant settlement patterns in BC and the contributions these families made to the historical transformation of our province and nation.

during and after the gold rush

DURING THE GOLD RUSH ERA the first generation of the Guichon family arrived and, alongside other French immigrants and French-Canadians, ranched in early British Columbia.[4] In 1857 three brothers, Charles, Laurent and Pierre, left France for California and then made their way to what is now BC. A younger brother, Joseph, arrived in 1864 via London, Liverpool, New York, Panama and San Francisco. Charles returned to France but maintained financial ties to the family here; Pierre died in BC in 1878.[5] Joseph and Laurent hiked from the Fraser Valley to Barkerville as gold prospectors and soon started working for the famous BC packer Jean Caux, known as Cataline, packing goods into the Cariboo on mules.[6] Eventually the two brothers also became hoteliers in Barkerville, opening a hotel to cater to the miners.

Interestingly, it was these experiences that led Joseph to ranching as, when "looking for wintering and feed for packhorses" in 1866–67, he came upon the area between Kamloops and Merritt where he took up a homestead in 1873 and began ranching the Nicola Valley, in the heart of BC's interior grasslands.[7] This was the origin of the historic Guichon Ranch, which in 1957

became the Quilchena Cattle Company and the Gerard Guichon Ranch. The constant growth of the company in the 1870s made it possible to supply food for the crews building the Canadian Pacific Railway in 1880–1885, thus connecting the family to this major historical event.[8]

As the ranch grew, Laurent and Joseph's marriages with the French Savoie-born Rey daughters, recent migrants to Vancouver Island, "strengthen[ed] the family ties"[9] and "ensured their respectability in the emerging dominant society", which in turn enhanced their success. Joseph's eldest son Lawrence described him as "an optimist and lover of BC and Canada" as well as "very much a Frenchman", which meant—according to grandson Gerard—that since Joseph and Josephine Rey were "both speaking French" they were able to get "to know each other".[10] In his time, Joseph witnessed the transition of BC into a Canadian province and persisted through the ups and downs of the family ranch. He also opened and ran the Quilchena Hotel, which would later become a historical landmark in the Nicola Valley, from 1908 to 1919.[11] Joseph Guichon formally retired from ranching in 1918 and divided the shares of the company, including his property per French custom, among his three sons and four daughters.

After the early years of ranching in the interior, the other gold rush pioneer in the family—Laurent Guichon—moved his family closer to that of his wife, buying land in the Fraser River delta at the suggestion of his friend William Ladner. The family moved to New Westminster and later to Port Guichon, west of what is now Ladner, BC. Laurent died in 1902 and, according to a descendant, his nine children each received 150 acres of his land holdings. He is remembered as the founder of Port Guichon, where many of his descendants still live and farm the land.[12]

* * *

After the first and second major waves of Chinese migration to Canada, the gold rush of the 1850s and 1860s and railway building in the early 1880s, the largest Canadian-born Chinese settlements grew in Victoria and Vancouver. But the Chinese Canadian community was largely male until well after the Second World War, and those few who managed to establish families in BC stayed intimately connected, oftentimes through marriage. At the time, the Louie and Seto families were part of an extended, close-knit family network created by these historical circumstances that connects Chinese families in Victoria, Vancouver and the United States,

especially the state of Washington.[13] In the third generation of the Setos and the second generation of the Louies the families joined, and this history is chronicled from that perspective.

In 1865, a year after Joseph Guichon arrived in BC, Seto Fa Gin arrived in Victoria via Hong Kong and San Francisco for the Fraser River and established a family, most rare among his fellow countrymen. The stories of his family's lives during that early time require further research, but we do know that he started Sam Kee, a business that made and sold tents, sails and western-style clothing.[14]

late 1800s to early 1900s

LAWRENCE PETER GUICHON, oldest of Joseph's seven children, ran the Guichon Ranch from the time he was 14 years old while his father pursued other business interests, but formally, from 1918 to 1957. He played an influential role not only in growing the family business but also in shaping and leading the BC cattle industry through its formative years. He served as a commissioner on the Brand Commissioners board and participated in drafting the Stock Brands Act, which regulates nearly every aspect of beef production from calf branding to cattle transportation.[15] He worked with other ranchers to organize the Provincial Bull Sale in Kamloops in 1919, continuing his father's work to improve BC cattle herds. And when the Nicola Valley grasslands were devastated by grasshoppers in the 1920s, he assisted with the Nicola Grasshopper Control Committee, which later provided a model for grasshopper-infested regions in other parts of the world.[16]

Lawrence's significant contribution to the BC cattle industry and the province was built upon his continuous and tireless hands-on work and his deep and thorough understanding of livestock and ranching practices.[17] Running the ranch required hard work both on and off the saddle and Lawrence diligently recorded the details of daily operation in his numerous diaries, preserved in the collections of the Royal BC Museum and Archives. Nephew Guy Rose recollected that Lawrence rarely went a day without recording in his diaries. Lawrence also quizzed his six children every night at dinner with the question "What did you learn today?" Bernard Guichon and Carolyn Guichon-Pearce, of the third and fourth generation, stress the importance that the family has placed on both hands-on family education and school, which has contributed to the success of the family and family business through the generations.[18]

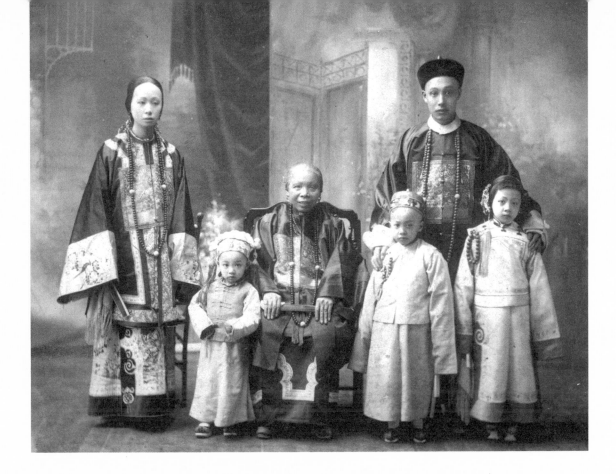

Lawrence's youngest son Bernard always remembers the use of French language, the discipline of ranch life and the respect for animals that his father taught by example. Bernard, like his older siblings, had been programmed for ranch life since childhood—getting up at 6:30 in the morning and fetching water and feed for horses and cows—and believes that "growing up in any kind of ranch is lucky," something "city folks wouldn't know". He remembers his father's famous saying: "If you sleep in, you miss the best part of the day." Bernard also recalls that Lawrence led by example—while he allowed people access to the ranch to hunt and fish, he always cautioned visitors about not disturbing the cattle and did his best not to disturb any natural processes. As a rancher, Lawrence was acknowledged for his work on rehabilitating the grasslands in BC.

* * *

The marriages of Seto Fa Gin's children and grandchildren and their extended families ensured the continuity of the family in the early gender-skewed society and helped to strengthen the close-knit network of early Chinese Canadian communities. In 1893 Seto Fa Gin's Canadian-born daughter Seto Chang Ann married Lee Mong Kow,[19] an immigrant from Hong Kong who worked at the custom house. Both the Seto and the Lee families shared the same tradition—an emphasis on education—and Lee Mong Kow emerged as a community leader. He helped found the Le Gun YiShu free Chinese school in Victoria's Chinatown in the 1890s and later founded the Victoria Chinese Public School, serving as its first principal. Seto Chang Ann also played active roles in this school and together they made it the first Chinese school in North America to hire female teachers.[20]

As with the Guichon and the Seto families,
in family education for his children...

In 1889 her brother Seto More (a.k.a. Situ Mau, 司徒旄 or Seto Ying-Shek)[21] was born in Victoria. He was also educated in Victoria, becoming "the most prominent Chinese scholar [of his time] in British Columbia"[22] and an influential activist in the early 20th century. His wife Fanny Lew Seto was born in Olympia, Washington, to a leading Chinese American family—the Lew family.[23] The Lew family also valued education highly and Fanny was the first American-born Chinese American to graduate from high school in the US.[24]

As a second-generation Chinese Canadian Seto More enjoyed a rich intercultural life and built upon the trans-Pacific connections that have been an integral and crucial part of BC and Canadian history. He worked as the Asiatic Passenger Agent for the Canadian Pacific Railway (CPR) and served their diverse clientele, but his impressive book and art collection reveals the breadth of his knowledge, ranging from history, culture and art to philosophy, religion and technology, and his active role in Chinese artistic and literary circles.[25] Within these circles were prominent figures in the modern Chinese history of the early 20th century. One piece that remains in the family collection is Lingnan School of Painting Master Yang Shan Shen's artwork *The Peony*, specifically dedicated to Seto. His surviving poetry was composed in Chinese calligraphy but the content was based on his BC experiences and the Vancouver landscape, making it uniquely Chinese Canadian.

Seto was a leader among his contemporaries through crucial historical moments of political turmoil in both China and Canada. He worked to defend Chinese Canadian rights, supported Dr. Sun Yat-sen's efforts for revolution in China and, in his youth, he co-founded the pro-revolutionary society known as Chi-Chi She.[26] He served as president and in other leadership roles in the Vancouver branch of the Chinese Consolidated Benevolent Association and in the wider community. Seto was an important agent and thinker to the many Chinese Canadians in BC who strongly supported Dr. Sun's efforts because of their patriotism towards their home country and their belief that a stronger China would help them fight discriminatory acts in their adopted country.

The beginning of the Exclusion Era marked one of the darkest moments of Chinese Canadian history and Seto led in the efforts to exert Chinese Canadian agency in this historical event. When the Chinese exclusion bill was debated in parliament in 1923, Seto and Joseph Hope Low represented British Columbia's Chinese community in Ottawa, lobbying legislators and distributing 18-page briefs even though the MPs did not read them.[27] Despite their efforts the bill, barring Chinese entry into Canada as of July 1, 1923, was enacted.[28]

H.Y. Louie placed a lot of importance

Most significantly, this act did not leave Chinese Canadians defeated. Seto continued to lead Chinese Canadian anti-discriminatory efforts and in 1924, for instance, their collective efforts successfully stopped the advance of school segregation.[29]

Hok Yat (H.Y.) Louie, the first of the Louie family in Canada, arrived in BC in 1898 and established the business that would continue through generations.[30] After working as a field hand, farm labourer and sawmill shift foreman, and having taught himself English, he opened the H.Y. Louie Co.—a wholesale and retail grocery and farm supply business that served as an intermediary between Chinese market gardeners and white grocers.[31] When municipal and provincial governments imposed restrictions on Chinese grocers, farmers and labourers, some white businesses regarded the H.Y. Louie Co. as "an intruder."[32] For instance, the family remembers that the B.C. Sugar Refining Company refused to sell it sugar. The motive at the time was likely racist, as BC Sugar had an agreement with the city about not employing Chinese people.[33]

H.Y. Louie worked through such opportunities and difficulties to build his business, which is evocative of Chinese Canadians' important contribution to the agricultural sector in BC history, and through its success he was able to establish his family in Canada. Chinese Canadian market gardeners were integral to many of BC's towns and neighbourhoods throughout most of the 20th century. In 1908, one year after the anti-Chinese riot ravaged Vancouver's Chinatown, he moved his business and home to the Urquhart Building at 255 East Georgia Street in Vancouver. H.Y. Louie's first wife Kwock Shih, with whom he had two daughters and a son, had remained behind in China. Like other Chinese merchants of his time who could afford it, he sent for a second wife from China and, in 1911, Young Shih arrived. Together they had nine sons and two daughters.

As with the Guichon and the Seto families, H.Y. Louie placed a lot of importance in family education for his children, as illustrated in his letters to them, and this informed the continuation of his family business through future generations. When he travelled to Hong Kong in 1934 he wrote letters to his third son Bill to instill important values in his children:

"Young people should always be earnest in your work. Treat your customers with trust and loyalty. Honour your mother; to your older brothers, show respect. To your younger brothers and sisters, offer them good advice. That is what pursuit of happiness in life is about. When pursuing prosperity you must follow the laws of heaven. Don't be afraid to be kind and charitable."[34]

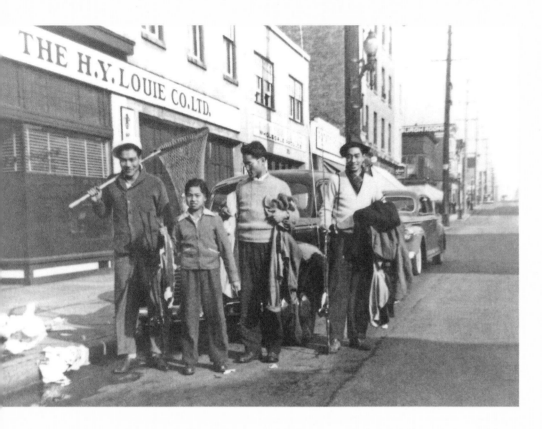

The Louie brothers, (*left to right*) Ernie, Willis and John, taking a break from warehouse duties to go fishing with John Lowe, 1941.

Courtesy of H.Y. Louie Co. Limited.

Three surviving letters have since served as the guiding principles for the business ethics that sustain the H.Y. Louie Co. In November 1934, not long after he sent those letters, H.Y. Louie died in Hong Kong and left his BC estate to his wife Yang Shih. When she died in 1948, her will stipulated that it be divided equally among their eleven children.

English and Chinese language use in the first two generations, as exemplified by Seto More and H.Y. Louie, played an instrumental role in their service to both society in general and to Chinese Canadian communities. In Seto's case, his Chinese language use moved beyond common usage as his literary achievements earned him a significant position in the modern Chinese arts and literary circles; and in both cases, it was an essential part of their family education.

mid to late 1900s

DURING THE SECOND WORLD WAR, like many of their contemporaries, the Guichon family supported the nation by sending sons into military service and continuing to take care of the ranch, which supplied food during the war years. Lawrence's second son Gerard remained to run the family ranch while his brothers Charles, Urban and Bernard all entered the service. Charles, the eldest, served in the air force; the third son, Urban, served in the army secret service; and the youngest son, Bernard, served in the navy, patrolling the area between Boston, Halifax and Newfoundland.[35]

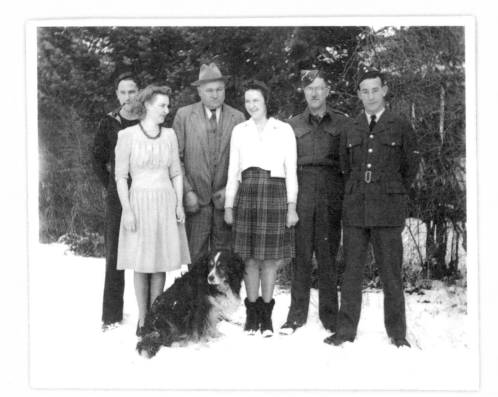

From left to right, Bernard, Jackie, Lawrence, Ruth and Urban Guichon, with Andy Des Maz, 1940s. J-01168.

The family continued to grow after Lawrence's retirement, and his son Gerard and nephew Guy Rose (son of Lawrence's sister Virginia Kathleen Guichon, nicknamed Babe) became the owners of the now divided Guichon Ranch: the Gerard Guichon Ranch and the Quilchena Cattle Company. Guy, a UBC graduate with an agriculture degree, remembers that he learned everything about running a ranch through Lawrence's down-to-earth approach and attention to detail "on everything".[36] Gerard, like his father before him, served the cattle industry in many capacities and was awarded the Order of Canada for his work in taxation. In her contribution to this volume, "Stewards of the Land through Many Generations", Gerard's daughter-in-law Judith Guichon offers a rare glimpse into what the extended families had to work through as the two cousins continued to manage their respective ranches, ensuring the generational continuity of both the business and the knowledge.

The first- and second-generation Guichons in BC spoke fluent French and English and, among the third-generation, from Guy Rose's recollection, French was still commonly spoken but family members were encouraged to speak English as the working language. Bernard remembers his brothers Charles and Gerard spoke French with grandparents and Urban spoke several languages. Their family-operated Quilchena Hotel, reopened by Guy and Hilde Rose in 1958, stands as a popular tourist destination today and is an integral part of "local history and legend"[37] as it was built upon close relations with First Nations and other Nicola Valley communities.

* * *

After H.Y. Louie's sudden death his oldest children Tim, Tong and Bill worked to support the large family and ensure the continuation of the family business against harsh economic and political challenges in Canada, expanding both beyond H.Y. Louie's imagination. This generation, building upon the hard work of the previous generation, served to break long-standing racial barriers and continued to challenge discrimination in society.

The Second World War marked a major turning point in history for Chinese Canadians, one that the Louie brothers in the second generation worked hard to be actively involved in despite government rejections. As Chinese Canadians they were not welcome in military service and had to fight their way in. Like many other Chinese Canadians they volunteered not only to serve in the army of their adopted country but also to fight for justice and franchise. Ernie Louie pushed his way into the army as a paratrooper and Guan Louie served in the Royal Canadian Air Force, first as ground crew service and then, through persistence, as a flying officer in the "Snowy Owl" squadron. Seto More's oldest son Wilfred Seto also persisted through obstacles to enter into service and attained the rank of lieutenant, serving in North Africa under General Viscount Montgomery and fighting in the Battle of El Alamein and continuing into Italy. Ernie Louie returned home after his successful service in the dangerous work of enemy surveillance and Wilfred Seto finished the war at the rank of Captain. Guan Louie, however, died in a final mission in January 1945. Their sacrifice and service, along with that of other Chinese Canadian veterans, resulted in access to citizenship, voting rights and professional fields for Chinese Canadians in 1947. Ernie Louie and Wilfred Seto were among the first to receive this hard-earned access.

Guan Louie (*lower left*) served in the RCAF during the Second World War. Courtesy of H.Y. Louie Co. Limited.

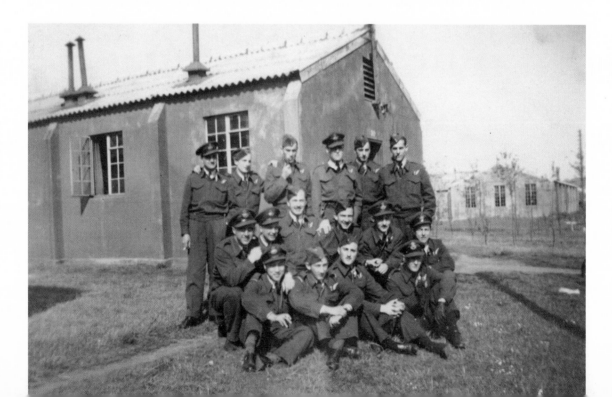

CANADIAN LEGION

WAR SERVICES Sept 7 1943.

Dear Wee.—
Thank you for your very welcome letter. Your grammar is much improved since the last time.

I hope you weren't trying to B.S. me with the picture you ~~sts~~ sent. I'm rather doubtful you could handle a fish that size. I think even I would have had trouble.

Regarding fighter aircraft.

A letter from Guan Louie to his brother Willis, written while Guan was serving in the RCAF during the Second World War.
Courtesy of Brian Louie.

In 1941, the third generation of the Setos and the second generation of the Louies were joined together by the marriage of two University of British Columbia graduates: Geraldine Seto, the second child of Seto More, and Tong Louie, the second son of H.Y. Louie. When the young couple bought a home in the expensive neighbourhood of Point Grey they encountered major controversy—a delegation working against such "intrusions" claimed they reduced property values by 20 per cent. When the city responded with a proposed "can't reside here" bylaw, the Chinese and Japanese consuls and communities united to protest it. Amazingly the protest was supported by many other organizations in Vancouver, such as the University Women's Club, the Young People's Union and others. And since the next-door neighbours warmly welcomed the Louies, the controversy gradually subsided. Through his leadership of the family company Tong Louie would become a leading industrialist and a widely respected philanthropist, and he lived in his Point Grey house until his death in 1998.

With their college education and upbringing, Tong Louie and Geraldine Seto were both at ease with Chinese Canadian intercultural lives and with society in general. They lived through times of harsh discrimination when Chinese Canadians were not entitled to Canadian citizenship and then through the gradual post-1947 integration process, during which they were known to serve as intercultural bridges. In this generation Chinese was still commonly used but, in many cases, due to societal integration, English began to replace Chinese as the common language among the fourth generation.

...we celebrate Canada as a place that brings

later generations

FROM 1979 TO 1999 Gerard's oldest son Laurie Guichon and wife Judith together managed the Gerard Guichon Ranch. Judith Guichon's piece in this volume offers a first-person perspective on this period and shares stories of the continuity of the family ranch. Guy Rose sold the Quichena Cattle Co. to the Douglas Lake Ranch in 2015, but some of his children continue to contribute to the ranching industry, as do many of their cousins of the same generation. Two of Laurie's children run the remaining portion of the Guichon Ranch.

As the family initially arrived prior to the emergence of the province and nation they identified fluidly with BC, Canadians and the French by the time of settlement in the 1870s. In this case land, which has mostly remained in the hands of the same family, has served as the anchor for identity formation. Over several generations the families have continued to act as its stewards and their accounts of ranch life and a close-knit lifestyle with neighbours, cowboys and workers of First Nations, Chinese and other descents characterize BC's intercultural history.

* * *

The H.Y. Louie Company continued from Tong Louie to his son Brandt and, with extensions into different fields of business, it has become one of the largest companies based in western Canada. The generational continuity has so far ensured the continuation of core family values in business practices and, like Lawrence Guichon in 1953, both Tong Louie in 1990 and Brandt Louie in 2016 received honorary doctoral degrees from the University of British Columbia for their long-term contributions to the province and the nation. The Louie children grew up with children of the Seto, Lew and other extended families[38] that shared the value of education. The bond of this early close-knit family network, formed against the background of discriminatory acts, continues to this day. Their experiences have shaped, and been shaped by, key moments in BC, Chinese Canadian and Canadian history.

that diversity together
 and—like all families—is constantly evolving.

Both the Guichon and Louie-Seto families started in British Columbia and Canada before province and nation were established and, through their persistence, generational continuity of family work experiences, access to marital choices in the early days, emphasis on education and intercultural lives, their families have survived and prospered. Each generation has had their share of individual and collective historical and identity-defining choices and, through their family stories, the perceptions and definitions of BC and Canada as political entities are constantly being redefined.

Canada turns 150 in 2017 and, at this historical juncture, is renowned as one of the few western countries to embrace multiculturalism through policy, referencing it as an important part of Canadian nationhood. No one can claim to know everyone in our Canadian family; we are too large and too diverse. But we celebrate Canada as a place that brings that diversity together and—like all families—is constantly evolving. That is worth celebration.

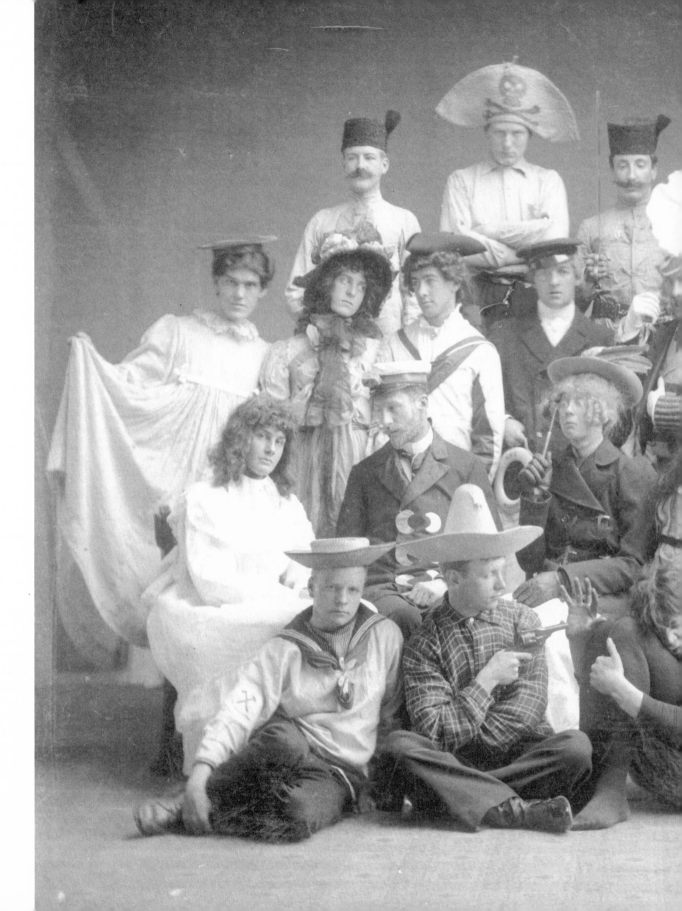

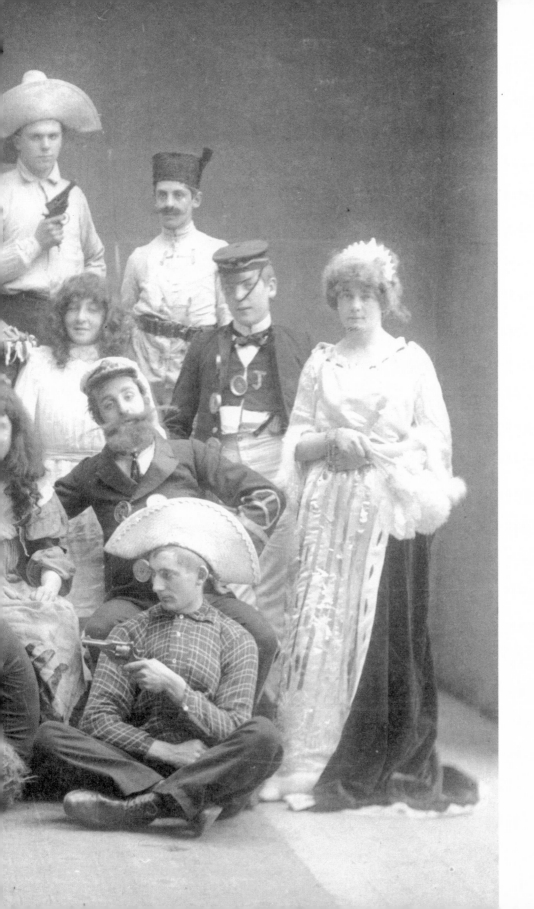

The officers of HMS
Warspite in costume
for a pantomime of
Robinson Crusoe, 1901.
F-03648.

The Loewen sisters
and their dog, *ca.* 1900.
The sign indicates they
are quarantined for
Scarlet Fever. C-08574.

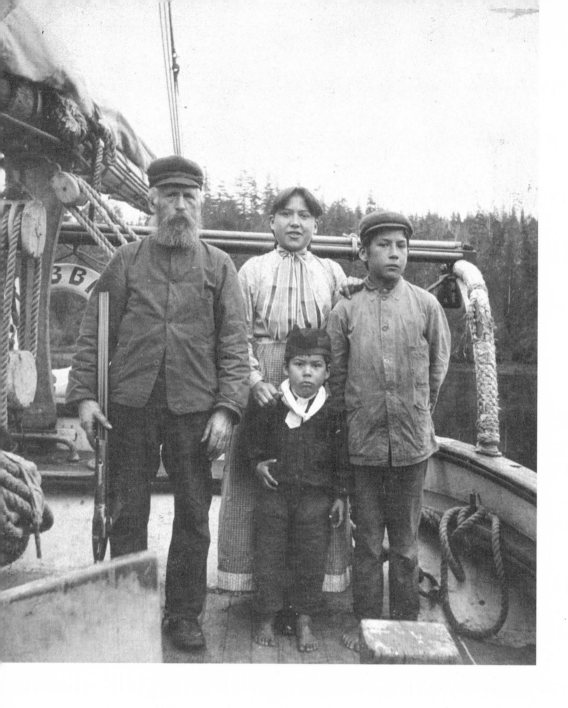

The Thornberg family,
ca. 1895. C-04898.

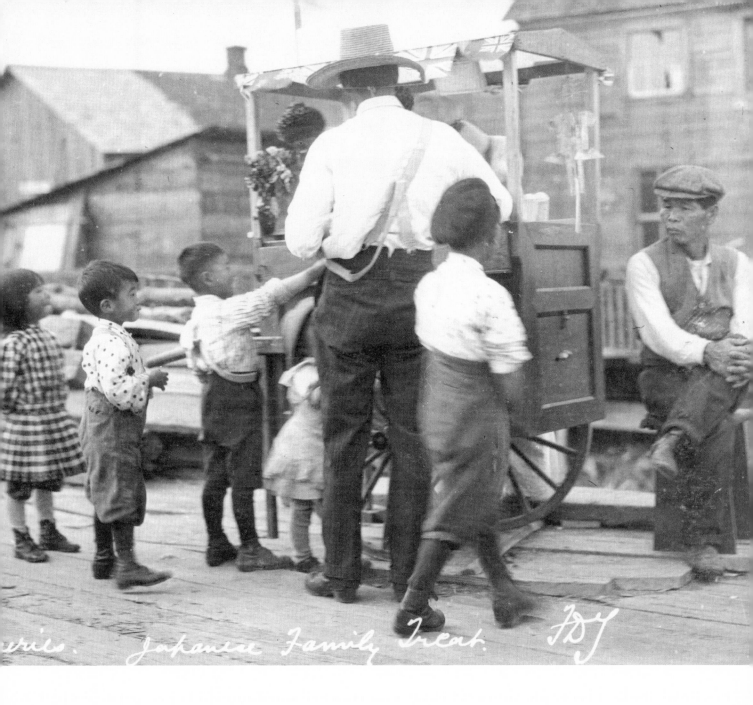

eries. Japanese Family Treat. FDT

BC Canneries, Japanese
family treat, 1912.
Frederick Dundas Todd
photograph. E-05073.

Doukhobor family,
ca. 1900. D-01140.

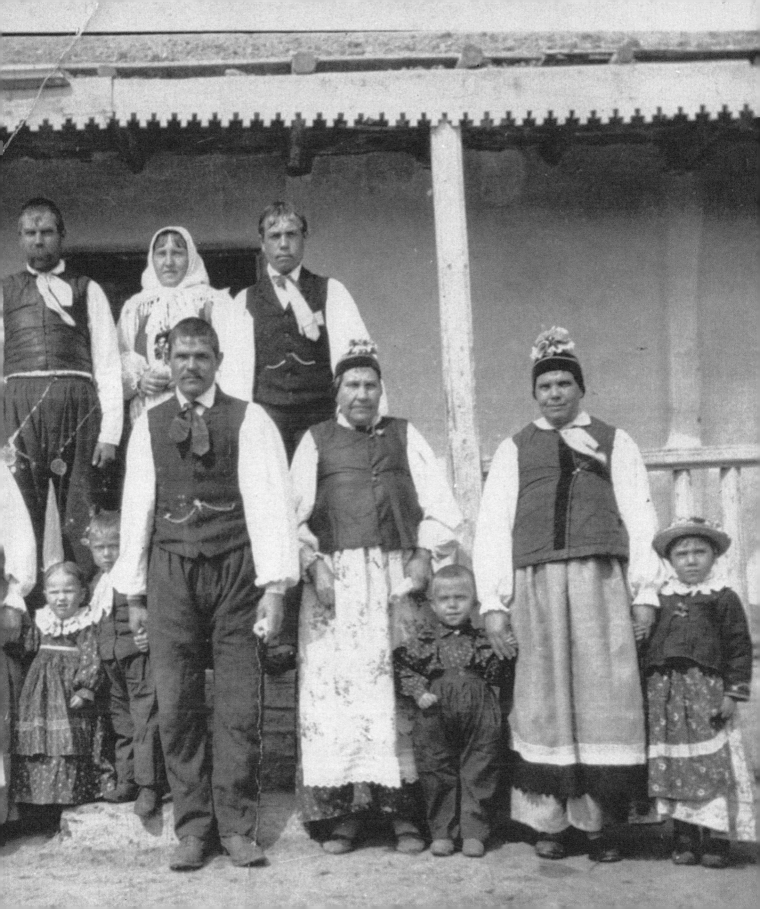

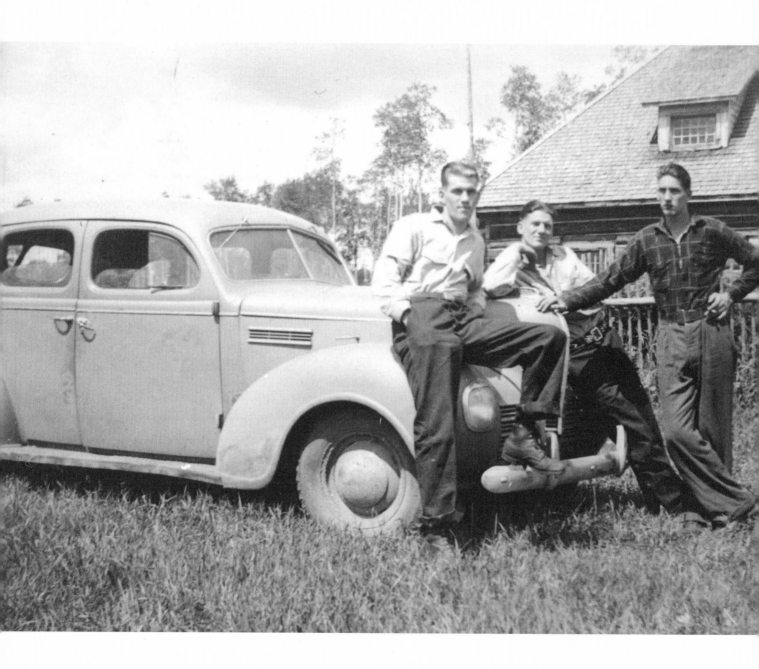

Garnet, Buel and
Hilbert Anderson in
front of their home at
Palling, BC, *ca.* 1935.
B-02101.

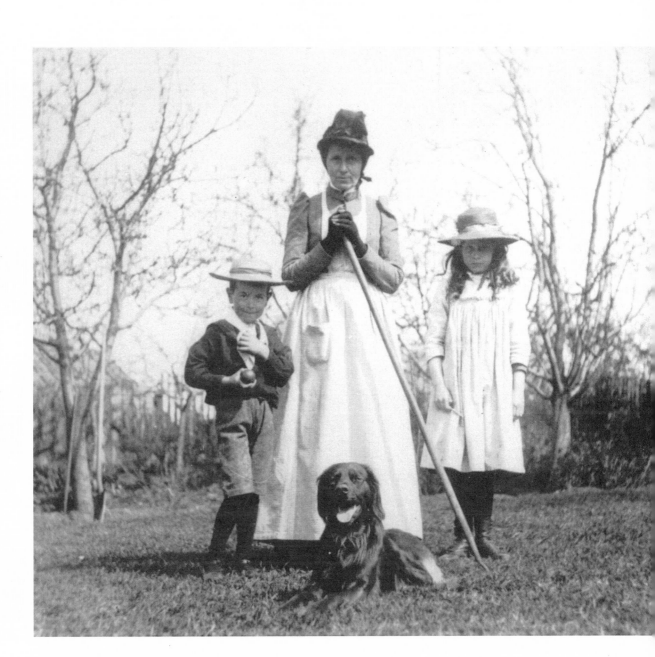

Mrs. J.H. Todd and
her children. C-06827.

contributors

MICHELLE VAN DER MERWE has been the publisher at
the Royal BC Museum and Archives since 2015. Her
background includes design and journalism, and her
extensive editing experience comes from many years of
both in-house and contract projects that have included
fiction and non-fiction books, magazines and corporate
communications. Michelle has been a contributing
editor at *Geist* magazine since 2004, was a member-
at-large on the board of the Magazine Association of
BC in 2014–2015, has sat as a director on the National
Executive Council of the Editors' Association of Canada
for the past four years and is an active member of both
the Association of Book Publishers of BC and the
Association of Canadian Publishers.

SADHU BINNING, a bilingual author, has lived in
the Vancouver area since migrating to Canada in 1967.
He has published eighteens books of poetry, fiction,
plays, translations and research and his works have been
included in numerous anthologies both in Punjabi and
English. He edited a literary Punjabi monthly, *Watno
Dur*, and co-edits a quarterly, *Watan*. Sadhu is a central
figure in the Punjabi arts community and a founding
member of Vancouver Sath, Ankur and various other
literary and cultural organizations. He has been actively
promoting Punjabi language education in BC as vice
president of Punjabi Language Education Association.
Sadhu retired after teaching Punjabi at the University
of British Columbia for 20 years.

MARTHA BLACK has been curator of ethnology at the Royal BC Museum since 1997 and prior to that she was curator and associate director of the Isaacs Gallery in Toronto. Martha has worked on many collaborative exhibitions and projects with First Nations and on repatriation within and outside of the treaty negotiation process. She has taught at the University of Victoria and lectured throughout Canada and abroad. Her publications include *Out of the Mist: Treasures of the Nuu-chah-nulth Chiefs* (RBCM 1999) and *Bella Bella: A Season of Heiltsuk Art* (Douglas & McIntyre 1997) and she was one of five authors who contributed to *Treasures of the Royal British Columbia Museum and Archives* (RBCM 2015).

DON BOURDON is the curator of images and paintings at the Royal BC Museum and Archives. He has worked in the archives and museum fields for over forty years in British Columbia and Alberta, focusing on collections development, preservation and access. Don has a lifelong fascination with photography and has examined countless family photographs and albums in his work at the North Vancouver Museum and Archives, the City of Vancouver Archives, the Glenbow Archives (Calgary), and as head archivist at the Whyte Museum of the Canadian Rockies (Banff) for 23 years. He is an honorary life member of the Archives Society of Alberta.

KATHRYN BRIDGE is a curator of history and art at the Royal British Columbia Museum and Archives and an adjunct faculty member in the Department of History at the University of Victoria, UVic. She has authored several books on women in 19th- and early 20th-century British Columbia and on Emily Carr, is currently revising her dissertation "Being Young in the Country: Settler Children in British Columbia and Alberta, 1860–1925" for publication and has curated exhibitions on Emily Carr, the gold rush and other BC topics.

Kathryn's early career as an archivist provided her with an in-depth knowledge of the BC Archives holdings, which have been integral to most of her research and project outputs.

TZU-I CHUNG is curator of history at the Royal British Columbia Museum and Archives. Her current research focuses on the intercultural history of British Columbia within historical, cultural and economic contexts, and on transnational migration theories. Her publications can be found in *Museum and Society, Aspects of Transnational and Indigenous Cultures* and other journals. Her Centre of Arrivals project is part of the museum's long-term commitment to exploring and sharing the stories of BC's diverse migrants through research, collection, exhibitions and education.

SHUSHMA DATT was raised in Kenya, graduated from the University of New Delhi and then moved to London, England, where she received her broadcast training with the BBC. She was also the foreign correspondent for the *Times of India* while in London. In 1972 Shushma moved to Canada where she has since worked as a radio and TV host. She started Canada's first South Asian radio station in 1987 and has been dedicated to encouraging intercultural harmony and cross-cultural understanding. Shushma has received many awards, including the Order of British Columbia in 1992.

MO DHALIWAL is a business and community leader in Vancouver. He worked in the Silicon Valley in software development prior to founding his own firm, Skyrocket Digital. With a deep appreciation and articulation for cultural diversity he set out on a personal mission to shatter barriers and encourage cross-cultural understanding. Mo was recognized for his contributions by Business for the Arts as the national recipient of the Arnold Edinborough Award, and has been awarded

the Queen Elizabeth II Diamond Jubilee Medal. Mo founded the Vancouver International Bhangra Celebration and serves on the boards of many prominent arts organizations.

ZOÉ DUHAIME is a Gender Studies and Religious Studies student at the University of Victoria, and she has been writing and performing poetry for the past eight years. Highlights from her pursuits in writing include mentoring young poets, having been the Youth Poet Laureate of Victoria (2015) and being permanently featured in the Hall of Honours of the Legislative Assembly of BC. She currently works as a ghostwriter of love letters/apologies/obituaries/vows/etc. Her work, inquiries, and collections are known as The Rabbit Writes and The Engineer's Lullaby (in collaboration with Amrit Thind). She lives and writes in Victoria, BC.

BARBARA FINDLAY is an old fat white lesbian lawyer with disabilities. She was raised working class and Christian on the prairies. The greatest honour of her life was being adopted in 2001 by the Wet'suwet'en people. When she is not lawyering barbara does work on unlearning oppression, particularly as a white settler in relation to racism and colonialism.

LYNN GREENHOUGH: Just as we read God's Self – description in Torah (I was, I am and I will be), so too are we. All our lives have been, are now, and will continue to be. In each moment. I once was a daughter, then I became a sister, and now I am daughter, sister, cousin, aunt, friend, wife, mother and grandmother. My work is to remember that while each moment is life, each moment is also death and that I have been called to do the best I can with those moments between my birth and my death.

JUDITH I. GUICHON was born in Montreal, the youngest of six. After travels in Europe, the West Indies and the US she left Montreal and drove across Canada to Whitehorse, Yukon, where she met and married commercial pilot Lawrence (Laurie) Guichon. In January 1972 they moved to Laurie's family ranch in the Nicola Valley where they raised four children. Judith served on the hospital board, 4-H, and Community Round Table, became president of the BC Cattlemen's Association and served on the Grasslands Conservation Council and Species at Risk Task Force. In November 2012 she was appointed Lieutenant Governor of BC.

LORNE F. HAMMOND joined the Royal BC Museum in 1997. A graduate of the University of Ottawa, he did Fulbright work at Columbia University. His writing includes papers on the Columbia River Treaty; oil tankers and pipelines; and Confederation politics and natural history. His exhibition work considers: BC's Italian communities; war; medical and religious history; surveying; the 1858 gold rush; and 1960s pop culture. Publications include entries in the *Oxford Companion to Canadian History, Canada Collects: Treasures from across the Nation, Environmental History, Making and Moving Knowledge, ORNAMENTVM, Public History*, and *Stewards of the People's Forests* (RBCM 2014).

JOY KOGAWA was born in Vancouver in 1935 and is best known for her novel *Obasan*, which was published in 1981. Her latest work, *Gently to Nagasaki*, is non-fiction and was published in 2016. Joy has received numerous honorary doctorates, the Order of British Columbia, the Order of the Rising Sun from Japan, and the Order of Canada. She lives in Toronto and Vancouver.

PATRICK LANE is an Officer of the Order of Canada and one of Canada's pre-eminent poets. His awards include the Governor General's Award for Poetry, the Canadian Authors Association Award, the Lieutenant Governor's Award for Literary Excellence and three National Magazine Awards. His distinguished career spans 50 years and 25 volumes of poetry as well as award-winning books of fiction and non-fiction. He has been a writer in residence and teacher at Concordia University in Montreal, Quebec, the University of Victoria in British Columbia and the University of Toronto in Ontario. Patrick Lane lives near Victoria, BC, with his wife, the poet Lorna Crozier.

JACK LOHMAN is chief executive officer of the Royal BC Museum and Archives, professor in Museum Design and Communications at the Bergen National Academy of the Arts in Norway and vice-president of the Canadian Museums Association. His most recent books are *Museums at the Crossroads?* (RBCM 2013) and *Treasures of the Royal BC Museum and Archives* (RBCM 2015).

LUKE MARSTON was born on Vancouver Island to carvers Jane and David Marston. He worked first with Coast Salish Master Carver Simon Charlie and later at the Royal British Columbia Museum's Thunderbird Park. He has exhibited locally as well as internationally, with commissioned work for the Canadian Government, the Lieutenant Governor of British Columbia and the Nanaimo Airport. Amongst his works are a healing bentwood box for the National Truth and Reconciliation Commission, and *Shore to Shore*, a bronzed sculpture at Stanley Park in Vancouver, BC, that commemorates the adventures of Portuguese Joe and his Coast Salish family.

BEV SELLERS is a former councillor and chief of the Xat'sull (Soda Creek) First Nation in Williams Lake, British Columbia. She served as Chief from 1987–1993 and again from 2009–2015. She has a degree in history from the University of Victoria and a law degree from the University of British Columbia. Bev is the author of *They Called Me Number One*, a memoir of her childhood experience in the Indian residential school system and its aftereffects. Her book *Price Paid: The Fight for First Nations Survival* looks at the history of Indigenous rights in Canada from an Indigenous perspective.

MONIQUE GRAY SMITH is of Cree (Peepekisis First Nation), Lakota and Scottish descent and is the proud mom of 13-year-old twins. She is an award winning author, international speaker and sought-after consultant. Monique has been sober and involved in her healing journey for over 25 years and is well known for her storytelling, spirit of generosity and focus on resilience. She and her family are blessed to live on Lekwungen territory in Victoria, BC.

ANN-BERNICE THOMAS is the 2016 Youth Poet Laureate of Victoria, BC. She has been writing all of her life, but she was pushed into spoken word poetry in 2014 and hasn't stopped since. In her 20 lively years she has lived in England, Jamaica and Aurora (GTA), and she now resides in Victoria as she completes her double major in Theatre and Creative Writing at the University of Victoria. Amongst other things, Ann-Bernice has delivered a TEDx Talk discussing the damaging effects of the 'Oreo' category (2017), and performed at Victoria's Ferguson Rally (2014), the Scotiabank AIDS Walk for Life (2015) and Victoria's Canada Day celebrations (2016).

LARRY WONG was born in Vancouver's Chinatown, attended the University of British Columbia and worked with the federal government as a financial planner. After his retirement he became a member of the Asian Canadian Writers Workshop and wrote a short play, *Siu Yeh*, which was produced at the Firehall Art Centre in 1995. He has been a director, curator and historian at the Chinese Canadian Military Museum Society and the founding director of the Chinese Canadian Historical Society of BC. Larry's stories of early Chinatown appeared in a 2007 anthology, *Eating Stories: A Chinese Canadian & Aboriginal Potluck*, which was reprinted in Learning Chinese Canada. His latest book is *Dim Sum Stories: A Chinatown Childhood* (Chinese Canadian Historical Society of BC, Gold Mountain Stories: 2011).

The Burrell family out for a walk on Oak Bay Avenue, *ca.* 1890. G-03353.

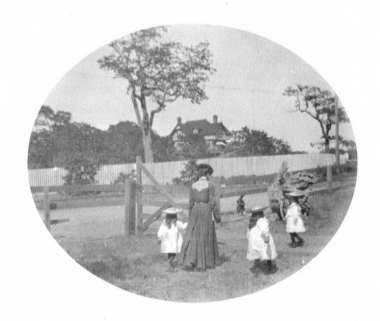

endnotes

embracing the family

1 RBCM 2007.37.1A-N.

2 Thomas King, *The Inconvenient Indian: A Curious Account of Native People in North America* (Toronto: Anchor, 2013), 162.

3 Wayson Choy, *Paper Shadows: A Chinatown Childhood* (Toronto: Penguin, 1999).

4 MS-3132, BC Archives.

5 Joy Kogawa, *Obasan* (Toronto: Lester & Orpen Dennys, 1981; repr. New York: Anchor Books, 1994), 53.

6 Andrew Solomon, *Far from the Tree: Parents, Children and the Search for Identity* (New York: Vintage, 2014), 211. Solomon discusses People First in his chapter on children and adults with Down's syndrome.

7 Ibid., 28.

8 King, *The Inconvenient Indian*, 213–14.

9 Walt Whitman, "The Sleepers," in *Complete Poems and Selected Prose* (Boston: Houghton Mifflin Company, 1959), 302.

in the name of education

1 In 19th-century and early 20th-century British Columbia, settler children and their families lived in towns and rural communities spread thinly over a large landscape. The settler society was mixed in terms of ethnicity, social class, gender and age; despite its distinctiveness in relation to the Indigenous peoples, it was not by any means uniform. Most settlers in British Columbia during this period were of British descent—their parents or grandparents were born in England, Scotland or Ireland. Others hailed from elsewhere in Europe, Canada or the United States, and a minority came from Asia.

2 Scholars offer various perspectives on how historical children matured and on the influences crucial to their growing. Leonore Davidoff, in *The Family Story: Blood, Contract and Intimacy, 1830–1960* (London: Longman, 1999), argues for the familial rubric (the physical situation of the family living together); Ellen Ross in *Love and Toil: Motherhood in Outcast London, 1870–1918* (New York: Oxford University Press, 1993) discusses the influence of the wider household, circle of friends and neighbourhood, as does Howard P. Chudacoff in *The Age of*

the Bachelor: Creating an American Subculture (Princeton, NJ: Princeton University Press, 1999), 22. In Searching the Heart: Women, Men, and Romantic Love in Nineteenth-Century America (New York: Oxford University Press, 1993), Karen Lystra contends that identity was formed, articulated and developed not only through physical interaction but also through letter writing.

3 Families invested financially in the education of their children —it was a priority, and it was an expensive process. Tuition alone was costly—it was to exclusive schools that children —boys in particular—were sent. Room and board, travel expenses, monthly allowances and the inevitable additional cost of clothing and doctor's or dentist's bills all contributed to a situation whereby a child's family often had to economize at home to support the child's education. For some families, keeping up appearances became an obsession, or at the very least an influence on daily life. Often families had more than one child away at boarding school at a time, or the children exchanged places, one returning home after schooling while another took his place. The financial strain of these activities on families has been underplayed in examinations of settler societies, of founding families and of community elite.

4 Henry Crease to Reverend P. Deedes, 20 July 1890. Henry Pering Pellew Crease papers, MS-55, box 1, f. 2, BC Archives.

5 Sarah Crease to Josephine Crease, 2 October 1890, MS-2879, BC Archives.

6 North American boarding schools for boys (and later girls) became increasingly available in the late 19th century and early 20th century. They were modelled on male British public schools and were often located in distant cities, in other provinces (chiefly Ontario) or in the United States. By the second decade of the 20th century, these establishments had become the norm for parental consideration.

7 Henry Crease to Josephine Crease, 3 June 1890, MS-2879, BC Archives.

8 In 1871 the Aboriginal population in British Columbia was almost 71 per cent of the total counted. Ten years later, the white settler population was less than 35 per cent of the total population; 8.8 per cent of residents were Asian, meaning 52 per cent were Aboriginal. Jean Barman, The West Beyond the West: A History of British Columbia (Toronto: University of Toronto Press), 363. For an examination of the changing attitudes of colonist to colonized as reflected in dress and behaviour, see E. M.

Collingham, Imperial Bodies: The Physical Experience of the Raj, c. 1800-1947 (Cambridge: Polity Press, 2001).

9 For discussion of the culture of respectability and racial exclusion (sturdy manhood and domesticated femininity) see Catherine Hall, "Of Gender and Empire: Reflections on the Nineteenth Century," in Gender and Empire, ed. Philippa Levine (Oxford: Oxford University Press, 2004), 46-77.

10 Fiona Paisley, "Childhood and Race: Growing Up in the Empire," 240-260, and Patricia Grimshaw, "Faith, Missionary Life and the Family," 260-281, in Levine, Gender and Empire.

11 Jean Barman, Growing Up British in British Columbia: Boys in Private School (Vancouver: University of British Columbia Press, 1984).

12 My larger study of settler children locates and analyzes the letters and diaries of over 50 children sent away for schooling, whose writings, alongside those of their parents, reveal the disconnection and heartache that characterized growing up and parenting at a distance.

13 Josephine Crease to Lindley Crease, 23 November 1879, MS-2879, BC Archives.

14 Josephine Crease to Lindley Crease, 29 March 1883, MS-2879, BC Archives.

15 Josephine Crease to Lindley Crease, 23 November 1879, MS-2879, BC Archives.

16 Lindley Crease to Sarah Crease, 24 February 1878, MS-2879, BC Archives.

17 Josephine Crease to Lindley Crease, 31 January 1881, MS-2879, BC Archives.

18 Arthur Crease to Lindley Crease, 18 January 1878, MS-2879, BC Archives.

19 Letters of Arthur Crease to Lindley Crease, 1878 through 1884, MS-2879, BC Archives.

20 Arthur Crease left for England on March 20, 1886. "Personal," British Colonist, 13 March 1886.

21 Jack O'Reilly to Frank O'Reilly, 10 May 1885, MS-2894, BC Archives.

22 Jack O'Reilly to Frank O'Reilly, 10 May 1885, MS-2894, BC Archives.

23 Jack O'Reilly to Kathleen O'Reilly, 3 December 1885, MS-2894, BC Archives.

24 Nancy Chodorow argues in *The Reproduction of Mothering: Psychoanalysis and the Sociology of Gender* (Berkeley: University of California Press, 1999) that women's mothering is taken for granted and rarely analyzed—that it is not a product of biology or intentional role training but is built into the mother-daughter relationship. The expectation that Kathleen O'Reilly should mother her brother is one result of the differences between mother–infant daughter and mother–infant son relationships, which led to feminine and masculine development that would recreate this mothering.

25 Jack O'Reilly to Peter O'Reilly, 7 July 1884, MS-2894, BC Archives.

26 Jack O'Reilly to Peter O'Reilly, 12 October 1884, MS-2894, BC Archives.

27 Jack O'Reilly to Peter and Caroline O'Reilly, 21 September 1885, MS-2894, BC Archives.

28 Jack O'Reilly to Kathleen and Caroline O'Reilly, 19 September 1886, MS-2894, BC Archives.

29 Jack O'Reilly to Kathleen O'Reilly, 19 October 1886, MS-2894, BC Archives.

30 Jack O'Reilly to Peter and Caroline O'Reilly, 26 April 1886, MS-2894, BC Archives.

31 Jack O'Reilly to Kathleen O'Reilly, 12 December 1886, MS-2894, BC Archives.

32 Jack O'Reilly to Kathleen O'Reilly, 12 August 1886, MS-2894, BC Archives.

33 Jack O'Reilly to Kathleen O'Reilly, 12 December 1886, MS-2894, BC Archives.

34 Jack O'Reilly to Kathleen O'Reilly, 19 September 1886, MS-2894, BC Archives.

35 Jack O'Reilly to Kathleen O'Reilly, 14 February 1886, MS-2894, BC Archives.

36 Lindley Crease to Sarah Crease, 29 June 1885, MS-2879, BC Archives.

37 Lindley Crease to Sarah Crease, 29 June 1885, MS-2879, BC Archives.

38 For examination of boy culture and boarding schools see Deslandes, *Oxbridge Men: British Masculinity and the Undergraduate Experience, 1850–1920* (Bloomington, IN: Indiana University Press, 2005); Tosh, *A Man's Place: Masculinity and the Middle-Class Home in Victorian England* (New Haven: Yale University Press, 1999); Tosh, *Manliness and Masculinities in Nineteenth-Century Britain: Essays on Gender, Family, and Empire* (New York: Pearson Longman, 2005).

39 The "sensuous body with musculature tuned by daily routines to draw parts of its physical surroundings into itself … patterns interiorized so thoroughly as habit memory and honed reflex that we might say they have become part of the self." Joy Parr, "Notes for a More Sensuous History of Twentieth-Century Canada: The Timely, the Tacit, and the Material Body," *Canadian Historical Review* 82, no. 4 (2001): 729. Embodiment is then "the remembered experiences in which the body figured prominently." Mona Gleason, "Embodied Negotiations: Children's Bodies and Historical Change in Canada, 1930 to 1960," *Journal of Canadian Studies* 34, no. 1 (1999): 113.

40 Jack O'Reilly to Peter O'Reilly, 16 March 1887, MS-2894, BC Archives.

41 Data from the 1901 census reveals that children under 15 in BC accounted for 25.5 per cent of the population and that the adult settler population was largely male with adult mean ages under 30. See also table 2.1 in Peter Gossage and Danielle Gavreau, "Canadian Fertility in 1901: A Bird's-Eye View," in *Household Counts: Canadian Households and Families in 1901*, eds. Eric W. Sager and Peter Baskerville (Toronto: University of Toronto Press, 2007), 59–109. For implications of the gender imbalance in BC see Adele Perry, *On the Edge of Empire: Gender, Race, and the Making of British Columbia, 1849–1871* (Toronto: University of Toronto Press, 2001).

at our best

1 See, for example, Jonathan Carson, Rosie Miller and Theresa Wilkie, *The Photograph and the Album: Histories, Practices and Futures* (Edinburgh: MuseumsEtc, 2013).

2 Online Etymology Dictionary, s.v. "album," http://www. etymonline.com/index.php?allowed_in_frame=0&search =album. In the Victorian era, 'scrap' referred to die-cut colour lithographic decorative collectibles that were pasted into scrapbooks. "Victorian Scraps," Ephemera Society of America, http://www.ephemerasociety.org/features-toggle.html.

3 Elizabeth Seigel, *Galleries of Friendship and Fame: A History of Nineteenth-Century American Photograph Albums* (New Haven: Yale University Press, 2010), 2, 70.

4 "Snapshot (n.) also snap-shot, 1808, 'a quick shot with a gun, without aim, at a fast-moving target,' from snap + shot (n.). Photographic sense is attested from 1890. Figuratively, of something captured at a moment in time, from 1897." *Online Etymology Dictionary*, s.v. "snapshot," http://www.etymonline.com/index.php?term=snapshot.

5 Martha Langford, *Telling Pictures and Showing Stories: Photographic Albums in the Collection of the McCord Museum of Canadian History* (Montreal: McCord Museum, 2005), http://collections.musee-mccord.qc.ca/notman_doc/pdf/EN/ENG-ALBUMS-final.pdf 2005 and Martha Langford, *Suspended Conversations: The Afterlife of Memory in Photograph Albums* (Montreal: McGill-Queen's University Press, 2001). Langford has pioneered the concept of the album as aide memoire.

6 The Funamoto album is now held in the BC Archives under accession number 197912-053.

7 Tim Clark, "The Vanishing Art of the Family Photo Album," *Time*, September 3, 2013, http://time.com/3801986/the-vanishing-art-of-the-family-photo-album/.

8 Stan Horaczek, "Google Photos Will Now Automatically Create Albums From Your 'Best' Photos and Videos," *Popular Photography*, March 23, 2016, http://www.popphoto.com/google-photos-will-now-automatically-create-albumbs-from-your-best-photos-and-videos.

museum collecting
with families

1 The Crossroads Museum collection, known to staff as the Watson collection, is RBCM 971.61.1-4401. Despite a lack of provenance, the collection remains useful due to the wide range of domestic culture and occupational tools represented within it.

2 Leonard Timothy Sandall Lyons was born in Nanaimo, BC, in 1966, the younger of Leonard and Mary Lyons's two sons. He died in Vancouver, BC, in December 1986. Collections documenting the life of a young man are rare. Terry Eade worked with his mother on RBCM 2003.17; I worked with her on additions (RBCM 2011.285).

3 The bowl is now BC Archives PDP10101. The incised signature on the base is 'Klee Wyck,' the First Nations name given to Emily Carr. It means 'the laughing one'.

4 Among Myfanwy Spencer Pavelić's most admired portraits are those of Prime Minister Pierre Elliott Trudeau (1919–2000), violinist Yehudi Menuhin (1916–1999) and actress Katharine Hepburn (1907–2003). Her works hang in Canada's parliament, the National Portrait Gallery in London, England, and the Maltwood Collection of the University of Victoria. See also Jack Hardman, Myfanwy Spencer Pavelić: a Selection of Works, 1950–1978. (Burnaby, BC: Burnaby Art Gallery, 1978); Patricia Bovey, *Myfanwy Pavelić: Inner Explorations* (Victoria: Art Gallery of Greater Victoria, 1994); and The Art of Myfanwy Pavelić, (Victoria: UVic TV Productions, 1992), videocassette.

5 The initial collection donated by Myfanwy Pavelić contained a variety of work by BC silversmith Maurice Carmichael (RBCM 998.86). She later donated family jewellery (RBCM 999.162). The family portraits were her last donation (RBCM 2000.19).

6 The 574 Bossi family objects arrived in three donations: RBCM 988.67, RBCM 992.19 and RBCM 998.11. Additional Bossi material is contained in RBCM 2013.118, donated by a close family friend and student of.Olga Bossi whose mother had trained with them as a teacher.

7 Bruce Peel, "Connolly, Suzanne," in *Dictionary of Canadian Biography*, vol. 9, University of Toronto, 2003–. http://www.biographi.ca/en/bio/connolly_suzanne_9E.html. See also Sylvia Van Kirk, Many Tender Ties: Women in Fur-Trade Society, 1670–1870 (Norman, OK: University of Oklahoma, 1983).

8 Helmcken donations include the building itself and the core collection with the family home—HH1988—but also individual donations in 1963, 1965, 1976, 1990, 2003, 2005, 2006, 2008 and 2017.

9 Some objects associated with Douglas family history are found within the Helmcken collection. Douglas material arrived in 1964, 1965, 1967, 1969, 1971, 1974, 1975, 1976, 1980, 1987, 1988, 1989, 1997, 1998, 2001, 2002, 2006, 2009 and 2011. Important Sir James Douglas items, such as his cane, remain with the family.

10 Theodore took up residence in our museum as RBCM 2003.25.1. Eleanor was bedridden for 15 months from 1906 to 1908. The manufacturer's button shows Theodore was made between the years 1908 and 1911.

11 The Pankratz collection is an ongoing acquisition. Family photographs are intended to follow. So far, there have been two accessions, RBCM 2012.121 and 2015.2, in addition to approximately 60 pages of transcribed interviews made during collecting.

12 The Mason sewing machine is RBCM 121.297a-b. Mr. Mason's interview was transcribed. He insisted his son overhaul Sally Pankratz's machine before it was donated.

13 Some refused to have their children attend school because of compulsory prayers, national anthems or the glorification of war and religion. They feared that their children would be indoctrinated and led away from their faith. Children were forcibly taken by the state. Homemade bombs were used in retaliation and things fell apart. Some Freedomites left Canada for South America.

14 The Fillipoff collection, RBCM 997.124.1, includes objects associated with post-commune farm life and textile and weaving materials, 1920s homespun material and some Russian language books. In 2000, Daniel Zarchikoff donated clothing worn by his grandparents Mary and Peter (RBCM 200.91). Both were born in Canada and spoke no English. They lived at the Claybrick commune at Winlaw in the 1920s. Neither donation was purchased.

15 Tent City collection, RBCM 2016.167. The plight of people living on the street reached a crisis point in 2016, as sky-rocketing real estate values, a lack of new social housing, in-migration from other provinces, overloaded social services, the arrival of cheap and deadly drugs, the deinstitutionalization of those with mental health issues, the closing of group homes and the conversion of hotels into condominiums contributed to a severe shortage of low-income housing. The right to camp overnight for the homeless began as a legal challenge in 2009. Among the outcomes of the Tent City movement was a pronounced increase in social housing.

all the related people

1 Martha Black, *HuupuKwanum.Tupaat: Out of the Mist; Treasures of the Nuu-chah-nulth Chiefs* (Victoria: Royal British Columbia Museum, 1999), 19.

2 Jennifer Webb, ed., *Objects and Expressions: Celebrating the Collections of the Museum of Anthropology at the University of British Columbia*, Museum Note 35 (Vancouver: University of British Columbia Museum of Anthropology, 1999), 61.

3 See, for example, Peter Macnair, Alan L. Hoover and Kevin Neary, *The Legacy: Continuing Traditions of Canadian Northwest Coast Indian Art* (Victoria: Royal BC Museum, 2007), and Aldona Jonaitis, *Art of the Northwest Coast* (Vancouver: Douglas and McIntyre, 2006), 255–267.

4 See *Thunderbird Park: Place of Cultural Sharing*, Royal BC Museum, 2009, http://www.royalbcmuseum.bc.ca/exhibits/tbird-park/main.htm?lang=eng.

5 See Bill Holm, "Will the Real Charles Edenshaw Please Stand Up? The Problem of Attribution in Northwest Coast Indian Art," in *The World Is as Sharp as a Knife*, ed. Donald N. Abbott (Victoria: British Columbia Provincial Museum, 1981) 175–200, and Kathryn Bunn-Marcuse, "Form First, Function Follows: The Use of Formal Analysis in Northwest Coast Art History," in *Native Art of the Northwest Coast: A History of Changing Ideas*, eds. Charlotte Townsend-Gault, Jennifer Kramer, and Ki-Ke-In (Vancouver: University of British Columbia Press, 2014), 404–443.

6 Carlo Ginzburg and Anna Davin, "Morelli, Freud and Sherlock Holmes: Clues and Scientific Method," *History Workshop* 9 (Spring 1980), 5–36.

7 For example, Holm, "Will the Real Charles Edenshaw Please Stand Up?" and Dinah Augaitis et al., *Raven Travelling: Two Centuries of Haida Art* (Vancouver: Vancouver Art Gallery, 2006).

8 Robin K Wright, *Northern Haida Master Carvers* (Seattle: University of Washington Press, 2001), 220.

9 James Andrew McDonald and the Kitsumkalum Education Committee, *People of the Robin: the Tsimshian of Kitsumkalum; A Resource Book for the Kitsumkalum Education Committee and the Coast Mountain School District 82* (Edmonton, AB: CCI Press, 2003) 41.

10 McDonald, *People of the Robin*, 46.

11 Cara Krmpotich, *The Force of Family: Repatriation, Kinship, and Memory on Haida Gwaii* (Toronto: University of Toronto Press, 2014), 74.

12 Krmpotich, *The Force of Family*, 6.

13 Quoted in Krmpotich, *The Force of Family*, 47.

14 Wright, *Northern Haida Master Carvers*, 300–301.

15 John A. Murray Jr. to Francis Kermode, December 20, 1923. Copy in ethnology collection files.

16 *Report of the Provincial Museum of Natural History for the Year 1924* (Victoria: Province of British Columbia, 1925).

17 Erna Gunther, *Klallam Ethnography* (Seattle: University of Washington Press, 1927), 264.

18 Elida Peers and Sooke Region Museum, *The Sooke Story: The History and the Heartbeat* (Sooke, BC: Sooke Region Historical Society and Sooke Region Museum, 1999).

19 Record Group 10, vol. 1343, 1902–04, Department of Indian Affairs, Ottawa.

20 Clellan S. Ford, *Smoke from Their Fires: The Life of a Kwakiutl Indian Chief* (New Haven: Yale University Press, 1941). The museum also has a collection of silver bracelets that were purchased from Nowell in 1914 by Charles F. Newcombe.

21 The portraits are reproduced in her book, *Potlatch People: Indian Lives and Legends of British Columbia* (Surrey: Hancock House, 2003), with the captions reversed. The portrait of Herbert Johnson was sold by Uno Langmann Gallery, Vancouver.

22 G. D. Brown and W. K. Lamb, "Captain St. Paul of Kamloops," *British Columbia Historical Quarterly* 3, no.2 (April 1939): 115-128, and Mary Balf, "Lolo, Jean-Baptiste," in *Dictionary of Canadian Biography*, vol. 9 (Toronto: University of Toronto, 2003–), accessed September 26, 2016, http://www.biographi.ca/en/bio/lolo_jean_baptiste_9E.html.

23 R. C. Mayne, *Four Years in British Columbia and Vancouver Island: An Account of Their Forests, Rivers, Coasts, Gold Fields and Resource for Colonization* (London: John Murray, 1862), 118–129.

24 Madge Wolfenden, "Tod, John," in *Dictionary of Canadian Biography*, vol. 11 (Toronto: University of Toronto Press, 2003–), accessed September 26, 2016, http://www.biographi.ca/en/bio/tod_john_11E.html, and John Tod, "Career of a Scotch Boy," edited with an introduction and notes by Madge Wolfenden (Victoria: Archives of British Columbia / British Columbia Historical Association, 1954), 133–238.

25 G. P. V. Akrigg and Helen Akrigg, *British Columbia Place Names* (Vancouver: UBC Press, 1997).

26 For more information about Jacobsen and this collection see Martha Black, "Living Cultures–From Artifacts to Partnerships," in *Treasures of the Royal British Columbia Museum and Archives* (Victoria: Royal BC Museum, 2015), 49–83.

generations

My special thanks to the members of the extended Guichon, Lee, Louie, and Seto families, and to the staff at both the Asian Library at the University of British Columbia and the Royal BC Museum and Archives, for their amazingly kind and professional assistance with this research.

1 Jean Barman, *The West Beyond the West: A History of British Columbia*, 3rd ed. (Toronto: University of Toronto Press, 1999), 385, table 11.

2 See table 11 in Barman, *The West Beyond the West*, 385. See also John Douglas Belshaw, *Becoming British Columbia: A Population History* (Vancouver: UBC Press, 2009).

3 See Judith Guichon, "Stewards of the Land through Many Generations," (pages 117–123, this volume) for the important family perspective.

4 Jean Barman, "Early French Ranchers in British Columbia" (keynote *to Société historique francophone de la Colombie-Britannique* event honouring Lieutenant Governor Judith Guichon, Simon Fraser University, Burnaby, BC, 2013). The modern borders of France had not been defined at the time of the Cariboo Gold Rush (Barman 2013, 1–2).

5 See "The Guichon Family," *Nicola Valley Historical Quarterly* 11, no.1 (August 1993): 6.

6 Cataline was a famous French packer during the Gold rush era. He provisioned the BC goldfields using the old Hudson's Bay Company brigade trails.

7 This was Joseph's grandson Gerard's account. See Barman, "Early French Ranchers," and Guichon, "Stewards of the Land."

8 John Douglas Belshaw, "Guichon, Joseph," in *Dictionary of Canadian Biography*, vol. 15, Toronto: University of Toronto, 2003–), accessed October 9, 2016, http://www.biographi.ca/en/bio/guichon_joseph_15E.html.

9 See Judith Guichon, "Stewards of the Land."

10 Barman, "Early French Ranchers," 6n5, 7, 12. Information on the Guichons comes principally from the second-, third-, and fourth-generation first-hand accounts of Lawrence Guichon and Gerard Guichon. See Lawrence Guichon, interview by Thomas Garnet Willis, c.1960, T4144:0001, BC Archives; Gerard Guichon, interview by Imbert Orchard, June 27, 1964, T0403, BC Archives; Gerard Guichon with Sandra Klein, "The Guichon Family," *Nicola Valley Historical Quarterly* 11, no. 1 (August 1993): 1–12; Gerard

Guichon, "On Education," *Nicola Valley Historical Quarterly* 1, no. 3 (July 1978): 8; and Guy Rose, interviews with Doug Cox, presented in Cox's *Ranching Now, Then, and Way Back When* (Penticton, BC: Skookum, 2004), 171–73.

11 See Judith Guichon, "Stewards of the Land" (pages 117–123, this volume) and Joseph's son Lawrence Guichon and grandson Gerard Guichon's accounts in note 10.

12 Peter Guichon in "Fifth Generation Farmers," *Delta Optimist* video, 2:41, October 10, 2007, posted December 11, 2013, https://www.youtube.com/watch?v=yFOMIWCq88M. The present essay focuses more on Joseph's side of the Guichon family in the cattle industry because the Royal BC Museum and Archives is currently the steward of the family collection and therefore has access to family files and images.

13 See Lisa Mar, *Brokering Belonging: Chinese in Canada's Exclusion Era, 1885-1945* (Oxford: Oxford University Press, 2010): "By the early twentieth century, generations of Chinese Canadians had approached Canada, China, and the United States as a single field of opportunity," 9.

14 Jing Liu and Phoebe Chow, "The Seto Collection in UBC Asian Library: Its Usefulness to Scholars and Students," *Journal of East Asian Libraries* no. 163 (2016). http://scholarsarchive.byu.edu/jeal/vol2016/iss163/6. This part of the family history was passed down as oral tradition in the Seto and Louie families and confirmed by the authors at UBC Asian Library in the Chinese language source *Kaipingwenshi*.

15 See Dr L.P. Guichon and Brodie Douglas, "Dr. Lawrence Peter Guichon, Part 3 of 4: The Stock Brands Act," *Nicola Valley Historical Quarterly* 23, no. 3 (Winter 2010); Gerard Guichon with Sandra Klein, "The Guichon Family," *Nicola Valley Historical Quarterly* 11, no. 1 (August 1993): 1–12; "Cattle Breeder Led by Example", *Merritt Herald*, November 25, 2010, http://www.merrittherald.com/cattle-breeder-led-by-example/; and the Guichon Collection at the Royal BC Museum and Archives.

16 See Dr. L.P. Guichon and Brodie Douglas, "Dr. Lawrence Peter Guichon, Part 2 of 4: Nicola Grasshopper Control," *Nicola Valley Historical Quarterly* 23, no. 2 (Summer 2010).

17 See the Guichon Collection at the Royal BC Museum and Archives.

18 See Gerard Guichon, "On Education," *Nicola Valley Historical Quarterly* 1, no. 3 (July 1978): 8, and Lawrence Guichon's certificate for his honorary doctoral degree, Guichon Collection, BC Archives.

19 Division of Vital Statistics Marriage Registration 002339, GR 2692, vol. 006, BC Archives.

20 Timothy Stanley, *Contesting White Supremacy: School Segregation, Anti-Racism, and the Making of Chinese Canadians* (Vancouver: UBC Press, 2011), 197.

21 Mar, *Brokering Belonging*, 80.

22 W.E. Willmott, "Approaches to the Study of the Chinese in British Columbia", *BC Studies* 4 (Spring 1970): 38-52.

23 See Bennet Bronson and Chiumei Ho, *Coming Home in Gold Brocade: Chinese in Early Northwest America* (Seattle: Chinese in Northwest America Research Committee, 2015), 195. In 1909 Fanny's brother, Lew Kay, became the first Chinese American college graduate from the University of Washington in 1909.

24 E.G. Perrault, *Tong: The Story of Tong Louie, Vancouver's Quiet Titan* (Madeira Park, BC: Harbour, 2002), 87-8.

25 His extensive library was donated by his second daughter Geraldine May Sin Seto and her husband Tong Louie to the Asian Library at the University of British Columbia in 1967.

26 "Chinese Special Collections: Seto Collection," UBC Library Research Guides, last modified October 16, 2016, http://guides.library.ubc.ca/rarechinese/seto.

27 Harry Con et al., *From China to Canada: A History of the Chinese Communities in Canada* (Toronto: McClelland and Stewart, 1982), 76.

28 Mar, *Brokering Belonging*, 84. Chinese Canadians called July 1, 1924—the day the bill went into effect—"Humiliation Day", and they did not celebrate the national holiday until after the bill was repealed in 1947.

29 Mar, *Brokering Belonging*, 84. For a detailed history of school segregation, see Stanley, *Contesting White Supremacy*.

30 Perrault, 27.

31 Perrault, 37-9.

32 Perrault, 62.

33 The Perrault book suggested that it was a way of punishing a wholesaler to sell retail.

34 Letter of March 30, 1934. Translated by Harb Leung and transcribed in Perrault, 71.

35 Bernard Guichon, interview with the author, July 7, 2016. Bernard fondly remembers his time with a convoy that happened to dock in Scotland on VE day and commented that "Being [in] a navy is a wonderful thing if you survive."

36 Personal interview with Guy Rose, October 1, 2016. He emphasized "everything."

37 "A Legacy of Ranching in the Valley," *Merritt Herald*, August 18, 2009, http://www.merrittherald.com/a-legacy-of-ranching-in-the-valley/. The hotel now is in the hands of new owners, but the family was promised that its historical traditions will be preserved.

38 Lew Kay-Lew Soun-Seto-Louie, "Family Album" (self-published photo album).

index

Italicized pages include an image.

Copyright © 2017 by the Royal British Columbia Museum, except as noted below.

Published by the Royal BC Museum, 675 Belleville Street, Victoria, British Columbia, v8w 9w2, Canada.

Pages and cover designed by Lara Minja, Lime Design Inc. Nest photographs by Jo-Ann Richards, Works Photography Inc.

Typeset in Bembo Std 9/13 pt with Typewriter MT and Whitney.

© Patrick Lane, "Fathers and Sons"; © Monique Gray Smith, "Voices of Our Ancestors". All images are from the Royal BC Museum and Archives except for those credited otherwise in the captions. All images and text excerpts reprinted with permission.

Printed in Canada by Friesens.

LIBRARY AND ARCHIVES CANADA CATALOGUING IN PUBLICATION

The language of family: stories of bonds and belonging / Michelle van der Merwe, editor.

Includes bibliographical references and index.
ISBN 978–0–7726–7052–6 (softcover)

1. Families—Literary collections. 2. Canadian literature (English)—21st century. I. van der Merwe, Michelle, editor II. Royal BC Museum, issuing body

PS8237.F33L36 2017 c810.8'0355 C2017-902051-X

MIX
Paper from responsible sources
FSC® C016245
www.fsc.org